night PHOTOGRAPHY

LANCE KEIMIG

WITH SCOTT MARTIN

night PHOTOGRAPHY

Finding your way in the dark

ELSEVIER

AMSTERDAM • BOSTON • HEIDELBERG • LONDON
NEW YORK • OXFORD • PARIS • SAN DIEGO
SAN FRANCISCO • SINGAPORE • SYDNEY • TOKYO

Focal Press is an imprint of Elsevier

Focal Press is an imprint of Elsevier
30 Corporate Drive, Suite 400, Burlington, MA 01803, USA
The Boulevard, Langford Lane, Kidlington, Oxford, OX5 1GB, UK

Notices

Knowledge and best practice in this field are constantly changing. As new research and experience broaden our understanding, changes in research methods, professional practices, or medical treatment may become necessary.

Practitioners and researchers must always rely on their own experience and knowledge in evaluating and using any information, methods, compounds, or experiments described herein. In using such information or methods they should be mindful of their own safety and the safety of others, including parties for whom they have a professional responsibility.

To the fullest extent of the law, neither the Publisher nor the authors, contributors, or editors, assume any liability for any injury and/or damage to persons or property as a matter of products liability, negligence or otherwise, or from any use or operation of any methods, products, instructions, or ideas contained in the material herein.

Library of Congress Cataloging-in-Publication Data
Application submitted

British Library Cataloguing-in-Publication Data
A catalogue record for this book is available from the British Library.

For information on all Focal Press publications
visit our website at *www.elsevierdirect.com*

ISBN: 978-0-240-81258-8

10 11 12 13 14 5 4 3 2 1

Printed in China

Contents

STEVE HARPER:
FOREWORD

Many photographers have taken a shot-in-the-dark approach to photographing at night, using whatever film they might have with them when the inspiration hit, but historically, few actually pursued it with inspiration and dedication. The history of night photography, although punctuated by generational lapses, has brought to the fore some distinguished efforts. But it was not until the mid-1970s that night photography began to capture the imagination of so many, and it has grown exponentially since, becoming truly universal with the advent of the digital camera.

Tim Baskerville, "Calling Mr. Harper," San Francisco, 2000

What impels many of us to photograph at night is our fascination with the transformation of reality by the passage of time; the compression of time into a single image. Motion, atmospheric changes, the unexpected, and the unexplained all etch themselves upon the image during a long exposure. The resulting image, at times touched with poetry, suggests another dimension or an altered reality—usually one that is more beautiful and more peaceful.

At night, in remote areas, while standing alone and focusing upon nature during a long exposure, you become aware of the universality of all things. The Earth is constantly turning in correlation to the stars and planets. The atmosphere around you becomes palpable whether it is totally still or on the verge of a storm. These elements, beyond your control, will alter not only the mood of the image you are exposing, but also its design and, at times, its ultimate meaning. Depending upon the direction you are photographing, the stars and planets will etch themselves upon the image as spirals around the North Star, inferring motion and infinity, or they will make diagonal lines that, at times, point directly at what your camera is focusing upon. The atmosphere, either still or moving, will mysteriously amplify the mood.

Night photography, of its very nature, is a subjective study. When I began exploring night photography in 1976, no textbooks had been written exclusively for the teaching of night photography, and most published guidelines dealt with rudimentary exposures, such as how to photograph neon signs, Christmas tree lights, friends sitting beside a table lamp, and a universal favorite, fireworks at night. It is easy enough to figure out such exposures on a hit-or-miss basis, and if you are using film, a sensitive light meter will work if used judiciously. A digital camera can capture such images in auto mode, but usually without the atmosphere.

Should you be inspired to go beyond such subjects and explore the variant atmospheres of the night, it becomes much more complex. But as this comprehensive book illustrates, such inspirations have become more fruitful with the introduction of the digital camera. With digital cameras you can make corrective adjustments on the fly—see the high-ISO test conversion tables in Chapter 8. And for those who prefer the proven viability of film, the guidelines are of such clarity and thoroughness that you can begin photographing at night productively even in the most remote regions of the night.

The atmosphere at night is one of the elements that determines the mood of an image. It can also be a major influence on the amount of contrast. Have you ever considered how a low-lying fog or mist spreads and amplifies the ambient light? And how it can add an element of mystery, particularly in black and white images? Do you know what design the stars and planets will make in the beautiful blue night, beyond the urban lights and during a long exposure, as you photograph toward the west as the Earth is turning all the while? All of these technical considerations are addressed and clearly explained in this book. Equally

important, the resultant artistic considerations are explored. This book is the result of 20 years of dedicated research. Consequently, it describes the technological advances both in film and in digital equipment. I wish there had been such an invaluable resource when I started photographing at night back in 1976!

Steve Harper
November 2009

ACKNOWLEDGMENTS

This being my first book, I was unprepared for the enormity of the project and for how much I would depend on the many people who contributed to the project in one way or another. Even thinking about the long lists of acknowledgements in other books I've read did not make me realize just how much of a collaborative project this would be. I'm truly grateful for the support of so many people who helped with this project.

First, I'd like to thank Valerie Geary at Focal Press; she invited me to write the book, something I had long wanted to do but never acted upon. Thanks also to my project managers at Focal Press, Danielle Monroe and Stacey Walker, whose encouragement and gentle nudges kept me focused throughout the project. Kara Race-Moore, also at Focal Press, was given the impossible task of tracking copyright holders for obscure and deceased photographers, and she made Herculean efforts to find them. Jeanne Hansen was the copy editor for the project, and her amazing attention to detail is much appreciated. I'm deeply grateful to Joanne Blank, the book designer, both for her elegant design and determined patience with my countless cover revisions.

A number of curators and historians assisted me with the history of night photography chapter, including Roy Flukinger and Linda Briscoe Myers at the Harry Ransom Center; Diana Carey at Harvard University's Schlesinger Library; and Alan Griffiths, Gerardo Kurtz, Arthur Ollman, Jeff Brouws, Peter Yenne, Shirley Burman, and Mark Katzman, who supplied beautiful scans for several of the images in Chapter 1. Very special thanks go to Keith F. Davis of the Nelson Atkins Museum both for his inspiration and thoughtful comments on the history chapter. Thank you also to Susan Friedewald for the introductions, and to Richard Misrach, George Tice, and Michael Kenna for your generosity with your time and images. Thanks also to the many other photographers who contributed images and information to the book. Throughout the process of writing the book, I found that, as a general rule, living photographers are much more helpful and generous than the estates of dead ones.

Robert Watts at Nikon, and Rudy Winston, Carl Peer and Chuck Westfall from Canon all provided invaluable technical advice on the inner workings of DSLRs. Thanks also go to Drew Epstein for sound legal advice, Andy Frazer for reviews of the first sections and his continuous support of all my work, and Tim Baskerville of The Nocturnes for his dedication and service to the promotion of night photography. Jill Waterman has been a great supporter and friend who included me in her own book on night photography in 2007. A tip of the cap goes out to my teaching assistants at the New England School of Photography, Katherine Moxhet and Myron "Fletch" Freeman. I thank J. Michael Sullivan, who provided excellent scans of my film images for the book, and Isa Leshko, who did her best to keep me focused.

The guest contributions, Jens Warnecke and Cenci Goepel, Tom Paiva, Troy Paiva, Christian Waeber, Scott Martin, and Dan Burkholder, all added perspective and depth to my own words. Shawn Peterson contributed in a major way to the section on stacking exposures in Chapter 8. Your images and knowledge are a big part of the success of this book. Thank you.

Scott Martin was the technical editor for the project, and I could not have asked for a better collaborator. His knowledge, insight, experience, and perspective have added tremendously to the quality of this book. Thank you Scott, it is always a pleasure to work with you, and I look forward to our next project.

It's always the family that pays the heaviest price when someone decides to write a book, and mine is no exception. My mother-in-law Dianne has been there for my family when I have not, and she provided all of us with sustenance and support. My wife, Brooke, and son, Skye, have endured my frequent long nights out photographing, long weeks away teaching workshops, and long nights at the computer for years, and have always fully supported my crazy endeavors. My mother always believed in me when she probably shouldn't have, and she has always been my biggest fan. Without all of your support, I couldn't do it.

Finally, my warmest appreciation and gratitude goes to my mentor and friend, Steve Harper, who taught and inspired not only me, but also a generation of night photographers. I dedicate this book to you, Steve, for if I had never taken your class all those years ago, this book never would have been written.

CONTRIBUTOR
BIOGRAPHIES

Troy Paiva has been shooting full moon, time-exposure night work in abandoned locations and junkyards since 1989. His surrealist and whimsical work examines the evolution and eventual abandonment of the communities, structures, and social iconography spawned during America's 20th century expansion into the deserts of the West. His work has appeared in print in a dozen countries. He's had two award-winning monographs published, *Lost America: Night Photography of the Abandoned Roadside West* in 2003 (Motorbooks International), and *Night Vision: The Art of Urban Exploration* in 2008 (Chronicle Books). Troy's work has appeared in galleries in New York, Los Angeles, Boston, and San Francisco. www.lostamerica.com

Tom Paiva is a professional, freelance photographer based in California where he has had his business for 20 years. He specializes in industrial and maritime settings, as well as architecture and interiors. Paiva's book, *Industrial Night*, was published by The Image Room in 2002. His passion is night photography and he loves to create images of urban and industrial settings on film, using the large format camera. He is an original member of The Nocturnes, and has co-lead photo workshops on night photography and view camera use over the past 12 years. Paiva earned a Bachelor of Fine Arts degree in photography from Academy of Art University, where he studied with Steve Harper. www.tompaiva.com

Christian Waeber was born in Fribourg, Switzerland in 1964 and moved to Boston, Massachusetts in 1993, where he now lives and works. He is a self-taught photographer, with interests in figure, night, and architectural photography. His work has been shown in numerous solo and group exhibits including Darkness Darkness at Harvard University in 2007, and has been featured in numerous magazines including *View Camera*, *Preservation*, and *Art-Photo-Akt*. www.cwaeber.com

Dan Burkholder has been teaching digital imaging workshops for 15 years at venues including The School of the Art Institute, Chicago; The Royal Photographic Society, Madrid, Spain; The International Center of Photography, New York; and many others. Dan's latest book, *The Color of Loss* (University of Texas Press, 2008), documents the flooded interiors of post-Katrina New Orleans and is the first coffee-table book done entirely using HDR methods. His award-winning book, *Making Digital Negatives for Contact Printing* (Bladed Iris Press, 1999), has become a standard resource in the fine-art photography community. Dan's platinum–palladium and ink-jet prints are in public and private collections all over the place. www.danburkholder.com

Cenci Goepel and Jens Warnecke are a couple from Hamburg, Germany who travel and collaborate together on their photographs. Cenci is a painter and Jens's background is in film, editing, and animation. They decided that photography was somehow meeting in the middle. They create shapes in nature by drawing with light using a variety of sources and photograph them on film with medium format cameras. www.lightmark.de

Scott Martin is a digital photography educator and fine art photographer. He has been working with digital photography since the 1980s and with full-time devotion to on-location private training since the 1990s, his experience has allowed him to consult with some of the most demanding professionals in the business. His fine art photography is exhibited around the country and can be found in many collections. Martin offers private one-on-one training and small group workshops on color management and photography workflow. Martin and the author teach workshops on night photography and light painting in various locations around the U.S. www.on-sight.com

INTRODUCTION

Why Night Photography?

Some of the very first photographs I ever took were made in a darkened room with an old camera mounted on a tripod with a flashlight as the only light source. With the shutter set to bulb and locked open with a cable release, I moved around the room with the flashlight. Sometimes behind the camera, and sometimes in front of it, I painted the room, my girlfriend, and myself with light. I had no idea what I was doing, but it was fun, and the results were interesting enough to inspire me to experiment further. I was fascinated with the idea of moving subjects and a moving light source, and how they would be represented in a photograph. From the very beginning, a big part of my interest in photography had to do with the expression of time. That was back in 1986, and to this day, most of my photography is done at night. When I decided to pursue photography as a career, I chose the school I did in large part because it offered the only course in night photography I could find. Moving to San Francisco to study with Steve Harper was a fateful decision, and one that has led me to where I am today, teaching classes and workshops on night photography, and now writing this book.

A normal, or daytime, photograph requires an exposure time that is just a small fraction of a second. A scene is captured with moving objects frozen in time. Over the course of more than a century and a half of looking at photographs, and centuries more looking at paintings and drawings, this is the way we've come to understand the world in pictures. A night photograph requires an exposure that is at least several seconds, and it may be as long as the night itself. The world is in a constant state of flux, and during a long exposure, anything at all might pass before the open shutter. A person walking through the scene pauses for a moment and is recorded as a transparent ghost. Cars speed by, leaving streaks of light from the headlights and taillights, or a traffic light changes from green to yellow to red, and all three colors are recorded in the photograph. Waves crash and recede on a beach, and the surface of moving water looks as though it were a sheet of ice. Clouds pass overhead, and the stars drag across the sky, leaving trails of light as the Earth turns on its axis. Over the course of a long exposure at night, all of these things are recorded by the camera in ways that we cannot see with our own eyes. The night photograph is an expression of time as a single still image, but our senses can only perceive time

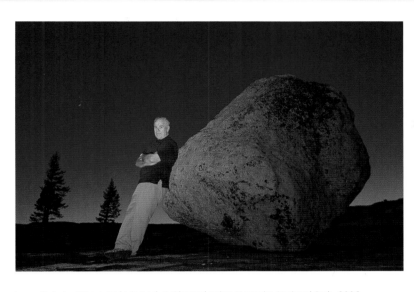

Lance Keimig, "Steve and His Rock," Olmsted Point, Yosemite National Park, 2006

as a continuum. Night transforms our experience of the world from one of routine certainty to one of mysterious unknowing. This is the essence of what makes night photography special.

There are numerous books available on the subject of night and low-light photography, and most of them perpetuate the stereotypical nighttime subjects of floodlit monuments, fireworks displays, neon signs, and Christmas lights. I saw a need for a book that truly embraced the potential of night photography to transform the world beyond literal interpretation. Night photography requires a different approach and a different way of thinking about making images than daytime photography. The use of high ISO settings and short exposures sometimes leads to images that lack many of the mysterious qualities of really good night photography. Long exposure night work is more art than science, and although technical knowledge and skills are important to successful results, it is having an open mind and creative spirit that is crucial to unlocking the secrets of night photography. I've written this book to present a concise technical guide to photographing at night, but more importantly as a starting point to explore the limitless creative possibilities of combining time and light together with the aid of a camera.

I've always felt that it is important to look at the work of other artists and that there is nothing wrong with learning from what others have done before us. It is in this spirit that I have included a chapter on the history of night photography to show the development of styles and techniques that have paralleled the evolution of photographic technology, from the early toxic and laborious chemical processes to the incredibly sophisticated digital cameras that most of us use today.

Much of the information presented in this book applies to both film and digital night photography. Although most of the other books on this topic have primarily focused on shooting film at night, I still feel the need to include a chapter on film-based night photography in my book. I've done this, in part, because I find that there are still valid reasons for shooting film at night, partly because many of the best night photographers working today still shoot film, partly because I wanted this book to be a complete reference on the subject, and partly because I've worked with film over the past 25 years and have developed my own specialized exposure and development techniques that I would like to share with you. That said, the book is written with the assumption that most readers will be working with digital cameras, and the bulk of the technical information relates to digital capture and RAW image processing.

Rapidly evolving technology makes writing about digital photography especially challenging because books can become quickly outdated. New camera models that have been released during the writing of this book have led me to reevaluate my approach to digital night photography. New features and the astounding image quality found in today's top-of-the-line professional DSLR cameras will probably be incorporated into future consumer-level cameras and will no doubt have a dramatic effect on night photography. With these newest professional cameras, released in late 2008 and onward, it is possible for the first time to record stars in the night sky as points of light rather than star trails without using tracking mechanisms normally reserved for telescopes. With this in mind, I have avoided recommending specific camera models and instead suggested features to look for. The Web site www.dxomark.com provides a useful and extensive database comparing and ranking the quality of RAW image data from digital cameras based on a number of variables. I highly recommend consulting and studying this database before making a new camera purchase. There are other important considerations besides RAW image quality to take into account, like ease of use, ergonomics, the availability of lenses, and of course, cost.

The sections dealing with image processing necessarily discuss current versions of available software. At the time of this writing, digital cameras and postprocessing software have evolved to the point where many of the major obstacles of night photography have been overcome by continuous advances in technology. Future camera models may incorporate features like in-camera exposure blending of RAW files to deal with extreme dynamic range or limited depth of field. Although it is doubtful that camera manufacturers had night photography in mind when developing new models, the improvements in each successive generation of digital camera have greatly benefited night photographers. Lower noise levels, the availability of increasingly higher useful ISO settings, and features like live view all make for better night photography.

Night photography is a broad field of endeavor, and there are limitless possibilities for the photographer with a basic understanding of the principles of photography, a willingness to look at the world from a different perspective, and the application of some creative thought.

Although there is tremendous diversity in subject matter, technique, and equipment, I have found remarkable similarities in what attracts people to photographing at night and a commonality of shared experiences, both in my research into the history of night photography and in conversations with colleagues and students.

Aside from often being night owls seeking relief from boring or stressful day jobs, night photographers are typically romantics, lured by the mystery and intrigue associated with night and darkness. First and foremost, night photography provides an outlet for the artist to reconnect to the physical world in ways that are often lost in the hectic pace of daily routines. We speak of how our senses open up to the physical world when we are out at night on a shoot. When the shutter clicks open and we find ourselves with 15 or 20 minutes and no obligation, nowhere to be, and nothing to do, the night rewards us with a sense of peace and freedom that we don't often experience in our busy lives. This heightened sense of awareness and connection to the physical world can open the doors to creativity, free us from constraints of the ordinary, and enable us to take advantage of the unique qualities night photography has to offer. Night photography is a ritual, one that involves the engagement of light and time, creative vision, and circumstance. The most successful night photographs are the ones that leave the viewer with unanswered questions. The enigma and ambiguity of what is portrayed in a night photograph draws in the viewer and leaves him or her longing for certainty where it doesn't exist. The interplay of light, shadow, and extremes of contrast heighten this uncertainty—and when combined with the element of time, the night photograph can transport the viewer into this mysterious realm so that they too may experience part of what the photographer felt when the image was created.

This book is written from the perspective of a photographer who has worked mainly at night as a means of self-expression for the past 23 years. Although the book is full of practical details, it is not intended to simply provide technical information on photographing in various low-light situations. There is no section on photographing fireworks, theater performances, or nighttime sporting events. There are no sunrise or sunset pictures. These have all been covered in other volumes. Thanks largely to the proliferation of information on the Web and the rapid development of digital technology, more and more people are discovering the wonder of night photography. My hope is that the reader will be drawn to photograph at night for its mysterious qualities and for the magical things that can happen during a long exposure.

This book is oriented toward aspiring amateur photographers and artists interested in exploring the creative possibilities of night photography. An understanding of the basic principles of exposure, depth of field, your camera's controls and functions, and at least rudimentary familiarity with RAW file image development will be invaluable in understanding the contents of the text. It is suited for advanced beginners through professional photographers, but the casual snapshooter with a point-and-shoot camera may find the book frustrating and of little practical use, other than perhaps as an inspiration for further exploration of the subject at hand. The book is written to be read in

sequence, and some information builds upon material that was presented in earlier chapters. Still, more advanced photographers should be able to pick and choose what is most interesting or relevant to them.

In addition to using my own photographs to illustrate this text, I'm honored to be able to include images by friends, mentors, colleagues, and even a few of my students to demonstrate particular techniques and to provide inspiration to you, the reader. I am an Apple computer user, and the screenshots in the image processing chapter were created on a Mac, primarily using Adobe Lightroom 2.6 and Photoshop CS3. As the book goes to press, Lightroom 3.0 is in public beta testing and promises to offer significant improvements over Lightroom 2.6 in noise reduction and many other features. I came across an outstanding application called Enfuse just as I was finishing the text and would not be surprised if its image blending features are incorporated into future versions of Lightroom and Photoshop. It is an exciting time to be involved in photography, and a great time to be a night photographer.

THE HISTORY OF NIGHT PHOTOGRAPHY

From Daguerreotype to Digital

1

DOI: 10.1016/B978-0-240-81258-8.00001-6

Nighttime has been associated with solitude, danger, mystery, and the unknown throughout human history. The night transforms our notion of the world from one of routine certainty to one of mysterious unknowing. The night holds secrets—secrets that may engage our curiosity, shelter us, or frighten us. There are those who seek comfort in the night and those who recoil from it. Brave was the ancestor who stepped outside of the light of the fire circle, for he might never return.

The motif of night was established in Western art long before the advent of photography. Artists as far back as the Flemish painter Hieronymus Bosch played off the instinctive fear of darkness and the night in his masterpiece from 1503, *The Garden of Earthly Delights*. The 16th-century German printmaker Albrecht Dürer and Dutch painter and printer Lucas van Leyden repeatedly invoked night scenes in their work. Aert van der Neer was a 17th-century Dutch painter whose main body of work consisted of moonlit landscapes of his native Netherlands. Rembrandt famously relied on dark tones and deep shadows to evoke powerful emotions in his work, and several of van Gogh's most famous paintings are night scenes. Captivated by the night, van Gogh wrote in a letter to his brother that, "I often think that the night is much more alive and more richly coloured than the day."[1] James McNeill Whistler painted a series of night and twilight scenes entitled *Nocturnes*, and of course Edward Hopper's *Nighthawks*, which conveys a sense of urban isolation and loneliness, is one of the most recognizable paintings of the 20th century. It seems only fitting that photographers should be drawn to the night as well for inspiration. Although painters put down on canvas whatever they see in their mind's eye, the photographer's camera records only what passes before the lens. In the case of the night photographer, the time that passes during the exposure is as important as the light.

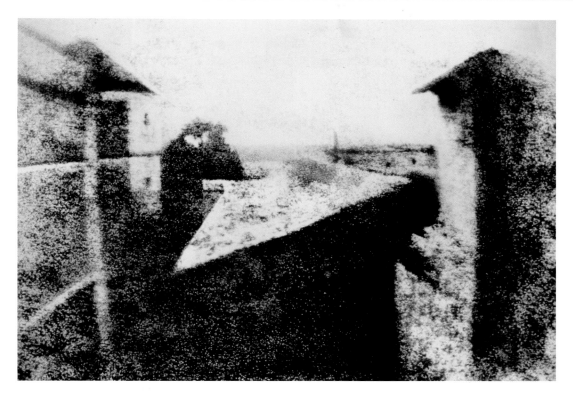

Joseph Nicéphore Niépce, "View from the Window at Le Gras," ca 1826–1827

After 10 years of work that began in 1816, Niépce took this image on a pewter plate coated with bitumen of Judea with a camera obscura and an optical device used by artists as a drawing aid. After an exposure of at least 8 hours, Niépce washed the plate with a mixture of white petroleum and oil of lavender, and the result was the first permanent photograph. The image is on permanent display at the Harry Ransom Center at the University of Texas at Austin.

Due to the limited sensitivity of early photographic processes, exposure times were exceedingly long, even in the daytime. The oldest existing photograph, which was taken by Joseph Nicéphore Niépce in 1826 or 1827, is a scene from his window in Le Gras, France. Although it is not a night photograph, the materials he used required an exposure of many hours to record the image on a pewter plate coated with a light-sensitive layer of bitumen of Judea. As the Sun moved across the sky during the long exposure, shadows were recorded on both sides of his house. The first commercially available photographic process was the daguerreotype, and when the process was introduced in 1839, exposure times of 10 minutes or more were required to take a photograph in sunlight. Although exposures were generally reduced to 5–10 seconds within a few years, photographing at night in the weak artificial light of the time or by moonlight was still impossible. The wet-plate collodion process was a tremendous technical advance over the daguerreotype

when it was invented in 1851. However, because collodion plates had to be exposed and developed before the emulsion dried on the plate, the lengthy exposures required at night made nocturnal photography essentially impossible. In 1871, Richard Leach Maddox, an English physician and photographer, proposed combining gelatin with light-sensitive silver nitrate and cadmium bromide to make dry glass plate negatives.[2] In 1878, Charles Harper Bennett, who was one of the first to produce dry plates, discovered that by heating the emulsion to 90F, it would become dramatically more light sensitive and stable.[3] With this advance, plates were soon manufactured in Europe and North America and were widely available by the end of the decade. It was this introduction of the gelatin dry-plate process with its inherently greater sensitivity that once and for all opened the doors to night photography.

A few early photographers experimented with night and low-light photography, and throughout the 19th century photographs were often manipulated to appear as though they were taken at night. In 1840, the American John Draper made the oldest known daguerreotype of the Moon, which required a 20-minute exposure.[4] From 1849 to 1851, Boston inventor and photographer John Adams Whipple and George Phillips Bond made daguerreotypes of the Moon through a telescope equipped with a clockwork mechanism that moved the telescope in sync with the Earth's rotation. The light-gathering power of the telescope also served to shorten the exposure time. After many attempts, they were able to record details of the Moon's surface for the first time. One of the resulting plates, which was made at the Harvard College Observatory where Bond's father was the director, won a gold medal at the Crystal Palace Exhibition in 1851.[5]

During the 1850s, Thomas Easterly was the first to record lightning strikes on a daguerreotype plate. There were numerous efforts to photograph in low-light conditions with artificial light sources beginning about 1860. The French photographer Félix Nadar photographed the catacombs and sewers below Paris, making about 100 plates between 1861 and 1862. Nadar used both magnesium lamps and electric lights powered by primitive batteries for these photographs, and he employed mannequins to represent workers because of the lengthy exposures.[6] In 1863, Whipple experimented with electric lights to photograph a fountain on Boston Common at night. He determined that an exposure that would require one-half second in sunlight required 90 seconds by the electric lights.[7] In April 1865, Charles Piazzi Smyth, Astronomer Royal of Scotland, made use of magnesium wire to photograph the interior passages of the Great Pyramid of Giza.[8]

It wasn't until Paul Martin in London and William Fraser and Alfred Stieglitz in New York began to photograph at night at the very end of the 19th century that anyone produced a significant body of true night images. Beginning in 1895, Martin photographed London street scenes, starting to work just before the last hint of twilight faded away to shorten the lengthy exposures required at night. Martin attracted the attention of passersby who wondered what he could possibly be doing out at night with a camera. The police also took notice and questioned his motives on more

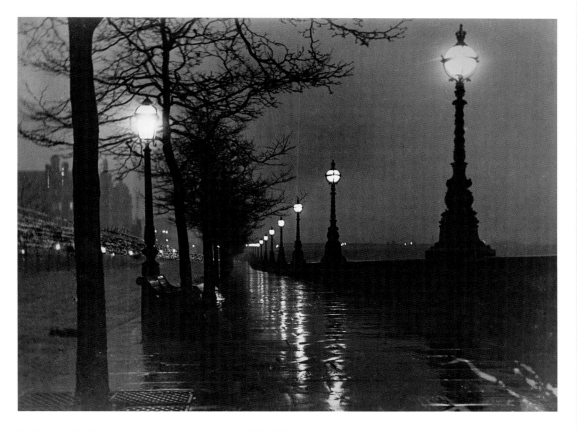

Paul Martin, "A Wet Night on the Embankment," ca 1895–1896

In 1896, Martin received the Royal Photographic Society's Gold Medal for his series of pioneering night photographs entitled "London by Gaslight," which caught the attention of Alfred Stieglitz in New York. Martin recounts in his autobiography, *Victorian Snapshots*, how he was routinely followed by a policeman during his nocturnal photographic exploits.

than one occasion.[9] To this day, many night photographers find themselves faced with similar experiences.

William Fraser began photographing New York at night about 1896, but there are very few existing prints of his work because he preferred to exhibit his photographs in the form of projected lantern slides. An article in *Scribner's Magazine* from 1897 stated that Fraser "has succeeded in taking some remarkable park and street scenes on snowy and rainy nights [that] show with surprising distinctness and truth, very picturesque and interesting aspects of New York."[10] It was also noted that Fraser took advantage of the "moon's diffused light" for these photographs. The light of the Moon no doubt made more of a contribution to these images than it would if the same scene was photographed today because the nighttime level of artificial illumination was much lower at the end of the 19th century.

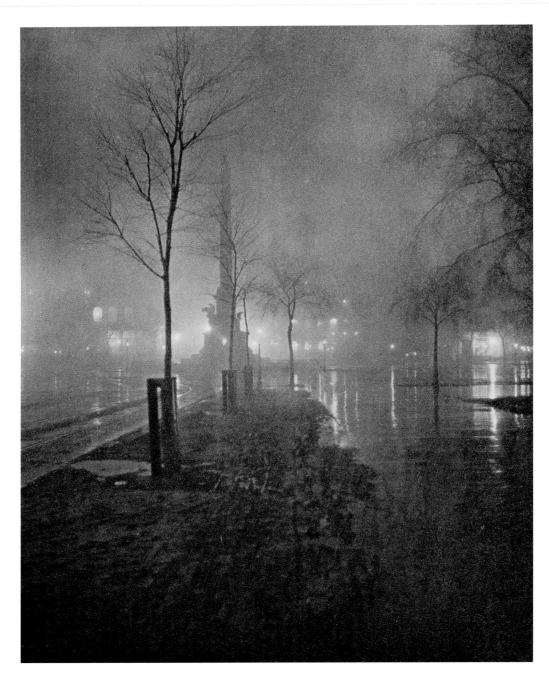

William Fraser, "A Wet Night, Columbus Circle," ca 1897–1898

Fraser, along with Alfred Stieglitz in New York and Paul Martin in London, were the photographers who established night photography as a viable and legitimate art form at the end of the 19th century. The image was originally published as a photogravure in Stieglitz's *Camera Notes* in January 1899, which is the source of this reproduction.

Alfred Stieglitz is one of the most important figures in the history of photography, both for his images and for his promotion of photography as an art form. He was perhaps the first person to record recognizable figures in a night photograph, and he used exposures of about 1 minute to photograph New York street scenes in 1897. One can't help but notice that all three of these night photography pioneers chose to photograph in poor weather conditions. Wet pavement, rain, snow, and fog all tend to add drama and atmosphere to night photographs (something that is not lost on contemporary night photographers). They were also no doubt aware that wet surfaces reflect lights in the streets. The image from 1898 reproduced here, "Icy Night," is a perfect example of how foul weather can yield spectacular results, as Stieglitz later wrote about this image:

> One night, it snowed very hard. I gazed through a window, wanting to go forth and photograph. I lay in bed trying to figure out how to leave the house without being detected by either my wife or brother.
>
> I put on three layers of underwear, two pairs of trousers, two vests, a winter coat, and Tyrolean cape. I tied on my hat, realizing the wind was blowing a gale, and armed with tripod and camera—the latter a primitive box, with 4 × 5 inch plates—I stole out of the house. The trees on the park side of the avenue were coated with ice. Where the light struck them, they looked like specters.
>
> The gale blew from the northwest. Pointing the camera south, sheltering it from the wind, I focused. There was a tree—ice covered, glistening—and the snow covered sidewalk. Nothing comparable had been photographed before, under such conditions.
>
> My mustache was frozen stiff. My hands were bitter cold in spite of the heavy gloves. The frosty air stung my nose, chin, and ears. It must have been two o'clock in the morning. After nearly an hour's struggle against the wind, I reached home and tiptoed into the house, reaching the third floor without anyone hearing me.
>
> The next day I went to the camera club to develop the plate. The exposure was perfect.[11]

Stieglitz had been suffering from pneumonia at the time and had been ordered to take care of himself. His success is all the more remarkable in the face of such adversity.

The preference for photographing in rain, fog, or snow was probably influenced by the pictorialist style that was prevalent at the end of the 19th century. Pictorialist photographers used soft focus and manipulation in their prints to create idealized, romantic images that evoked the impressionist paintings that were popular at the time. Photography had not yet achieved widespread acceptance as an art form, and another decade would pass before photographers had the confidence to present photographs that truly represented the new medium's mechanical potential to convey reality.

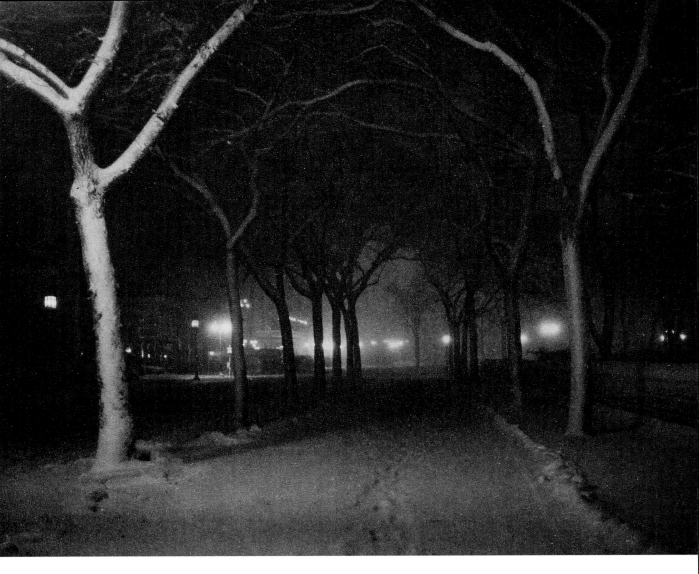

Alfred Stieglitz, "Icy Night," 1898

Alfred Stieglitz made this image on a frigid night during a snowstorm in January 1898 after a bout with pneumonia. Stieglitz was particularly proud of this image, and it cemented his interest in night photography. His influence on art and photography in America was enormous, and he is also largely responsible for night photography taking hold in New York at the turn of the last century.

Stieglitz would go on to inspire his colleagues at the New York Camera Club to brave the night with their cameras. These photographers included Alvin Langdon Coburn, Karl Struss, Paul Haviland, W. M. Vander Weyde, and most notably Edward Steichen, who all created significant numbers of night photographs between 1900 and 1910. Although other photographers outside of New York and London most certainly were experimenting with night photography at this time, it is mostly the images of Stieglitz and his colleagues that survive today as a record of these early endeavors. There was some rivalry between club members, particularly Coburn

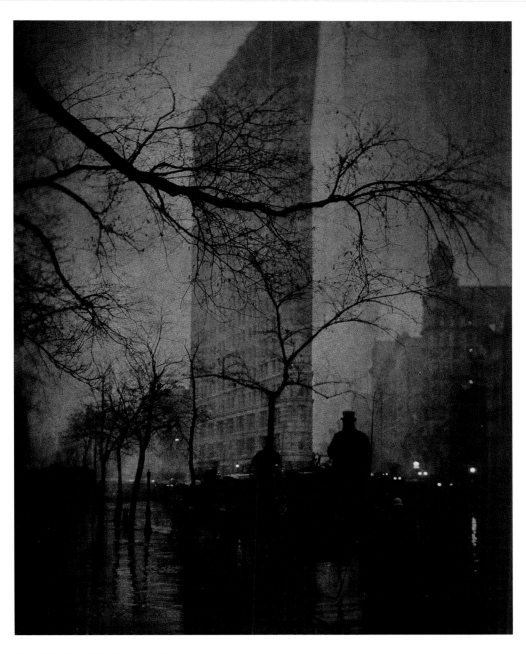

Edward Steichen, "The Flatiron," 1904

Steichen made numerous variations of this image, and the best three are housed at the Metropolitan Museum of Art. Color was added using multiple impressions of gum bichromate over the underlying platinum print. This image of the iconic Flatiron Building in Manhattan is considered one of the masterpieces of pictorialist photography.

and Steichen, and they both made twilight studies of the famous Flatiron Building. Steichen's version is considered one of his masterworks, and he made some truly remarkable gum over platinum prints of this image, three of which are housed at the Metropolitan Museum of Art in New York.

Steichen made another significant contribution to the genre with his series of 1908 photographs of Rodin's sculpture of Balzac that were taken entirely by moonlight. Although there had been various other efforts to photograph by moonlight before Steichen, most notably by John Frith of Bermuda, who made moonlit exposures of up to 6 hours in 1887,[12] it is the Balzac photographs that are the best extant examples of early moonlight photographs. Because there was no precedent for determining exposures, Steichen made a series of exposures of varying lengths over 2 nights. He had gone to France to photograph at the invitation of the sculptor himself, who commented that the images would "make the world understand my Balzac through these pictures."[13] Steichen brought three large prints back to America, which were exhibited at Stieglitz's 291 Gallery in 1909. Steichen made exposures by moonlight, at dusk and dawn, and even one by flash, but the three he exhibited were all taken by the full light of the Moon. Stieglitz was so taken with them that he bought them for himself.[14]

Inspired by their better-known contemporaries, many other photographers began to photograph at night shortly after Martin, Fraser, and Stieglitz. There is a remarkable record of the development of style and technique in the photographic journals dating roughly from 1898 to 1916. Writing in response to an 1897 article in *Scribner's Magazine*[15] that praised the night photographs of Stieglitz and Fraser, a Detroit photographer by the name of Edward Van Fleet expressed his desire for recognition of his own night photographs taken from the roof of the Detroit Tribune

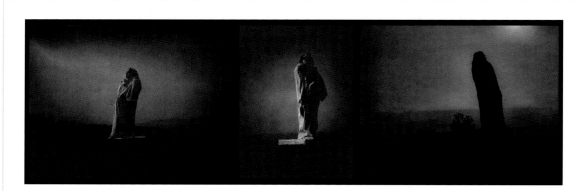

Edward Steichen, "Three Views of Balzac," 1908

Steichen traveled to Meudon, France at the invitation of the sculptor Rodin to photograph the plaster model for his Monument to Balzac. Steichen produced numerous moonlight views of the sculpture, working from dusk to dawn one night. These are some of the earliest extant photographs taken entirely by moonlight.

Building in 1896.[16] A photographer by the name of A. H. Blake proposed and organized the Night Photographer's Society of England in 1908.[17] Blake shared his night photography experiences with the American audience in the journal *American Photography* in 1910. Undoubtedly, there were many photographers experimenting with night photography at this time aside from the few who are mentioned here.

The new century brought a significant change in the style and subject matter to many of these photographers' work as the romantic sensibilities of Pictorialism gave way to the more objective and sharply defined aesthetic of Modernism. Beginning around 1910, there was a shift from impressionistic pictorialist images to crisply focused modernist photographs that is evident in the work of each of these photographers. This change seemed to be an appropriate response to advances in technology and changes in attitude that came with the dawn of the 20th century. Although Modernism was well established by 1920, there were those like Adolf Fassbender who employed pictorialist sensitivities well into the 1930s.

Although the photographic record seems to indicate that early night photography was limited to Europe and North America, this was not at all the case. The photo historian Peter Yenne has worked diligently to promote the remarkable photographs of the Vargas Brothers of Arequipa, Peru. Carlos and Miguel Vargas Zaconet opened a commercial photography studio in Arequipa in 1912 after apprenticing with a photographer named Max T. Vargas (no relation). Their timing was incredibly fortunate because Arequipa was just beginning to blossom with newfound prosperity and the influence of European culture and ideas. Their studio flourished, and in addition to their portraiture business, they created a remarkable body of night images through the 1920s. Yenne says that "the influence of Pictorialism is clearly evident in the nocturnes, their most self-consciously artistic work." Yenne surmises that it was advances in photographic technology and the advent of electric light that led to this body of work. In an article accompanying an exhibit of the brothers' work titled *The Vargas Brothers, Pictorialism, and the Nocturnes*, Yenne writes that "taking a cue from the silent screen, they concocted a series of elaborate tableaux using moonlight, lanterns, bonfires, flash powder and street lamps. These theatrical scenes required exposures of up to an hour, and meticulous attention to detail."[18]

In contrast to the theatrically staged images of the Vargas Brothers, some photographers photographed at night for journalistic or documentary purposes. Lewis Hine was a sociologist who worked as a photographer traveling the country for the National Child Labor Committee (NCLC) during a 10-year period beginning in 1907. Hine documented the cruel conditions of child labor in factories and children who worked in the streets selling newspapers and as messengers. Unlike the pictorialist photographers, Hine was not concerned with making art, but instead with recording working conditions to aid the NCLC in its aim of ending child labor in America. That he made many of these photographs at night was only incidental to the fact that children were being

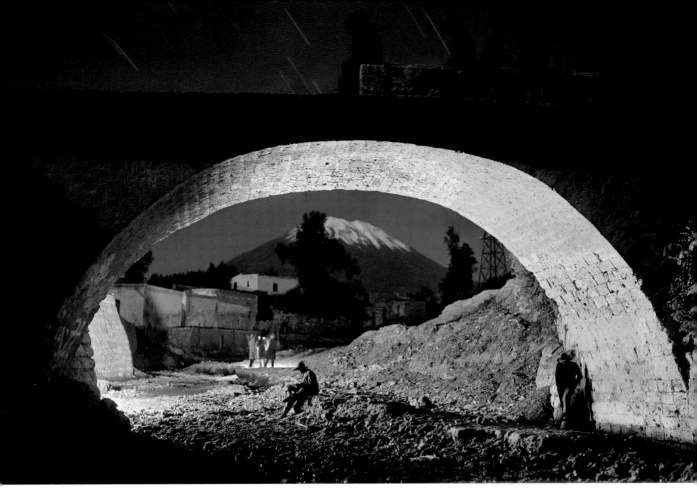

Carlos and Miguel Vargas, "Bridge in Sán Lazaro," Arequipa, Peru, ca 1926

The Vargas Brothers had a successful portrait studio in Arequipa from 1912 through the 1920s, but by night they produced a remarkable series of nocturnes that combined the use of moonlight, street lighting, and flash powder. Relatively unknown outside of Peru, the brothers were true pioneers of night photography, using light painting and staging photographs at night before anyone else.

forced to work late into the night. Most of Hine's night images are portraits of children working in factories, as *newsies*, or as messengers, and were primarily lit with flash powder.

Jessie Tarbox Beals is generally known as the first woman news photographer, but she was also the first woman night photographer. Beals lived from 1870 to 1942, which made her a close contemporary of Alfred Stieglitz. Although Stieglitz left a larger legacy, Beals was a remarkable woman whose drive and spirit enabled her to succeed in a challenging profession against significant odds. There is barely any mention of night photography in her papers, nor in her 1978 biography, written by Alexander Alland, but there is plenty of photographic evidence. The archive of her work at Harvard University's Schlesinger Library contains well over 100 prints of nocturnal images that span her photographic career. Beals photographed New York at night at the same time as Stieglitz and the other pictorialists, and although she was aware of Stieglitz and his 291 Gallery, there is

no evidence that they associated with each other. Beals took many night views of the pavilions of the 1904 St. Louis World's Fair, houses lit by gaslight in Boston's Beacon Hill neighborhood, and later the mission-style architecture of Santa Barbara after she moved to California in the 1920s. Throughout her career, Beals worked with an 8 × 10 view camera, even at night. A large view camera is cumbersome even in the daytime, and it is exceedingly difficult to work with at night. Many night photographers shifted to smaller format cameras as they became available.

The documentary work of Lewis Hine and the more commercial work of Jessie Tarbox Beals are somewhat anomalous examples of night photography put to more practical uses, but like the pictorialists before them, most of the night work to follow would belong to the worlds of art and illustration. The Hungarian André Kertesz began photographing at night around 1914 in Budapest. He moved to Paris in 1925, where he continued to make night photographs. A fellow Hungarian

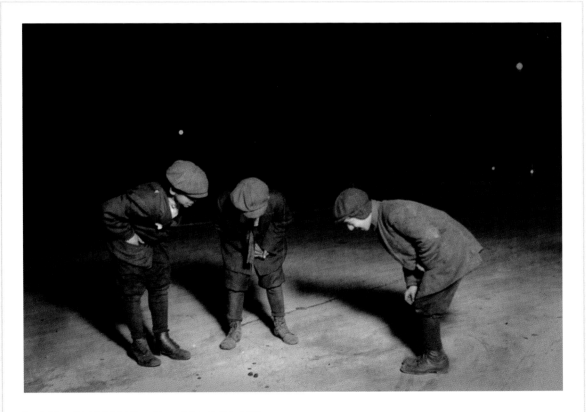

Lewis Hine, "A Midnight Crap Game," Providence, 1912

Hine was a social worker who tirelessly documented child labor practices in the United States at the beginning of the 20th century. Hine was not interested in night photography itself, but he often photographed at night, generally using flash to illuminate the young newsboys and messengers who worked through the night.

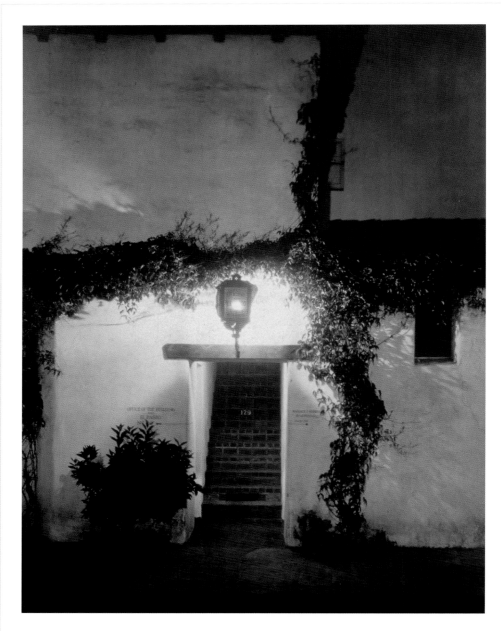

Jessie Tarbox Beals, "El Paseo Building," Santa Barbara, ca 1928–1929

Beals is best known as the first woman news photographer, but she is also the first woman to have photographed extensively at night. She was primarily a journalist and commercial photographer, and she worked all her life to compete in a world where women were generally not wanted. Beginning at the World's Fair in 1904 and continuing throughout her career, Beals made many night views, mainly with a large format view camera.

painter named Gyula Halász, who also lived in Paris, was introduced to photography by Kertesz one night in December 1929 as they wandered the streets of Paris. Halász, who would later change his name to Brassaï, would go on to become the most influential night photographer of his generation, and perhaps of all time. Paris in the 1930s was a magnet for artists and writers, and Brassaï lived and worked among many of the most important artists of the 20th century. He counted Picasso, Dali, Giacometti, Matisse, and the writer Henry Miller as his friends. It was Miller who gave him the nickname The Eye of Paris.

Brassaï's photographs are an indelible record of the dark underbelly of Paris nightlife at the time of the Great Depression. Within 2 years of taking up photography, Brassaï had accumulated a large series of nocturnal photographs of Parisian street scenes and images from brothels, opium dens, bars, theaters, and cabarets. Much of this work was published in 1932 as *Paris de Nuit*,[19] which was the first monograph of night photographs ever published. Decency standards of the time did not allow for many of his interior views depicting scenes of nudity and overt sexuality to be published, and this work was not widely known until the publication of *Le Paris Secret des Années Trente*[20] in 1976. The subjects of Brassaï's photographs were certainly aware that they were being photographed because his style was bold and direct, and he generally had their cooperation. Brassaï often used magnesium flash powder to light his interiors, which led Picasso to nickname him The Terrorist[21] because of its explosive qualities.

The publication of *Paris de Nuit* was a milestone not only because it was the first of its kind, nor simply because it was sumptuously printed in photogravure, but because of the remarkable influence it had on contemporary photographers of the time. The English photographer Bill Brandt met Brassaï in Paris about the time *Paris de Nuit* was published, and Brassaï's influence on the Englishman's work was profound. Brandt's motivation is uncertain, but he recreated one of Brassaï's photographs of prostitutes using his wife, Eva, as a model and placing her outside of a Chinese restaurant in Hamburg's red light district in 1932.[22]

Brassaï's revealing pictures confirmed people's expectations of Parisian nightlife, but Brandt's more surrealist vision transformed the ordinary into something mysterious and uncertain. Brandt had assisted for the great surrealist photographer Man Ray in Paris in 1930, and this experience also shaped his artistic vision. Brandt's book *A Night in London*[23] was published in 1938 by Arts et Métiers Graphiques, the same company that had published Brassaï's *Paris de Nuit* a few years earlier. Although *A Night in London* was clearly inspired by Brassaï's work, Brandt's style and working methods were distinctly his own. Brassaï's subjects were the people he met in his nocturnal wanderings, but Brandt took the novel approach of employing his friends and family as models to create his nighttime scenes. Additionally, several of the photographs from *A Night in London* were actually daytime images printed darker than usual to look like night scenes. Brandt had no qualms about using any available technique to achieve his expressive ends.

Two English contemporaries of Bill Brandt who were also inspired by the work of Brassaï were Harold Burdekin and John Morrrison. Although they are virtually unknown today, Burdekin and Morrison produced a body of spectacular nocturnal images of London that were published as *London Night* in 1934, little more than a year after Brassaï's book. Like *Paris de Nuit*, *London Night* was also printed in photogravure but with blue, rather than black, pigment. The quiet alleyways and dark corners of London portrayed in these photographs are completely unpopulated and were mostly shot on foggy nights. The moody atmosphere and timeless stillness of these images makes them among the most memorable of the genre.[24]

At about the same time, a young photographer by the name of Volkmar Wentzel was working as a darkroom technician for National Geographic in Washington, D.C. Wentzel had also been inspired by Brassaï's night work and photographed America's capital at night during the mid- to late 1930s. Like many of the photographs of his contemporaries, Wentzel's night photographs of Washington landmarks and architecture were shot mainly on foggy nights. Wentzel would go on to have a long career as a National Geographic photographer, and his night images of Washington were not published until 1992 in *Washington by Night*.

The bombing raids of World War II left much of Europe dark at night between 1939 and 1942. The darkened city skylines made for unusual opportunities for night photographers at this time, and two photographers in particular made the most of them. The bombing raids usually took place at night, when German planes could fly over enemy territory under the cover of darkness. Bill Brandt, who had photographed London at night earlier in the 1930s, was confronted with a very different city with the lights extinguished and inhabitants hiding in the underground subway tunnels for shelter. The full moon provided illumination for Brandt's photographs, and also just enough light for the German bombers to navigate.[25] The danger level was highest on these full moon nights, and Brandt found the streets of London silent and completely deserted as he photographed the dark city. Although Brandt's blackout photos were shot for *Lilliput* magazine in Britain and *Life* magazine in the United States,[26] Brandt's biographer, Paul Delany, suggests that these images had a deeper and more personal meaning for the photographer, comparing them to de Chirico's visionary surrealist city. Brandt was compelled by the appearance of the city illuminated only by moonlight and the city's apparent withdrawal into concealment.[27]

Margaret Bourke-White also worked for *Life* magazine and photographed London during the blackouts of 1939. In the spring of 1941, she was sent to Russia by her editor at *Life*, and she was the only foreign journalist in Moscow when the German bombers arrived. With the tacit approval of the U.S. Embassy in Moscow, she was allowed to stay after almost all other foreigners had left, and at one point she even photographed Stalin after months of attempts to gain access to him. She initially photographed the bombing of Moscow from the roof of the U.S. Embassy because the Russian blackout wardens at her hotel forced everyone underground during the raids. Later, she set up multiple cameras on the balcony of her hotel room (which faced the Kremlin and Red

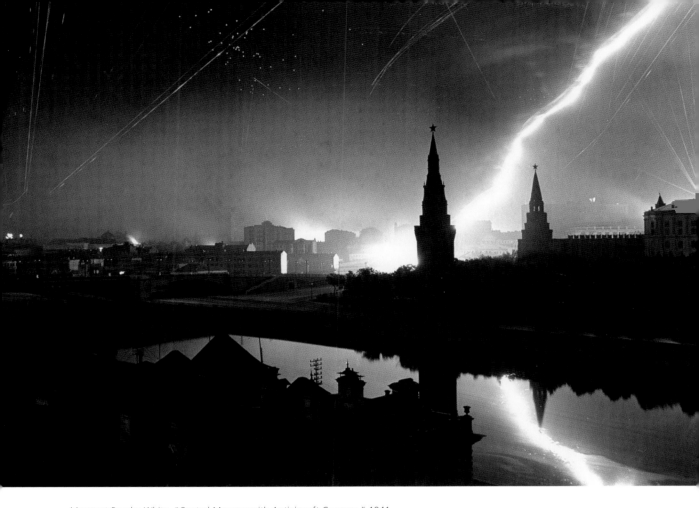

Margaret Bourke-White, "Central Moscow with Antiaircraft Gunners," 1941

Margaret Bourke-White was one of the only foreign journalists in Moscow when war broke out between Germany and Russia in 1941. She photographed the nightly bombing raids, initially from the roof of the U.S. Embassy and later from her hotel room balcony, which overlooked Red Square. Bourke-White worked with several cameras simultaneously, the number determined by the intensity of the bombing.

Square) when the raids began, then rushed to the underground shelters. After the all clear was given, she returned to close the shutters and develop the film in her bathroom. Bourke-White wrote, "To me, the severity of a raid was determined by whether it was a two camera, a three camera, or a four camera night."[28]

Jack Delano was hired in 1940 as a photographer for the Farm Security Administration and later worked for the Office of War Information, where he documented the Atcheson, Topeka & Santa Fe wartime rail service between Chicago and Los Angeles in 1943.[29] Delano used early 4×5 transparency film for his nighttime rail yard photographs. In addition to being some of the earliest color night photographs, this work is interesting for the trails of light left by the lanterns of the

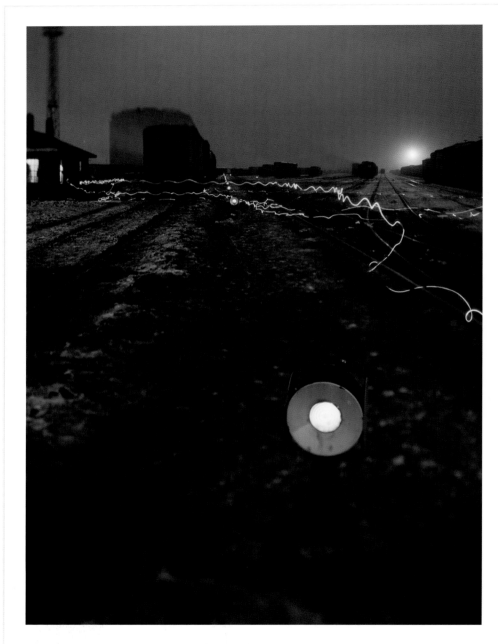

Jack Delano, "Departure Yard at C&NW Rail Road," Chicago, 1942

Jack Delano worked as a Farm Security Administration photographer and later for the Office of War Information when this photograph was taken in 1942. This image was shot on 4 × 5 inch Kodachrome transparency film and is part of a series of night and twilight rail yard images.

rail yard workers as they walked through his photographs during the long exposures. Delano's photographs are now in the collection of the Library of Congress.

There is a long tradition of nighttime railroad photography in America that began with Delano in 1943 and continued into the 1980s with a trio of photographers who called themselves *Rails After Dark*. America has had a fascination with trains and railroads since the completion of the transcontinental railroad in 1869, and trains have long been a photographic subject as well. Images of the last operating steam railroad in America were taken by O. Winston Link from 1955 to 1960 and are some of the best-known night photographs ever taken. Link was a New York industrial photographer with a passion for steam trains, and he spent 5 years documenting the Norfolk and Western Railway before it switched to diesel engines. Link used his commercial photography experience to orchestrate (with the cooperation of the railway) images using elaborate lighting setups with custom-made flashbulb reflectors and multiple cameras. Link's images are remarkable not only for the complex lighting he employed, but also in the way that he showed the trains in the context of small towns along the railroad, frequently with people going about their lives with the trains passing in the background. Link's photographs preserve the last years of an important part of American history, and they are an indelible record of life in small towns along the rails in mid-20th-century America.

Although Link is better known than other train photographers, many others photographed trains and rail yards in the second half of the 20th century. Among them were Robert Hale, Richard Steinheimer, Jim Shaughnessy, Philip Hastings, Mel Patrick, and Ted Benson, who all took significant night photographs of trains after 1950. These men were as much railroad enthusiasts as photographers, and their images are mostly known from the pages of the magazines *Vintage Rails* and *Trains*. Hale and Steinheimer began photographing trains at night around 1949—several years before Link—and Benson and Patrick, in particular, were inspired by Link's work.[30]

In 1951, Alfonso Sánchez García was commissioned to produce photographs of Madrid to promote the city as a safe and normal place. Spain was trying to repair its tarnished image after the Spanish Civil War and associations with the Axis powers in World War II. Alfonso's romantic night views of the old quarter of Madrid were published as photogravures in a book titled *Rincones del Viejo Madrid: Nocturnos* (*Corners of Old Madrid: Nocturnes*). According to photo historian Gerardo F. Kurtz, this project was unusual because of the lavish nature of the publication at a time when Spain was still reeling from civil war and economic isolation after Franco seized power. Each of the 41 images has a description of the location where the photo was taken in both Spanish and English. It's doubtful that the book made much of an impact on international relations with Spain, and although García is one of the more important Spanish photographers of the time, he is not widely known for this work.

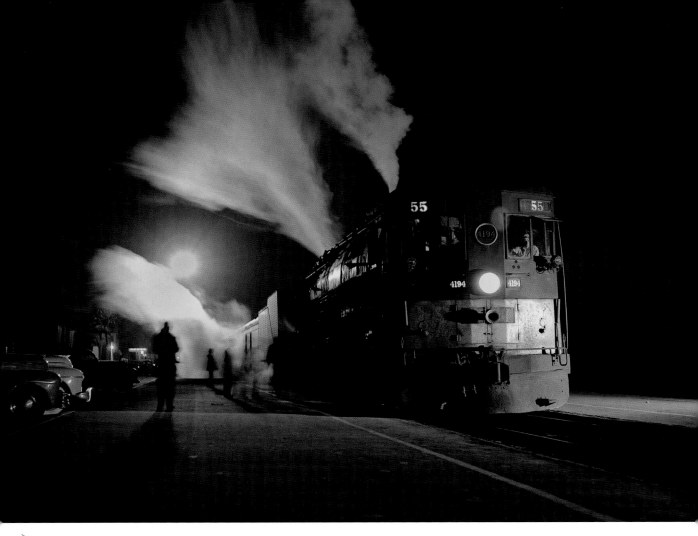

Richard Steinheimer, "Southern Pacific #4194 'Tehachapi' Night Train 55 at Glendale Station," Glendale, CA, 1950

Steinheimer was one of a number of highly dedicated train photographers who often shot at night from the 1950s through the 1980s but are generally less well-known than O. Winston Link. See Jeff Brouws and Ed Delvers's outstanding book, *Starlight on the Rails*, for more about Steinheimer and his contemporaries.

There are surprisingly few substantial bodies of night photography from the 1960s, but one notable exception is the work of the late William Gedney. He photographed at night throughout his career, which spanned from the late 1950s to the mid-1980s. Most of Gedney's night works are part of larger bodies of images. Major projects included documenting communities in Kentucky, Brooklyn, India, and San Francisco. Gedney's formal architectural studies of quiet neighborhoods at night provide stark contrast to his daytime record of the human condition. It is tempting to say that people were too preoccupied with other things in the 1960s to photograph at night, but just as San Francisco was the epicenter of the counterculture revolution, it also became a nexus for much of the more prominent night photography that would emerge in the following decade.

In addition to Gedney, Arthur Ollman, Jerry Burchard, Richard Misrach, and Steve Harper all made significant contributions to the genre from the early 1970s through the mid-1990s. Burchard began photographing at night in the late 1950s while documenting an artist colony in San Francisco. His style was free and loose, and he used mostly fast film and relatively short, handheld exposures, often standing on one foot—a technique he employed while photographing at rock concerts where the vibrations from the speakers and people dancing precluded the use of a tripod. By the late 1960s, Burchard began applying the same techniques to shooting landscapes at night. Ollman began photographing at night in 1966 after being involved with theater in college. He was drawn to photograph subjects that were isolated by localized light sources, similar to the way that emphasis is placed on actors and sets on the stage with spotlights.[31] Ollman switched to color in the mid-1970s, when Kodak released the first 400 speed color negative film. He was attracted to the way the notorious San Francisco fog absorbed and blended the various colors of different artificial light sources at night. Like Burchard, Misrach also began his career as a night photographer with a documentary project, photographing the subculture of Telegraph

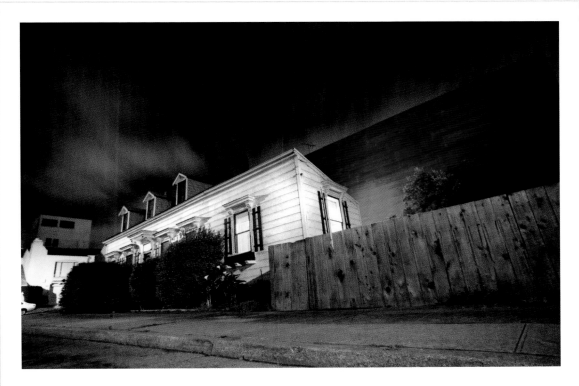

Arthur Ollman, "My House," 1977

Ollman shot at night in black and white starting in the late 1960s. The introduction of Kodacolor 400 35 mm film in 1976 provided the impetus for Ollman to begin working with color film at night.

Avenue in Berkeley in the mid-1970s in black and white on 35 mm film. Misrach decided to abandon sociopolitical documentary work and began photographing cacti in the California desert, combining long exposures with open flash to bring attention to the foreground subjects. He would use this same approach to photograph Stonehenge before switching to 8 × 10 format and color negative film toward the end of the 1970s. Misrach has continued to photograph at night throughout his career.

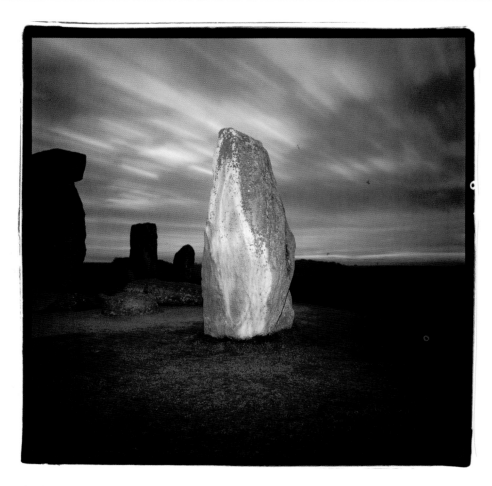

Richard Misrach, "Stonehenge #4," 1976

Richard Misrach has photographed at night throughout his career, beginning with a documentary project of homeless people in Berkeley, California in 1974. This image was originally printed on long-obsolete Agfa paper that produced a wide range of colors using a split toning technique. Shortly after creating this series of work, Misrach switched to the 8 x 10 view camera and color negative film. He was one of the first artists to produce large-scale photographic color prints.

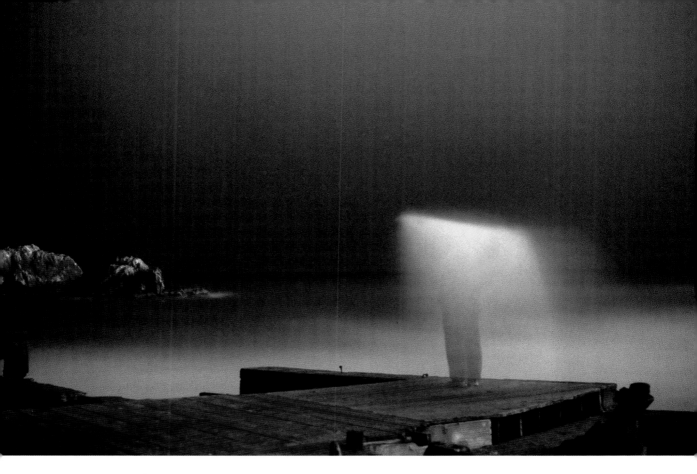

Steve Harper, "Self, Sutro Baths Ruins," 1979

Steve Harper says that this image "represents the universality of all things—I, the blanket, the fog and the sea are all the same substance."[33] Harper developed and taught the first college-level class on night photography at the Academy of Art College in San Francisco in 1979. He inspired a generation of night photographers (including the author) and was an important part of the vibrant night photography scene in the Bay Area from the 1970s through the 1990s.

Harper began his photographic career in front of the camera as a model for the Ford Agency in New York in the 1960s. After moving to California, he began teaching at the Academy of Art College in 1979, where he developed and taught the first college-level class on the subject of night photography. He taught this course for 12 years and mentored a new generation of night photographers, ensuring the continuation of the rich tradition of night photography in the Bay Area. Camaraderie and community were always important to Harper, and his students continued to photograph and exhibit together long after the classes were over.[32] Among Harper's more notable students were Tim Baskerville, founder of The Nocturnes, an organization that promotes night photography in the Bay Area, and Tom Paiva, a commercial and industrial night photographer based in Los Angeles. Harper's own images often included figures, sometimes his students, but often himself. Of the image reproduced here, Harper says, "I identify this image with the universality of all things—the way the ocean, the sky and I appear to have morphed into the same molecular elements."[33]

Although the bulk of night photography activity shifted from the East Coast to the West Coast after World War II, there were still photographers on the East Coast working at night, like George Tice, who made many night photographs of his native New Jersey throughout the 1970s. Undoubtedly, his best-known image is "Petit's Mobile Station, Cherry Hill, NJ," 1974. Tice says that the water tower looming above the gas station reminded him of Lincoln Cathedral rising above the town in F. H. Evans's 1898 photograph "Lincoln Cathedral: From the Castle." This 2-minute exposure on 8 x 10 inch Tri-X film actually required about 10 minutes to make because Tice had to cover the lens whenever cars passed in front of the camera. This technique of repeatedly covering the lens to block the lights of passing cars requires diligence

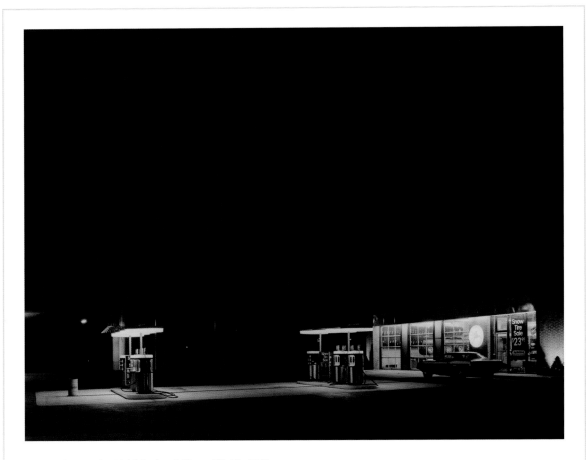

George Tice, "Petit's Mobil Station," Cherry Hill, NJ, 1974

George Tice's iconic image of a water tower looming over a gas station in New Jersey is probably his best-known work. Throughout the 1970s, Tice photographed twilight and night scenes of his native New Jersey on 8 × 10 black and white film. Original gelatin silver prints of this image have unbelievably rich shadow detail and luminous highlights.

and patience, but it has been successfully employed by photographers dating as far back as Paul Martin in 1896.[34]

In 1979, photographer Jan Staller published a book of color night and twilight photographs taken in the industrial wastelands around New York City. The photographs are notable for the surreal nature of the subject matter and the unusual colors created in the darkroom when Staller color corrected for the various industrial light sources in the scenes he photographed. Staller's prints could only be balanced for a single light source, but the scenes he photographed were often lit by multiple sources. Many of his images have intense red or purple skies.

Unquestionably, the most prolific night photographer of the second half of the 20th century is Michael Kenna. In the mid-1980s, Kenna retraced the footsteps of his countryman Bill Brandt, who had documented the industrial cities and mill towns of northern England in the 1930s. Although most of Brandt's work from this series was shot during daylight hours, his prints are dark and contrasty, such that many of the images almost look as if they were taken at night. This in turn influenced Kenna's decision to photograph some of the same sites at night nearly 50 years later. Kenna's work gained a wider audience after the publication of his photographs of Ratcliffe Power Station in Nottinghamshire, also in the industrial north of England. A great traveler, Kenna would go on to photograph extensively in France, Japan, and many other locations, often at the intersection of the man-made and natural worlds. Kenna says, "The underlying subject matter is the relationship, confrontation, and/or juxtaposition, between the landscape ... and the human fingerprint, the traces that we leave, the structures, buildings and stories."[35] Kenna tries to create work that is timeless noting that "the images could be created in the day or at night, today or a year ago."[36] Kenna continues to be one of the most prolific and successful landscape photographers working today.

To date, there have been at least four significant group exhibits of night photography in the United States. The largest and most ambitious was curated by Keith F. Davis from the Hallmark Photographic Collection. Night Light, A Survey of Twentieth Century Night Photography opened at the Nelson Atkins Museum of Art in January 1989 and was subsequently shown at 10 art museums across the country, closing at the Museum of Photographic Arts in San Diego in 1991. The printed catalog of Davis's exhibit was the starting point for the research in this chapter.

In 1991, photographer Tim Baskerville curated a group exhibit of night photographs at Gallery Sanchez in San Francisco entitled The Nocturnes, which eventually became the basis of the organization of the same name. In 2003, the Williams College Museum of Art presented an exhibit of contemporary night photographs called Wait Until Dark from a private collection. In 2007, the Three Columns Gallery at Harvard University premiered an exhibit titled Darkness Darkness, curated by the author of this book, that showcased the work of 34 contemporary night photographers and was subsequently presented in several different venues.

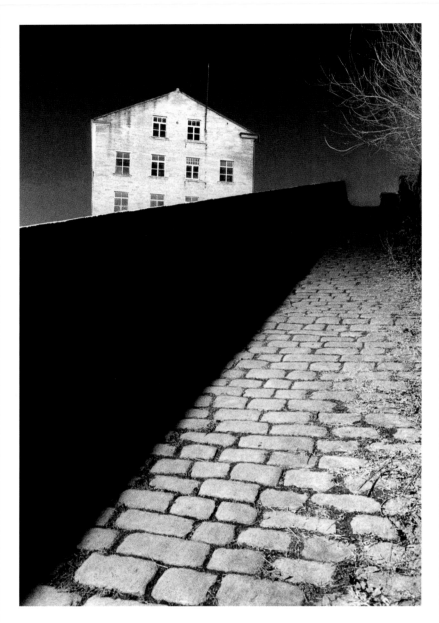

Michael Kenna, "Bill Brandt's Snicket," Halifax, Yorkshire, England, 1986

Early in his career, the English photographer Michael Kenna retraced the footsteps of his countryman Bill Brandt to photograph the mill towns of northern England. Brandt made a similar daytime view of this scene in 1937. In Brandt's version, most of the tones are reversed from Kenna's night view—the building is dark and the sky is light.

Advances in night photography have paralleled advances in photographic technology for the last hundred years, and as night photography has become increasingly more accessible, an ever-increasing number of photographers engage in the practice on a regular, rather than occasional or experimental, basis. Major improvements in both color and black and white films in the 1980s and 1990s, the rapid development of digital photography during the last 15 years, and the explosion of photography's popularity in general have made photographing at night almost a routine endeavor. Although police and security guards still seem to be overly suspicious of night photographers, the general public no longer finds it so strange to see photographers with cameras on tripods after dark. The Web has also made the work of night photographers available to a broader audience than ever before. The Nocturnes organization has had a Web presence (www.thenocturnes. com) since 1996, and in its early years it routinely received comments from night photographers around the world who were surprised and pleased to discover that they were not the only ones photographing after dark.[37] A quick search on the photo-sharing Web site Flickr, or simply a look at the *O. Winston Links* page on The Nocturnes Web site, will show that there are literally thousands of people around the world who have discovered the magic of night photography. It seems appropriate, therefore, to end this history of night photography here and share more recent images by contemporary photographers in the other chapters of this book.

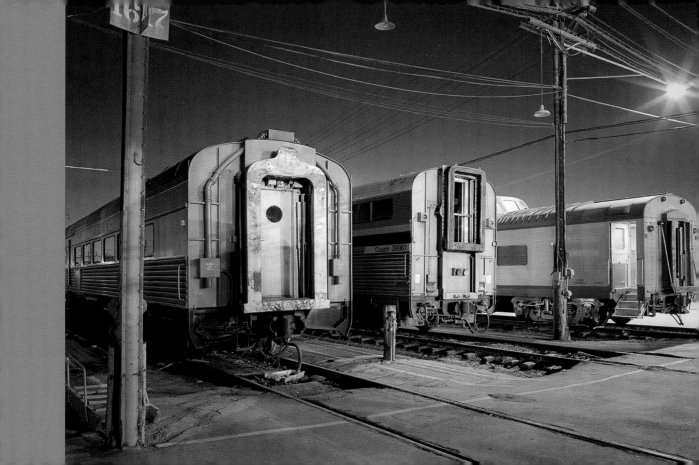

NIGHT PHOTOGRAPHY ²
EQUIPMENT

DOI: 10.1016/B978-0-240-81258-8.00002-8

Having examined the origins and evolution of photographing at night, let's begin to explore the practical side of night photography. In this chapter, we will look at the tools and talk about how they relate to the processes and challenges of night photography. Although the selection of cameras, lenses, tripods, and other gear is mostly a matter of personal choice, a brief discussion of the essential night photographer's tool kit is presented to help the reader make informed decisions about equipment choices.

CAMERA CHOICE

Almost any camera that can be mounted on a tripod, has manual exposure control, and has the ability to do extended exposures can be used. Point-and-shoot cameras generally do not work very well at night, and even ones with built-in night scene modes are really only suited for low-light snapshots of floodlit monuments, fireworks, or people shots that combine the camera's built-in flash with slightly extended exposures. The general rule for film cameras is the simpler, the better. Fully mechanical cameras that do not require a battery to operate the shutter work well for night photography. Inexpensive SLR cameras from the 1970s, like the Pentax K1000, Nikon FM or FG, or Canon FTB, are widely available on the used market and are generally durable and reliable. Most medium format SLR and TLR cameras are also well suited to this type of work and are surprisingly affordable now that the professionals who used to favor them have switched almost entirely to digital. The venerable Hasselblad 500 series cameras are used by many of the best night photographers, and for good reason. They are simple to operate and built to last. Even large format view cameras can be used successfully at night, although it can be extremely challenging to compose and focus on the ground glass. When I shoot film, I use an Ebony 23SW camera, a compact view camera that combines the large format advantage of perspective control with the cost effectiveness of medium format roll film. There are also faster lenses available for this camera's 6×9 centimeter format than there are for 4×5 cameras. Faster lenses make it much easier to focus and compose in low light levels. After many years experimenting with different medium format cameras, I found that the Ebony was the best film camera for my working method and subject matter.

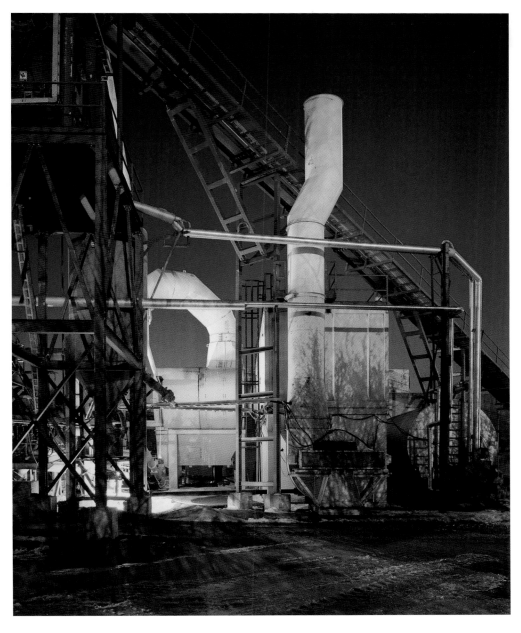

Lance Keimig, "Unknown Industrial Site," Providence, Rhode Island, 2007

This industrial facility in Providence, Rhode Island has all of the right elements to make a great night shot. Strong shapes and colors combined with mixed light sources and a clear, crisp night all came together in this shot made with an Ebony 23SW camera and 65 mm Nikkor F4 lens on Fuji NPL film. The exposure was unrecorded at f11.

Ebony 23SW view camera

The Ebony 23SW view camera combines the features of a large format view camera with the convenience of 120 roll film and a small, compact size. Working with film appeals to photographers who would rather not spend any more time at the computer than they have to. There are advantages to both digital and film, and the choice of which to use should be based simply on personal preferences. Many people, including the author, enjoy working with both.

All DSLR cameras can be used at night, but in most cases, the newer the model, the better the results are likely to be. The biggest advantage of the most recent DSLR cameras is that they produce less long-exposure and high-ISO noise than older cameras, and this is especially true of the more expensive full-frame sensor cameras. Full-frame sensor cameras will almost always produce lower noise levels than cameras with smaller sensors, but noise is becoming less of an issue as each successive generation of cameras and RAW processing software continue to improve. Digital cameras are one commodity where you truly get what you pay for, and it generally is a good strategy to buy the newest and most expensive model you can afford—assuming that you plan to print your images. If you don't expect to print your photographs and will only display them on a Web site, a lesser camera will suffice. The main features to look for when purchasing a new digital camera are the following:

- First and foremost is the ability to shoot RAW files and full manual exposure controls.
- Look for a CMOS sensor because it is less susceptible to long exposure noise from heat buildup in the sensor. Canon and Nikon use CMOS sensors in all of their current models.
- Live view is extremely helpful for focusing.
- A high-ISO capability (6400 or higher) is important for performing test exposures in moonlight.

- Look for high-ISO noise reduction.
- Check into the availability of a cable release with a built-in timer. Aftermarket timers are about one-third the price of brand-name timers.
- In-camera long-exposure noise reduction (LENR) buffering allows you to keep shooting without waiting for the noise reduction to finish. As of this writing, LENR buffering is limited to the Canon 5D and 5D Mark II.
- A few cameras have LENR permanently on, but look for the ability to turn it on and off.
- Full-frame sensors generate less noise, and a wider selection of lenses is available.
- The camera should have weatherized and durable construction.
- The ISO controls for switching from high to low ISOs for test shots should be easily accessible.
- Look for an illuminated top LCD panel, or even better, full camera information on the back LCD.

LENSES

After the camera, lens selection is the next most important equipment consideration. As a general rule, fixed focal length, or *prime*, manual focus lenses yield the best results and are the easiest to work with in low-light situations. Autofocus lenses do not work very well in low-light conditions. Even though autofocus lenses generally can be switched to manual focus mode, they are optimized and engineered for autofocusing. Focusing speed is of primary concern for lenses to be able to focus on moving subjects. As a result, the *throw*, or amount the lens must rotate to focus from a near focus point to infinity, is greatly reduced on autofocus lenses. The short throw in combination with low tension on many lenses makes them difficult to focus manually with any precision. Another engineering concession that was made to preserve the autofocus motor on modern lenses is that they will focus beyond infinity. By extending the throw beyond infinity, it puts less stress on the motor when the lens comes into focus at the infinity setting. What this means for those who are focusing manually is that you cannot simply turn the lens until it stops to set focus to infinity. If a lens is accidentally focused beyond infinity, nothing will be sharp in the resulting images.

Prime lenses usually have larger maximum apertures than zoom lenses, which makes it easier to focus and compose in the dark. Most primes yield better image quality and performance than even the best zoom lenses. Primes are designed for a single purpose, and zooms are required to do the job of several lenses, often at a lower price point. Primarily because they are convenient, zoom lenses are much more prevalent than prime lenses today. Zooms can certainly be used with a little extra care. The image quality of zoom lenses has dramatically improved in recent years, and the problems of reduced sharpness, resolution, and flare from stray light is less of an issue than it was even 10 years ago. Still, the complex optical design of zoom lenses means that there are more glass surfaces to reflect light and cause flare. If zoom lenses are to be used, it is best to avoid the inexpensive kit lenses that come with many cameras, as well as lenses that cover a very wide range of focal lengths. Although it is undeniably convenient, a lens that ranges from 18 mm

(wide angle) to 200- or even 350 mm (telephoto) and costs only a few hundred dollars cannot be expected to perform as well as a prime lens, especially under the challenging conditions of night photography. For the most part, money spent on top-quality prime lenses is well spent. Zeiss is now producing superb quality (and expensive) manual focus prime lenses in Nikon, Canon, and Pentax mounts. These lenses are designed to stand up to the demands of high-megapixel, full-frame DSLRs.

Manual focus primes from the 1970s and 1980s offer great value for the money, and there is a plentiful supply of them on the used market. They are not as good as modern primes, but they offer a good return for a minimal investment and have the added advantage of being small and lightweight. Of course, not all DSLRs can be used with manual focus lenses, and many of them require adapters to be mounted. Fortunately, these adapters are inexpensive and are becoming increasingly common.

When Canon and Nikon (who have long dominated the SLR market) first released autofocus cameras in the mid-1980s, the two companies took different approaches to engineering the new cameras and lenses. Canon chose to start from scratch and designed a completely new lens mount, and Nikon chose to keep their existing lens mount to enable photographers to continue to use their old lenses. This resulted in Canon's early autofocus lenses performing faster and more smoothly than the Nikons. This disparity has now been eliminated, and some think that Nikon even has a slight advantage in autofocus performance. The advances in autofocus technology have been primarily in focusing speed, rather than in low-light performance.

Most manual focus Nikon lenses can be adapted for contemporary DSLRs. Canon manual focus (FD) lenses cannot be used on Canon DSLRs without an adapter that includes an additional glass element, which usually reduces image quality. These extra elements act as teleconverters by increasing the focal length and severely limiting wide-angle photography. Ironically, and fortunately for Canon shooters, Nikon, Olympus, Leica, M42 screw mount, and Contax manual focus lenses can all be easily adapted to fit on Canon cameras without an additional lens element.

There are two major drawbacks to adapting other manufacturers' lenses to your DSLR. Due to the thickness of the adapter that goes between the camera body and lens, the distance scale on the lens may not be accurate. If a lens adapter is used, focusing must be done visually rather than with the distance scale on the lens barrel. No adapter is required to use manual focus Nikon lenses on Nikon DSLRs, and the distance scale can be used for hyperfocal focusing, a technique that is discussed in Chapter 3. Additionally, these adapted lenses will need to be manually stopped down to the working aperture. This is simple enough to do, but it is a common and annoying mistake to forget to stop down the lens before starting an exposure. Because these lenses must be stopped down and focused manually, they are not suited for other types of photography that require spontaneity and a quick response time.

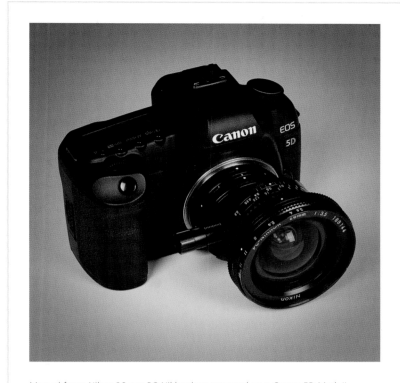

Manual focus Nikon 28mm PC Nikkor lens mounted on a Canon 5D Mark II

Perspective control lenses allow the photographer to keep the camera level and avoid the converging vertical lines associated with tilting the camera up to include the tops of buildings or other high objects. Older lenses originally designed for film cameras are a less expensive alternative than the modern equivalents.

Perspective control (PC) lenses are especially useful for photographers who shoot primarily architectural subjects and want to avoid converging vertical lines from tilting the camera upwards to capture the tops of buildings. PC lenses are also great for creating panoramas from two images taken with the lens shifted to the extreme left and extreme right. The perspective doesn't change when PC lenses are shifted, and this enables images to be seamlessly blended using Photomerge, a feature in Photoshop that automatically combines multiple images into a single panoramic image. Older PC lenses can be easily adapted to fit DSLRs and are substantially less expensive than their contemporary counterparts. Modern PC lenses have considerably better optics and coatings than PC lenses from the 1970s and 1980s; they are therefore sharper and suffer less from chromatic aberration and flare. (Chromatic aberration is discussed in Chapter 6.)

Lance Keimig, "Under the Fore River Bridge," Weymouth, Massachusetts, 2007

The Fore River marks the boundary between Quincy and Weymouth, Massachusetts, and the bridge that spans it has been in transition for the past 10 years. This image is a combination of two photographs that were taken with a 28 mm perspective control lens, each one shifted to the maximum but to opposite sides. By using the shift feature rather than rotating the camera, the two shots line up perfectly and blend easily in Photoshop without any loss of quality.

Most night photographers favor wide to normal focal length lenses, which capture more of the atmosphere that makes for successful night photography. They can also be used with larger apertures (making for shorter exposure times) and still maintain a reasonable depth of field. A basic selection of prime lenses for night photography would include an extreme wide-angle lens, a moderate wide lens, and a normal perspective lens. Extreme wide-angle choices for APS size sensors are very limited and expensive. There is no reason why longer focal length lenses cannot be used effectively at night, but they generally have smaller maximum apertures, which makes them harder to compose and focus in the dark. Telephoto lenses may need to be stopped down considerably to get a reasonable depth of field, necessitating longer exposures or higher ISOs, in turn risking noisier images.

TRIPODS

The next important equipment selection is a tripod. It is well worth the money to purchase a professional-quality tripod because inexpensive consumer models do not provide adequate stability and support for long exposures in even the gentlest breeze. It is important to consider stability against size and weight because even expensive carbon fiber tripods may vibrate or blow over in windy conditions if they are extremely light. These tripods may be adequate for exposures of a few seconds, but the long exposures required to photograph by moonlight dictate that a sturdier tripod be used. Some tripods have a hook at the bottom of the center column on

which you can hang a stabilizing weight on windy nights. Quality tripods are sold as separate components—the head and the legs. You should choose tripod legs that extend high enough that you rarely have to raise the center column because doing so makes your tripod considerably less stable. Tripods that have only three leg sections are also more stable than travel tripods that have four or five leg sections for compactness. Most tripod legs are made from either aluminum or carbon fiber. Aluminum tripods are less expensive, and carbon fiber tripods are lighter. There are two main types of tripod heads: pan–tilt heads and ball heads. Pan–tilt heads have three knobs for adjusting the camera angle separately in each direction, and ball heads move freely in all directions when the adjustment knob is loosened. Pan–tilt heads are often preferred by photographers who shoot architectural subject matter because the camera can be positioned and aligned to the subject with more precision. They tend to be larger and more cumbersome, but they are usually less expensive than ball heads of comparable quality. Ball heads use a ball and socket mechanism to adjust the camera position, and the camera can be adjusted in all directions with the release of a single control. Better ball heads also have a tension adjustment that makes them easier to control, but this feature often adds considerably to the price. Ball heads are preferred by photographers who work with moving subjects, like people, and need to respond and adjust the camera position quickly and frequently. Although the distinction between these head types isn't significant for night photography, having a stable tripod head is important.

CABLE OR REMOTE RELEASES

The shutter speed range on most cameras does not extend past 30 seconds in manual mode, and although this is sufficient for some brightly lit night scenes, most night scenes require much longer exposures. To take very long exposures, you'll need to set the shutter speed or mode to bulb and use either a cable release or wireless remote release. These are available for almost all cameras from the manufacturer and also as less expensive aftermarket products. A manual shutter release is basically a locking switch that holds the shutter open as long as the switch is engaged or until the camera's battery runs out. Although newer cameras have camera- or brand-specific releases, older film cameras, as well as most medium and large format cameras, use a universal mechanical cable release. For anyone who will be doing long exposures on a regular basis or anyone interested in star trails, a shutter release with a built-in timer is highly recommended. The price difference between brand-name and aftermarket releases can be substantial. It appears as though the Canon and Nikon timed releases are manufactured by another company and then rebranded, and the aftermarket timers sell for about one-third of the cost. The great advantage of these timed releases is that they can be programmed to take exposures, or sequences of exposures, of almost any length. With a manual shutter release, you must time the exposure with a watch and manually close the shutter at the correct time. This is discussed further in Chapter 8.

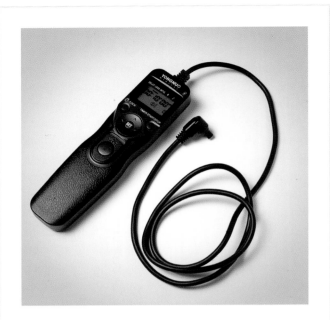

Timed remote release

A remote release that includes a timer is tremendously helpful for digital photographers because most cameras do not have shutter speed settings longer than 30 seconds. Timed releases also make shooting a series of images for stacking easier.

LENS SHADES AND FLARE BLOCKING DEVICES

Flare from light sources just outside of the frame can be a major problem at night. For this reason, it is essential to always use a lens shade, hood, or other flare-preventing device. It is important to choose a shade or hood that is made specifically for the lens you are using. A shade for a longer lens will result in vignetting on a wide-angle lens, and a wide-angle shade will not provide adequate protection on a longer lens. The butterfly-style lens shades that are designed for zoom lenses are compromised to accommodate for the variable focal length of the lens and do not block the light from many potential sources of lens flare. A handy alternative or compliment to a lens shade is a hot shoe or tripod mounted arm with a clip that holds a dark card. With these devices, the card can be placed in almost any position and is more effective than a shade alone. The Flare Buster is a flexible arm that attaches either to the camera's hot shoe or clips onto the tripod. Ebony, a Japanese view camera manufacturer, makes a hot shoe mounted articulated arm with a clip for holding a card that serves the same purpose as the Flare Buster. It is more stable in breezy conditions but slightly less adaptable. Attaching one of these devices on a windy night risks camera movement during long exposures because the card will catch the wind like a sail.

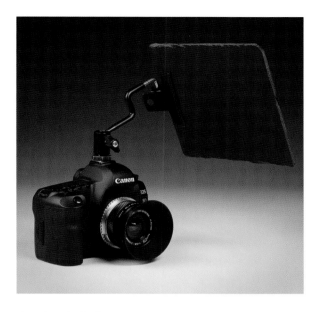

Ebony lens shade clip

The Ebony lens shade clip is a sturdy device for blocking light
sources outside of the frame that can cause lens flare. In windy
conditions, it may be better to hold the card in your hand to avoid
camera movement during the exposure.

OTHER EQUIPMENT BASICS

These are the basic necessities for night photography, but there are a few other things that will
make your work easier and more comfortable in the field. Although battery technology has improved
along with cameras, a second or even third camera battery assures that your camera will have
enough power to last the night. A small penlight or flashlight that can be attached to a lanyard and
worn around your neck is an invaluable aid for finding things in your camera bag or controls on your
camera. This should be a relatively weak light, preferably red to preserve your night vision in dark
environments. Using a bright light to adjust your camera when your eyes have been dark adapted
is most unpleasant and can also draw unwanted attention to yourself. A raincoat for your camera
can make the difference between calling it a night and sticking it out to get a great shot if it starts
to rain. There are several options for high-tech (and expensive) camera protection, but a disposable
hotel shower cap weighs next to nothing, doesn't take up much space, and does the job nicely in
light rain and drizzle. A plastic bag and rubber band will also work in a pinch, and keeping a plastic
trash bag handy is a great way to keep your camera bag dry or clean if you need to put it down in
the muck. Lens tissue or a small chamois or microfiber cloth is also helpful to keep your lens clean
and dry. Digital camera EXIF data records exposure, camera, and lens data, but many photographers

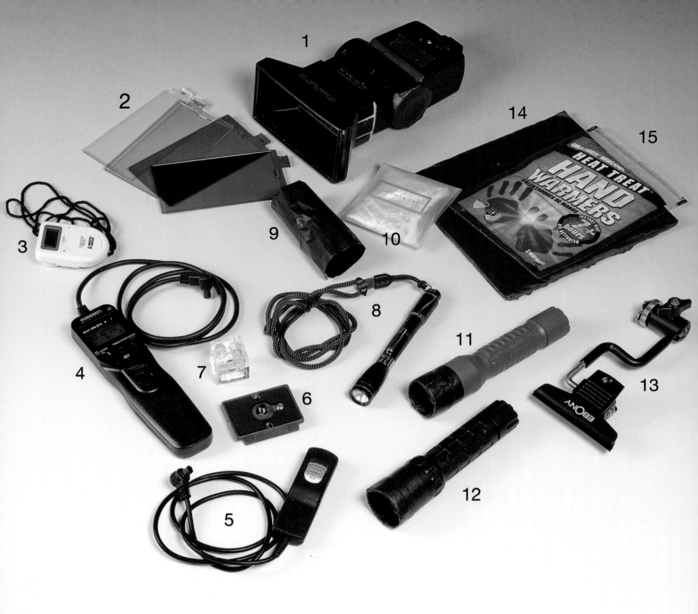

Night photographer's tool kit

carry a digital voice recorder to make notes about location, exposures, or detailed descriptions of light painting. Of course, an old-fashioned note pad and pencil will work too. Taking exposure notes is essential for film photographers because the best way to learn to gauge exposures is by comparing negatives or transparencies to carefully recorded notes. There's not much else you'll need in terms of equipment, except for more powerful flashlights, a battery-powered strobe, or other portable light sources if you plan to do any light painting; these are discussed in Chapter 9.

A checklist of basic night photography accessories is as follows:

1. Vivitar flash with filter holder
2. Colored filters for flash
3. Digital timer for film shooters
4. Remote release with timer
5. Spare untimed release
6. Spare tripod mounting plate
7. Bubble level
8. Penlight on lanyard for finding things in your bag
9. Cinefoil or Blackwrap for snooting flashlights
10. Hotel shower cap for camera
11. Streamlight PolyTac LED flashlight for light painting
12. SureFire G2 Nitrolon flashlight for light painting
13. Ebony lens shade clip to prevent flare
14. Black foam core for lens shade clip
15. Chemical hand warmers

DRESSING FOR NIGHT PHOTOGRAPHY

Now that your camera bag is fully loaded, you'll want to make sure that you are dressed appropriately for night photography and have whatever creature comforts you may want in the field. It may seem obvious to wear warm clothes on a cold night, but many people are surprised with how cold they get standing around waiting for long exposures. Dress in layers, and bring a hat and gloves if the temperature is expected to fall below about 50F or 15C. Mittens with flip tops that open to expose your fingers are a good way to avoid the need to take your gloves off to adjust your camera. If you prefer gloves, spending the extra money on a close-fitting pair that doesn't impede your dexterity too much is a worthwhile investment. Chemical hand warmer packs that are worn inside of your gloves can make a huge difference in your comfort level on cold nights, so keeping a few in your bag assures they'll be there when you need them. The kind made for shoes actually work better with flip-top mittens because they come with an adhesive strip that will keep them in place when you open your mittens. These chemical hand and foot warmers are available from camping or outdoor outfitter stores, as well as in the sporting goods department of big-box stores.

Wearing dark-colored clothing serves a dual purpose. If you inadvertently walk in front of the camera or intentionally walk into the shot to add light, wearing black will minimize the chances of showing up in the image as long as you don't remain in the same place for too long. You'll also be less likely to attract attention to yourself if you happen to be trespassing or just want to work unnoticed. Sensible shoes that offer a reasonable amount of protection when you'll be putting your feet down in unfamiliar territory are also a good idea. Wearing flip-flops for night photography

is not a good idea. A thermos of coffee, bottle of water, and a snack (brownies are the traditional choice) will also serve you well on a cold night. Being well fed and dressed appropriately can make all the difference on long, productive nights. Finally, keeping a few samples of your work with you may go a long way in explaining your motives should you be accosted by the police or

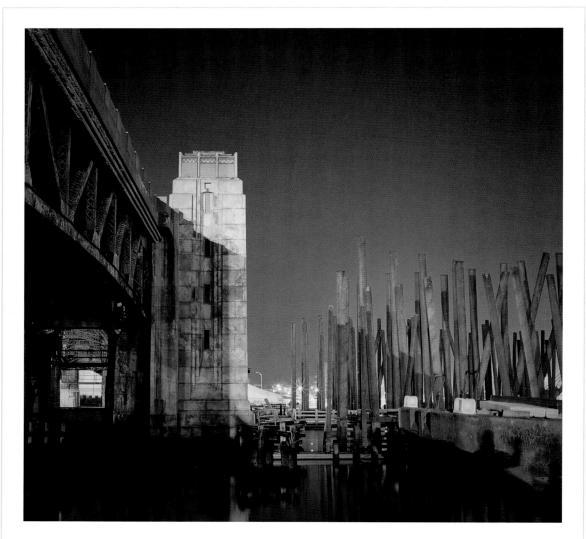

Lance Keimig, "Fore River Bridge in Transition," Weymouth, Massachusetts, 2001

This image of the old Fore River Bridge and pilings where the new bridge will be was taken 6 years before the bridge in the panoramic image earlier in this chapter. Returning to photograph the same location over a period of time can be photographically rewarding. Change is inevitable, which often makes retaking a photograph impossible, even on successive nights.

security guards—an occasion that is bound to happen at some point. Being prepared with the right equipment, clothing, and comfort items will make your experience much more enjoyable and help you stay focused on the task at hand.

Troy Paiva: Access and Permission

In the 20 years that I've been shooting at night in abandonments and junkyards, the one question that comes up most often is, "How on earth did you get in *there* to shoot?" A lot of the time it's simply a matter of walking right in. A surprising number of abandoned roadside haunts, isolated desert ghost towns, closed industrial sites, and decommissioned military bases that I shoot are just wide open. No fences, no gates, no security—you can just show up and start shooting.

If it's a secure location, it can be a matter of simply asking permission for access. Telling them that you're taking pictures at night usually just confuses them, but *showing* them how interesting you can make the site look is a huge selling point, so always carry prints of your night work. Before my books were released, I'd always carry a sheaf of 8 × 10 prints and thumb through them while explaining about time exposures, star trails, cloud movement, and light painting. More often than not, after seeing my work, they'll give me the run of the place.

If they're not present while you shoot, verbal permission may not be enough. Make sure you get a person's business card. I once had a sheriff catch me in a highly secure site. He was ready to arrest me on the spot until I produced the site manager's business card. The officer then called her at midnight to make sure I had permission. She hated getting the call, but it saved me from taking a ride downtown. So even a written note giving you permission may not be overkill in certain situations.

Some owners may require further convincing. Offer them prints from your shoot of their location, and make sure you deliver on that promise. I've even used a 12-pack of beer as an icebreaker. It's all in your attitude and manner when you talk to them. Make sure they understand your motives for shooting there. Tell them, "I love the history and atmosphere of your location" and that you're an "artist that wants to capture the spooky soul of the place." Be upbeat, personable, and excited about the prospect of shooting there. It also helps to know your subject so you can talk with the owner using terminology that they'll understand.

Some owners may ask to be paid. Professional photographers frequently pay site owners for access privileges, writing it off as part of the expense of a paying job. If you are selling the images, the property owner deserves a cut, if he wants it. If you're just shooting for fun, however, explain that you're not making any money with the work and that it's a pure art project. The classic line "I'm an art student" has worked wonders over the years, but the older I get, the less it seems to work.

Some owners will say, "My insurance won't cover you. If you get hurt, I'm liable." The best way to beat this is to have your own insurance. A $1 million rider for photographers costs about $500 per year. If having a policy means getting access to a prized location, it's a smarter investment for taking better pictures than that new lens you've been thinking about.

Having permission to access a site allows you to relax and not worry about getting caught. You don't have to suppress your lights, especially important if you're a light painter. Plus you can publish the work later without worrying about angry property owners coming after you.

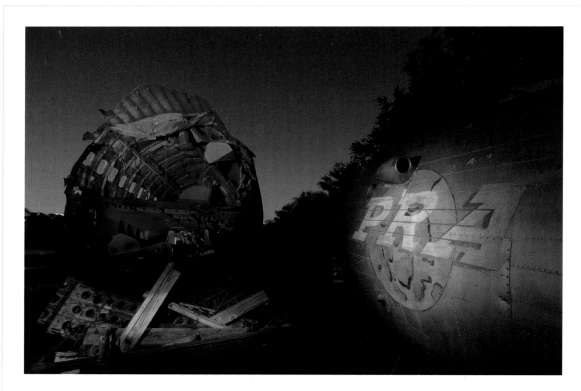

Troy Paiva, "PRA," El Mirage, California, 2006

I had stopped by the legendary Aviation Warehouse boneyard at El Mirage Dry Lake in California's Mojave Desert many times, trying to gain access for night photography, only to arrive when the office was closed or to be summarily turned away by the staff. After 15 years of trying, my luck finally changed when I arrived on a day when the owner was there. I met with him and showed him samples of my other night work. He was instantly thrilled with the potential for making his yard look evocative and dramatic and granted me total access. Normally he charges very high rates to photographers and filmmakers to shoot in his yard, but he understood that I was a fine artist, obsessed with his tropical paradise, and not shooting commercially, so he never requested payment. These two airframes, lit during a 2-minute exposure with red-gelled and natural flashlights, are just a tiny sampling of hundreds of aircraft in the yard.

Sometimes you just have to sneak in because there's simply no one available to contact. The increased thrill of shooting like this is undeniable, but you can open yourself up to all kinds of problems and danger. Sometimes you'll run across other trespassers. Generally, they should be avoided. Salvagers tearing down walls to steal the copper wiring and other metals have a lot to lose if they get caught by the police, so they're distrustful of anyone they run across and can become aggressive when cornered. Remember, your gear is worth a lot more than any metal they're stealing, so you should always stay aware of your surroundings and keep your equipment and bags or packs where you can see them. Partying teenagers can come in all levels of dangerous. Some are just drinking beer and legend tripping, but others may be hard-core drug abusers, intent on mayhem and destruction. Being a ninja night photographer, you should see and hear anyone else long before they see and hear you, so the best thing to do if you run across *anyone* is to melt into the shadows and slip away.

If you get caught trespassing by security or the police, be friendly and contrite. Trespassing without intent to cause harm in most abandoned sites is a minor misdemeanor in most states. Don't run. If you make them chase you, you're only admitting guilt and they'll hate you for making them sweat. If they catch you, nothing you can do from that point on will make them treat you well. There will always be a lot of angst on their part at first, so disarm them by saying "Hello! I'm just a photographer" in a friendly way. Talking back or copping an attitude is another surefire way to elevate the hassle level. Always carry samples of your work and sell the officers on the concept of night shooting as if you were talking to the property owner. Make sure they see your gear and understand early on that you are not a salvager or vandal. They may want to go through your bag or pockets. Let them, but make sure you don't have incriminating items like souvenirs from the site, tools that can be used for breaking and entering, spray paint, or weapons. If they find contraband on you, expect a very long night.

Understand what kind of site you're entering. Getting caught trespassing in some locations, like functioning industrial or transportation centers, will get you a guaranteed ride in a police car and a day in court. It can literally become a federal case and wind up costing you thousands of dollars in fines with possible jail time.

I have personally been caught trespassing countless times, by all kinds of authorities, from minimum-wage security guards to federal agents like the Border Patrol, and have never been cited or arrested. Part of it is luck, but it's also because I'm using basic human engineering skills to convince them that I'm just a harmless oddball artist.

I've had some close calls, though. I've shot some spectacular locations only to be caught midshoot by a furious caretaker who hissed, "If these images ever appear publicly in any form, I'll sue the hell out of you," and then threw me off the property. I've had crazy desert rat property owners holler me off their land while racking a shotgun. If you get rousted, the best thing you can do is take your lumps, say "yes sir" a lot, and minimize the damage. If they tell you to leave, do it, and consider yourself lucky.

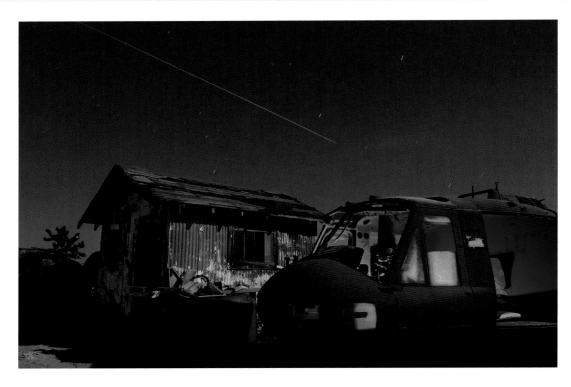

Troy Paiva, "Apocalypse Now," El Mirage, California, 2006

Aviation Warehouse is a remote, high-desert outpost northeast of Los Angeles. The proprietor supplies the film and TV industry with aviation props. Whenever you see aircraft wreckage in a movie, it probably came from the collection at Aviation Warehouse. This 2-minute exposure gave me time to move through the scene, pop a red-gelled strobe inside the helicopter, and wash the metal building with a warm-toned flashlight. Seeing the eastbound aircraft cutting across the sky after I opened the shutter, I ended the exposure while it was still in frame to evoke the sense of an incoming missile.

Trespasser's Checklist:

- Permission is better than sneaking in.

- Always carry samples of your work.

- Be friendly and open with property owners and authorities.

- Have insurance.

- Avoid other trespassers.

- Understand the ramifications of trespassing based on the type of location.

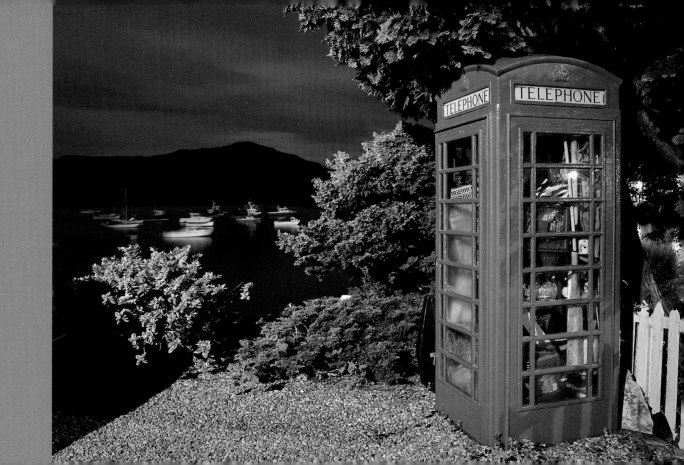

THE BASICS OF
NIGHT PHOTOGRAPHY

DOI: 10.1016/B978-0-240-81258-8.00003-X

Photographing at night requires one to look at the world from a different perspective. Night photography should not be considered merely an extension of daytime photography because night light transforms the known world into something unfamiliar and strange. In much the same way that moving into the studio after photographing outdoors with natural light demands a different approach, photographing at night requires many different considerations. Of course, your photographic skills and knowledge will serve you well, but there are surprises ahead, many new things to learn, and exciting discoveries to be made. Because the light at night is such a huge part of what makes nocturnal photography special, scouting locations during the daytime is of limited value. Returning to a location at night to photograph a scene observed during the day can lead to disappointment because the circumstances at night may make the photograph you envisioned impossible to take. Conversely, scenes that must be photographed jump out at you at night but go unnoticed, or simply don't exist, in the daylight. Night photography presents numerous technical challenges, but also countless opportunities.

MANY VARIABLES

There are more variables than constants with night photography, and many of them are beyond the control of the photographer. Some find this frustrating; others find it exciting. Whichever the case, learning how your camera's sensor or film will respond under different conditions is a big part of understanding what works and what doesn't work when shooting at night. Extreme contrast and a wide dynamic range are the most challenging obstacles to successfully photographing many night scenes. Film photographers face the additional hurdle of not being able to accurately meter exposures, and they must also anticipate reciprocity failure. Digital photographers have to contend with noise created by long exposures or high ISO settings.

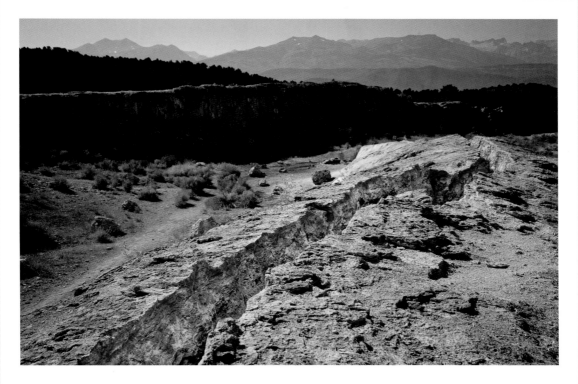

Scott Martin, "Travertine Hot Springs," Bridgeport, California, 2008

Travertine Hot Springs in California's Eastern Sierra consists of a series of remarkable travertine ridges with crevices running along the top of them. In some places the crevices are only an inch deep, but others are shoulder deep and wide enough for two people to walk side by side. In this photograph Scott Martin highlighted the crevice in this ridge by walking the length of it while shining a bright incandescent flashlight down into the crevice during this 15-minute exposure. This particular ridge has scalding water running through it, which runs off the far end where it collects in a series of man-made pools, one of which the author was soaking in during this exposure.

Composing and focusing in low light levels can also be cumbersome and difficult. Lens flare from the multitude of light sources in the nighttime environment is often problematic and can be difficult to predict. In this chapter, we'll explore solutions to these technical challenges as well as other uncontrollable variables like weather and light sources. Simply getting acclimated to working in the dark takes some getting used to, but it makes a big difference in your night photography comfort level.

BEING PREPARED

Dressing appropriately for the weather and your intended location, packing your camera bag in a logical and orderly way, and being confident using your camera's frequently accessed controls are all steps you can take to increase your comfort and productivity in the field. Unless you are accustomed to working on a tripod, chances are that slowing down to the night photographer's pace will require an adjustment in attitude and approach. Night photography is not a spontaneous act, and working in a methodical and deliberate fashion minimizes user error. Simple things like always keeping each item in your bag in the same place means that you won't have to fish around for it with a flashlight—you can just reach in and grab what you need. Although some people prefer to use headlights, they tend to be brighter than you really need and may draw unwanted attention to yourself; most importantly, it can ruin your shot when you forget to turn it off and walk around inadvertently shining it all over the place. After 15 or 20 minutes, your eyes will have adapted to the lower light levels to the point where you may not need a light at all, and not using a flashlight will preserve your night vision. Another simple thing you can do to facilitate your fieldwork is place a small piece of adhesive Velcro on the back of your cable release or timer and attach it to your tripod leg. Most releases have unnecessarily long cords, and Velcro will keep the device within easy reach rather than dangling from the camera. Simple things like this can have a surprising impact on your overall experience. Every step that you take to standardize your workflow in the field helps to minimize technical errors that can ruin a shot.

A basic understanding and awareness of the lunar cycle, the path of the Moon through the sky (where it rises and sets), celestial events (like eclipses, meteor showers, and comets), and a heightened awareness of weather will serve you well as you decide when, where, and what to photograph. Adding a lunar calendar to your desktop or phone keeps this useful information at your fingertips, and you'll probably find yourself reserving a couple of nights a month around the full moon for photography. Planning ahead is always beneficial, but being prepared to venture out and photograph should a dense fog or some other favorable condition arise without warning will lead to unique opportunities. Allow yourself the spontaneity to make the most of special circumstances. Hopefully, your significant other will do the same. If your mate is suspicious of your nocturnal activities, invite him or her to join you. If he or she accepts, you'll either have a new partner in crime or never be questioned again when you declare that you are going out to photograph on a dark and stormy night.

COMPOSITION AND SUBJECT MATTER

Night photographers capture a wide range of subject matter in a variety of conditions and locations. Landscapes, cityscapes, grand vistas, and intimate tableaux are all part of the oeuvre. Many night photographers specialize in a particular type of photography. Some photograph mainly the natural landscape or industrial areas. The English photographer Michael Kenna photographs mainly in locations where man-made and natural environments intersect. Many people involved

Lance Keimig, "Framed, Austin, Texas," 2009

Interesting photographs can sometimes be found in the most mundane locations. The combination of creating a frame within the composition and multidirectional lighting transforms this typical street scene in Austin into something a little more unusual. The lens was stopped down to f22 to get maximum depth of field with the normal focal length lens. Canon 5D Mark II, 50 mm f3.5 macro lens, 30 seconds at f22, ISO 100.

in the urban exploration movement also photograph during their adventures. Urban explorers venture into abandoned buildings—factories, schools, and psychiatric hospitals are particular favorites. There is even a large group of photographers in Melbourne, Australia who specialize in photographing underground sewer and storm drains using sophisticated light painting techniques. Troy Paiva has inspired a generation of night photographers with his colorful photographs of abandoned places in the California desert. Light painting, or the use of portable handheld lights to illuminate or create subject matter, has become increasingly popular in recent years, largely proliferated through photo-sharing Web sites like Flickr. Anything that can be photographed in the daytime can be shot at night, although it will probably look completely different. Even in the absence of all light (those Australian sewer pipes, for example), it is possible to photograph with the addition of light from flash, flashlights, or even fire.

In most ways, composing a night photograph is not very different from composing a daytime image. The rules of design apply equally in the dark as in the light, and they are still made to be broken. Sometimes it may be necessary to modify a composition to exclude bright light sources from the image. Such a modification may be a compromise of the ideal composition, but if it restricts the dynamic range of the scene to that of the camera's capability, it may be justified. Bright areas at the edge of an image always draw the viewer's attention, and this is particularly true at night. A light or brightly exposed area near the edge of the frame can lead the eye away from the subject and away from the image entirely. The most interesting images are ones where the viewer's gaze is kept in motion, moving from one spot to another within the frame. Strong graphic shapes, diagonal lines, exaggerated perspective, and the rule of thirds are compositional devices that make for more dynamic images. Including foreground elements in landscape photographs adds depth and visual interest. Consider the direction of lighting, be it streetlights or moonlight, and don't be afraid to break the rules. With a little added light on the foreground, using the Moon as a backlight has the potential to create real drama.

COMPOSING AND FOCUSING

Both composing your shot and focusing can be difficult in low-light conditions, simply because it is hard to see the image in the viewfinder. Fortunately, there are simple solutions to deal with these problems. Digital photographers have the obvious luxury of being able to view the image immediately after capture, and it is easy enough to adjust the camera position and recompose as needed. Setting your camera to the highest ISO setting and doing a series of handheld test exposures is a good way to refine a shot. Even if the light level requires exposure times of a few seconds, most people can hold the camera steady enough to get a reasonable idea of what the final image will look like. This technique is a great way to predict and correct for potential problems like flare and also to spot stray objects at the edges of the frame that might have otherwise gone unnoticed.

Film photographers who also own a DSLR might consider using their digital camera for high-ISO test shots, or *digiroids*, just as professional photographers used to do with Polaroid film. Although testing

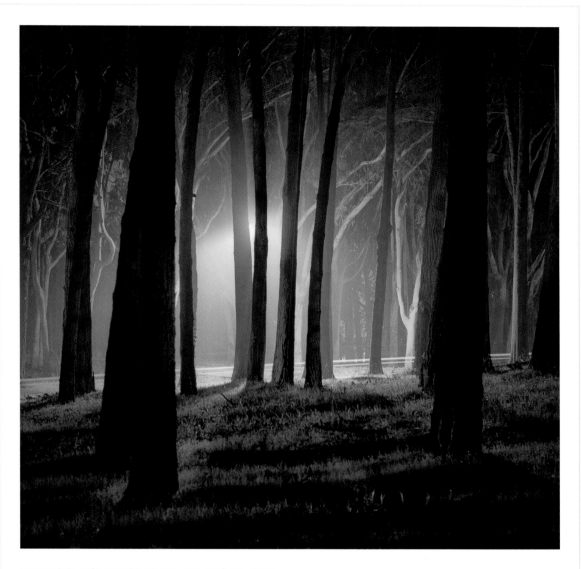

Lance Keimig, "The Arrival," San Francisco, California, 1999

Backlighting is employed here to add drama and mystery to this wooded scene inside San Francisco's Presidio. The typical San Francisco fog intensifies the effect.

with a DSLR is useful as a framing aid, it will not necessarily provide accurate exposure information for film photographers because digital cameras do not respond to long exposures the same way that film does, and they do not suffer from reciprocity failure. Still, DSLRs can be used to establish a starting point for film exposures, which will almost always be longer than digital exposures.

Live view is an extremely useful feature that can be used in combination with a flashlight to make focusing in darkness more manageable. A bright flashlight, such as a SureFire or Streamlight, can aid with both composing and focusing your night shots. By shining the light around in the image while looking through the viewfinder, it may be easier to find the corners of the frame. It's a common mistake for both day and night photographers to concentrate their attention strictly on the subject and to ignore the edges of the composition. Night photographers should pay extra attention to the entire image, both because it can be difficult to see and because night photographs generally require a greater commitment of your time and energy. It's always disappointing to invest 10 or 15 minutes in a single exposure only to later find an unnoticed object in the shot that could have easily been avoided with a little more care. A great trick for determining the edges of your image in a very dark and confined environment—inside a building, for example— is to shine your flashlight through the camera viewfinder and observe where the light falls. This can be a very useful technique, but it will only work with a very bright flashlight in a confined space that is almost completely dark. Flashlights are also very useful as focusing aids, as we will see.

Although your camera's autofocus system will probably work in a bright urban environment, autofocus does not usually work well in low light. Infrared (IR) assist beams on some cameras will be helpful for autofocus in certain situations, but these are more commonly built into flash units than cameras. Focusing manually is the best option at night, and there several ways to achieve accurate focus. As discussed in Chapter 2, manual focus (MF) lenses are better suited for night photography. Autofocus (AF) lenses are engineered to focus as quickly and accurately as possible—in autofocus mode. Unfortunately, what works best for autofocus is not what works best for humans. The short throw between the closest focusing point and infinity, as well as the low tension of most AF lenses, makes them super sensitive and very difficult to focus precisely by hand. Additionally, to protect the AF motor during rapid focusing, the throw actually extends beyond infinity. Unlike MF lenses, which can be racked to the end of the throw and will reliably stop at infinity, almost all AF lenses rotate just past infinity, and no part of the image will be sharp if the lens is accidentally set this way.

Just as your flashlight can be helpful when composing a shot, it is also a useful tool for focusing. The most obvious technique is to stand behind the camera and shine the light on the area to be focused. Then, while still holding the light in position, focus manually while looking through the viewfinder. Focusing utilizing this technique in conjunction with live view is even better. The live view image may not be bright enough to use for focusing without the aid of a flashlight, but combining the zoom feature on live view with a flashlight allows for extremely accurate focusing. Some cameras have a variation in the live view mode that simulates how the exposure will look with the camera settings as they are currently set on the camera. You should disable this exposure simulation option because it will darken the image and make it harder to see in most situations. Additionally, it is not an accurate way of gauging exposure. It is a good idea to experiment with your own camera to see what settings will give you the best results. Another method is to place your flashlight at the focus

FOCUSING TECHNIQUES

Technique	Useful for/with	Reliability
Manual focus, shining flashlight on subject	Very accurate focusing with bright flashlight and live view	Best
Manual focus, placing flashlight in scene at the point of focus	Works well with or without live view	Best
Unassisted manual focus	Manual focus lenses, brightly lit scenes with or without live view	Good
Hyperfocal focusing	Convenient and maximizes depth of field	Good
Autofocus	Brightly lit scenes, lots of ambient light	Limited
IR-assisted autofocus	Use your flash's IR assist beam for focusing with relatively short focus distances	Limited
Zone focusing	Similar to hyperfocal but does not include infinity focus	Limited
Auto or manual infinity focusing using the moon or streetlight	Wastes much of your depth of field	Last resort

point in the scene, pointed back toward the camera. Return to the camera and focus on the light itself, again using live view if you have it, and then retrieve your light before taking the shot.

A CONSTANT APERTURE

Because there are so many variables that are beyond your control when photographing at night, it is helpful to have one fixed point to provide a frame of reference. Film shooters especially need a way to be able to compare one image to the next or images shot on different nights in different locations. Comparing results from one session to the next is a great way to learn what's working and what isn't in your photographs. It is counterproductive to always use the same white balance because the range of color temperatures found at night varies widely. It would be inconvenient to limit yourself to a single ISO or film speed, and there's no single shutter speed that will work for every photograph. The logical fixed point is aperture. Picking one aperture that provides a reasonable depth of field

(DOF) and using it for the bulk of your photographs will help you to understand nighttime exposures. For wide to normal lenses, f8 seems to be a good compromise between DOF and overly long exposures from smaller apertures. If you tend to shoot with longer lenses or use a medium or large format camera, you may want to choose a smaller aperture for more DOF. If you shoot with extreme wide-angle lenses, f5.6 may provide all the DOF you need. The important thing is having a fairly constant aperture to be able to compare results with a fixed frame of reference. This is more important while you are first learning and still building confidence. For those shooting film, it is imperative to take good exposure notes and then compare your results and notes. If you use hyperfocal focusing, keeping a constant aperture also prevents the need to refocus for every shot. A constant aperture is also necessary if you will use high dynamic range (HDR) or manual layer blending to combine several exposures as a means of contrast control. Of course, there are times when you will want to use a larger or smaller aperture for more or less DOF, and you absolutely should when it's called for. It is just good practice to vary your exposure with time rather than aperture.

HYPERFOCAL FOCUSING

Manual focus prime lenses can be prefocused using the hyperfocal distance (HFD) or zone focusing techniques. The hyperfocal distance is the nearest point for any given focal length, aperture, and camera format that will keep infinity in acceptably sharp focus. Remember, for every lens there is an exact point of focus, and an area in front of and behind the focal point that is reasonably, or acceptably, in focus. Sharpness falls off gradually as you move farther away from the focal point until the image is noticeably out of focus. This zone of focus is what we call depth of field. In short, hyperfocal focusing maximizes your depth of field. When a lens is focused at the hyperfocal point, the depth of field extends from half of that distance to infinity. For example, if the hyperfocal distance for your lens–aperture–camera combination is 30 feet, then your depth of field extends from half of that distance, or 15 feet, to infinity. Technically, it is possible to use hyperfocal focusing with any lens, but with short throw zooms, it is so difficult to do it with any precision that you are better off using another focusing method. Manual focus prime lenses have a DOF scale that allows you to prefocus to the hyperfocal distance, unless you are using an adapter to mount the lens to the camera. The scale combines the use of distance markings with pairs of numbers or colored lines representing the f numbers of the lens, one on either side of the mark that represents the focal point. By lining up the infinity symbol on the distance scale with the outer number or colored line representing your working aperture, you have just focused the lens to the hyperfocal distance. The near distance in the DOF will be indicated by the inside number or colored line on the DOF scale. The scale provides only an approximation of the true DOF, and for this reason, it is a good idea to use the HFD for the aperture one stop greater than your working aperture. In other words, if you are shooting at f11, focus to the HFD for f8, which ensures that infinity will be tack sharp and gives you a comfortable margin of error. Zoom lenses do not have DOF scales because the DOF changes with the focal length as the lens is zoomed in and out.

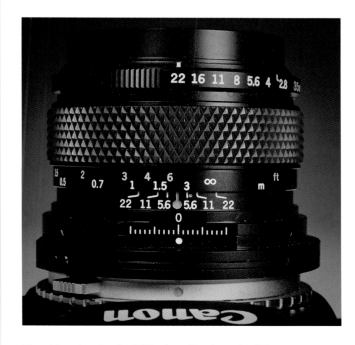

Manual focus lens showing DOF scale and lens focused to HFD

This manual focus Zuiko 35 mm shift lens shows the depth of field scale and is set to the hyperfocal distance for f22. By placing the infinity mark just inside the right-hand 22 on the DOF scale, this sets the HFD. The actual focal point is at a little more than 6 feet, and the depth of field extends from about 3½ feet to infinity. The HFD increases as the aperture diameter is increased, and depth of field increases as the aperture gets smaller.

Photographers working with view cameras, or any lens that does not have a depth of field or distance scale, can still use hyperfocal focusing. Carrying a hyperfocal calculator or small laminated reference card in your wallet or camera bag with just the HFDs you are likely to need will make it easy to access them in the field. When you determine the appropriate HFD from your table or calculator, walk off the distance from the camera by counting your steps and place a flashlight on the ground pointed back toward the camera. Focus on the light, and you're focused at the HFD. The average adult stride is about 3 feet, so if your HFD is 30 feet, start at the camera, walk 10 steps into the shot, and place the light and focus at that location. Don't worry if your measurement isn't completely accurate; this is one of the reasons for calculating the hyperfocal distance conservatively by closing down the lens an extra stop.

If this all sounds confusing, rest assured that once you have your lens focused at the HFD, you can leave it there as long as you use the same aperture. Those with low vision or who have difficulty focusing at night should consider prefocusing their lenses before leaving home. You can measure

the HFD for your working aperture with a tape measure to make sure you are focusing at the true HFD. The focus ring on the lens can then be secured with tape, ensuring the lens will remain focused all night. Of course, if you change apertures, your HFD will change, and you will need to refocus. There are several online resources and mobile phone apps to calculate HFD, some of which are listed in the resources section at the end of this book.

None of these focusing methods will work in every situation, so it's great to have several different techniques at your disposal. Now let's look at some of those uncontrollable variables and see what we can do to work around them.

CONTRAST AND DYNAMIC RANGE

The range between the darkest black and brightest white in a scene, digital file, negative, or print is called dynamic range. Daytime photographs usually involve a single light source—either the Sun or an overcast or cloudy sky. On a clear day, the Sun is a moderately-high-contrast light source that creates deep shadows, midtones, and bright highlights. Unless the scene contains specular highlights like sunlight reflected off water, glass, or metal, the dynamic range of the scene can be recorded by a DSLR sensor or film. An overcast sky is a diffuse light source, with much lower contrast, a smaller dynamic range, and only a couple of stops between the darkest and lightest tones in a scene. The situation at night is completely different because nighttime illumination involves many different localized light sources that are quite weak in comparison to the Sun or diffused skylight. A typical night scene might be described as a sea of darkness punctuated by small pools of light. Night photographs are often described as theatrical or stagelike because the light often comes from different directions and different sources. The exception is photographs that are taken in remote natural environments by moonlight. As you might expect, moonlit scenes have a similar dynamic range to sunlit scenes, with two important differences. The first is obvious; moonlight is much weaker because it is sunlight reflected off the surface of the Moon. Secondly, because moonlight is so weak, which requires exposures to be long, the Moon moves in the sky during the exposure. As the Moon moves, its shadow advances with it, and the edges are softened as they are washed over with light. The end result is that Moon shadows are not as deep as Sun shadows. Moonlit scenes usually express a fairly narrow dynamic range, unless the camera is pointing toward the Moon.

The dynamic range between bright and dark areas in artificially lit environments can easily be 15 stops, and if light sources are included in the image, that range is greater still. This exposure difference between shadows and highlights is more than any camera sensor or film can accommodate without going to extreme measures. Sometimes an image is worth the investment in postprocessing time to try to recover such high contrast, but the best way to handle such extremes is to manage them in-camera whenever possible. A slight adjustment of the composition can often reduce overall contrast. By making minor camera adjustments, it may be possible to hide a prominent light source behind a tree, street sign, or other object in the scene. In complex

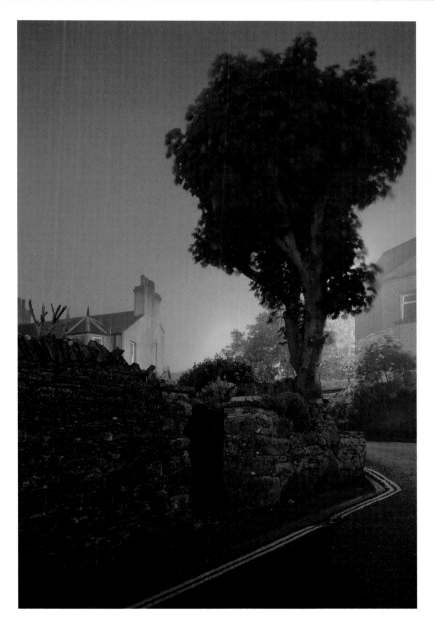

Lance Keimig, "A Strange Night in Scotland," Stromness, Orkney, 2007

A combination of low-pressure sodium vapor and tungsten light sources on a foggy night account for the unusual colors in this image taken in a village in northern Scotland. The tungsten light is hidden behind the tree, and the low-pressure sodium is below the horizon, but their effects on the scene are obvious.

situations with many light sources, finding the best camera position to hide the most problematic lights can be like solving a puzzle—move the camera to obscure one light, and another appears.

Another option might be to crop the image a little tighter to eliminate light sources near the edge of the frame that are causing lens flare and increasing the overall contrast. Sometimes a compromise of the ideal composition is the only way to photograph a particularly contrasty scene. In other instances, it simply may not be possible to capture the scene you see before you in a single image. In this situation, high dynamic range (HDR) imaging or manually blending exposures in Photoshop can be considered. See Chapter 7 for information on these techniques. Taking the dynamic range of your DSLR or the exposure latitude of your film into consideration will help guide you in determining if a scene can be effectively photographed in a single capture or if it will require multiple exposures to record all of the important detail in the scene. It is necessary to differentiate between important highlights where detail needs to be preserved and highlights that can be allowed to clip or be overexposed. There is no hard rule here; it is a subjective decision made by the photographer at the time of exposure. A surprising amount of highlight detail is contained in a RAW file and can be recovered in postprocessing. However, when there is clipping in all three channels and the sensor sites become fully saturated, there can be no recovery of detail.

Each new generation of digital cameras expands the dynamic range that digital photographers have to work with. Early DSLR cameras had a dynamic range of about 10 stops, which had been improved to about 12 stops by 2008. The Nikon D3X has a dynamic range of 13.7 stops,[1] the greatest of any DSLR on the market in late 2009. Black and white film has a similar potential dynamic range. Currently there is no print media that can reproduce the full dynamic range of many night scenes. A quality print will convey a sense of the dynamic range of the image, but it will be compressed to fit the dynamic range of the paper.

LIGHT SOURCES AND COLOR TEMPERATURE

The color of daylight changes throughout the day depending on the amount of atmosphere that sunlight travels through to reach the Earth, and the amount of atmosphere depends on the elevation of the Sun above the horizon. Because there is only one primary light source during the day, most daylight pictures can be easily color balanced for that light source. However, there are many different types of light sources in our nighttime environment, and each of them has its own color balance, or temperature. Our eyes do a remarkable job of compensating for varying brightness levels because our irises continually expand and contract the pupil based on the brightness of what we see before us. Our brains accommodate for the various color temperatures of streetlights, which we mostly think of as being neutral. When we see different types of lights adjacent to each other, the color differences are more obvious. Photography appears to exaggerate the color of light because film or digital sensors do not adapt to light the way our eyes do. Mixed lighting is one of the things that creates so much potential in night photography, but it can also cause some of the biggest headaches. Digital cameras have a white balance function that is generally set for the

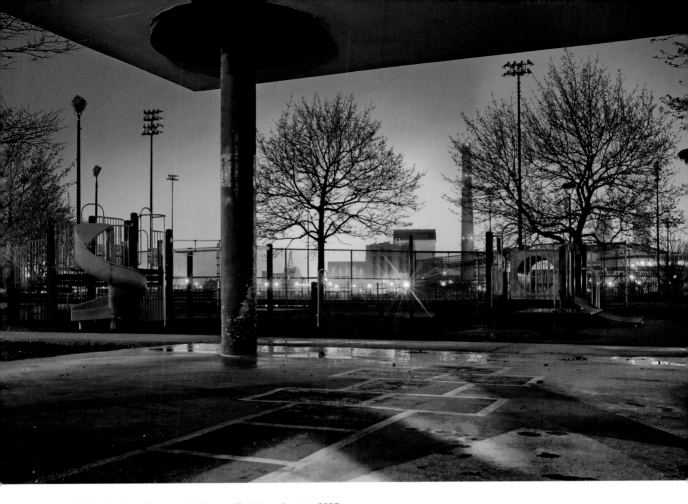

Christian Waeber, "Hopscotch," Somerville, Massachusetts, 2007

This image is a blend of three exposures (12, 36, and 76 seconds at f8, ISO 100, Canon 5D). The brightest areas were selected from the shortest exposure and layered over the 36-second exposure, as described in the manual layer blending section in Chapter 7. An exact selection of the roof was taken from the 76-second exposure (with no feathering) and layered over the 36-second exposure to open up the shadow areas. While taking the images, the photographer also used a flashlight to bring out some of the details and texture. He used a blue filter on the flashlight to add some interest to the ceiling, and he lit up the ground with a very low angle to emphasize its texture. The photographer tried to hide as many of the distant floodlights as possible behind fence poles and trees, and of course he had to choose a night when there was no baseball game on the field.

dominant light source in a scene. Cameras can be set for daylight, cloudy, tungsten, fluorescent, custom white balance, a specific color temperature, or to auto white balance (AWB). Auto white balance generally works well except when there are strong multiple light sources—exactly the situation that is frequently found at night. Film is more limited, being either color balanced for daylight (5500K) or tungsten light (3200K). Film photographs can be color corrected to a certain extent using color-compensating gels, but these filters are of limited use when multiple light sources are present. Neither film nor digital can completely accommodate for multiple sources in the same scene, but modern professional films have a fourth emulsion layer that is an improvement over older films, and imaging software can be used to compensate for mixed lighting in most

situations. Naturally, the color of various light sources is not an issue when shooting black and white film, but white balance is still important when shooting for black and white with digital cameras.

In some instances, it may be desirable to have a completely neutral and natural color balance in an image, but more often than not, juxtapositions of different colored light can add to the visual impact of a photograph. Just as theatrical and Hollywood lighting designers use warm and cool colors to set the mood of a scene, night photographers can take advantage of different types of light in the same way. The first step is to learn to recognize what these light sources are and how they are rendered in photographs.

The Kelvin temperature scale is used to quantify the color of light, which ranges from about 1500 K for candlelight, 4000 K for moonlight, 5500 K for sunlight, to as high as 12,000 K for blue sky. The lower the color temperature, the warmer (redder) the color, and the higher the color temperature, the cooler (bluer) the color. The Kelvin temperature scale is not the most accurate measurement of the color of many artificial light sources because it actually only applies to incandescent light sources—fire, sunlight (or moonlight), gaslight, or tungsten bulbs. Gas discharge sources, like fluorescent, sodium vapor, and metal halide lights, as well as LED (light-emitting diode) lights, give light that varies in hue from red to blue on the Kelvin scale. Fluorescent, mercury vapor, and metal halide lights all contain green, which cannot be accounted for on the Kelvin scale. Film photographers compensate for the green or cyan in these light sources with magenta or red color-correcting gels, and digital photographers have the magenta to green slider in RAW processing applications in addition to the yellow to blue slider in the white balance correcting tool palette.

Most DSLRs have white balance settings that range from about 2500 K to 8000 K. White balance can also be refined with RAW processing software in postproduction, but it is best to set the white balance in-camera. The white balance setting will affect the exposure histogram, which is your primary means of determining exposure. Therefore, setting the white balance to a color temperature that renders colors close to the way you want them will also ensure a better exposure histogram.

The most common artificial light sources are sodium vapor, metal halide, fluorescent, tungsten, and mercury vapor. Low-pressure sodium vapor lights are instantly recognizable for their strong monochromatic yellow–orange color. They are commonly used in Europe to alert drivers that they are about to enter a village or small town. Despite their high efficiency rating, low-pressure sodium vapor lights are rarely used for street lighting in North America because it is difficult to see colors under this type of lighting. Conversely, high-pressure sodium vapor is the predominant type of streetlight found in most cities around the world. These lights have a pinkish–orange cast and are difficult to color correct, but they appear more neutral to the eye. Mercury vapor lights emit a greenish–blue or cyan cast, as well as a fair amount of ultraviolet radiation, and remaining fixtures are mostly found in industrial settings. The sale of new mercury vapor lamps was banned in the United States in 2008 and will be banned in the European Union in 2015. Metal halide lights are closely related to mercury vapor but include other elements along with mercury in the tube to produce a broader spectrum of light. Metal

COLOR TEMPERATURES

Light source	Color temperature	Hue	Primary use
Low-pressure sodium vapor	589.3 nm mono-chromatic	Deep yellow	Outdoor lighting near observatories, more common in Europe than the United States
Candle	1500 K	Orange	Romantic dinners
High-pressure sodium vapor	2000 K	Yellow–orange–pinkish	Most common street lights
Incandescent–tungsten	2700–3200 K	Yellow	Traditional indoor lamps
Moonlight	4100 K	Neutral–bluish	Werewolves
Fluorescent	4000–6000 K + green	Neutral–greenish	Indoor lighting, illuminated signs
Metal halide	3000–20,000 K (usually around 5000 K)	Neutral–greenish–bluish	Stadiums, parks, streetlights
Mercury vapor	6500 K + green	Blue–green; similar to metal halide, with a stronger color cast	Being phased out, but still in industrial areas and some street lighting

halide lights are increasingly common in parking lots and public parks, but the most common use is in stadiums and sports facilities because of the clean white appearance of the light. Metal halide lights can vary widely in color temperature, but most of them appear slightly bluish in photographs. Ceramic discharge metal halide lamps are a new form and are competing with LED fixtures to be the next generation of streetlights. LEDs are used in traffic lights and crosswalk signs, and they are replacing neon tubes in sign lighting. They are highly efficient but very expensive compared to other light fixtures. They can be manufactured in many colors but usually have a color balance similar to daylight, between 4000 K and 7500 K. Many modern flashlights use LEDs. Fluorescent fixtures are occasionally used outdoors, but they are primarily found in office and other commercial buildings. If you photograph a city skyline at night and notice that the interiors of the buildings are glowing green, the building is illuminated with fluorescent lighting. Tungsten incandescent lights are the type of lights most people have in their homes, and they have a warm yellowish color balance between 2800 K and 3200 K.

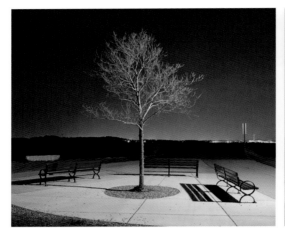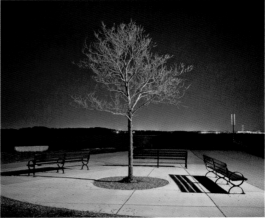

Choosing white balance, Lance Keimig, "Castle Island," Boston, Massachusetts, 2008

Metal halide lights at Castle Island in South Boston cause this scene to take on an unpleasant green cast when auto white balance is chosen in-camera. Using the white balance eye dropper tool on the sidewalk neutralizes the green and turns the sky a deep shade of magenta.

Aside from the occasional neon sign, these are the main artificial light sources that will impact your night photographs, and as was mentioned earlier, it is worthwhile to learn to distinguish among them.

WEATHER

Weather conditions can dramatically affect both the contrast and color balance of night photographs. In addition to the extremes of contrast between areas illuminated by streetlights and the surrounding darkness, there can be similar extremes between subject and sky. On clear nights, the exposure for the sky is considerably longer than the exposure for artificially illuminated scenes. The photographer must compromise the exposure by favoring either the scene at ground level or the sky. One way to compensate for this exposure disparity is to photograph on nights when there is a full, or nearly full, moon high in the sky. Moonlight will have relatively little impact on ground-level illumination, but it will add light to the sky, giving it tone and color in the photographs. On overcast nights, the clouds in the sky will reflect the light from the ground, reducing the overall image contrast and adding color to the sky. The predominant light source in the area will flavor the color of the sky, but the end result will be a combination of all of the light from the city or town mixed together and bounced back down off the clouds. In most locations, a cloudy sky will have a purplish hue that varies in intensity depending on the height of the cloud cover, the overall level of ground illumination, and the type of lighting in the immediate surroundings. If there is a difference between the type of subject matter illumination and the dominant lighting of the area, there can be major differences in the color temperature between the ground and sky.

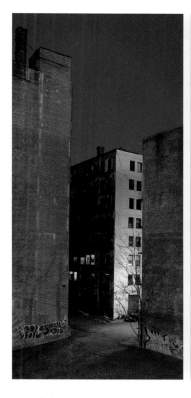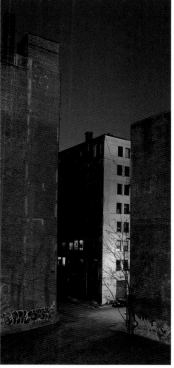

Mixed lighting, Lance Keimig, "Loft Conversions," Fort Point Channel, Boston, Massachusetts, 2009

The overall lighting in this scene is high-pressure sodium vapor, but the single light in the center of the frame is mercury vapor. The image on the left is corrected for mercury vapor, and the white balance is set to 3000 K + 74 magenta. The image on the right is adjusted for sodium vapor, with a white balance of 2300 K + 4 magenta. Canon 5D, 28 mm f3.5 PC Nikkor lens, 1 minute, f8, ISO 100.

These differences can make for truly interesting images, but they can also be tedious to color correct if a natural appearance is desired. Urban night photography will usually be more successful on cloudy nights or when there is a full moon on clear nights. Clear nights will generally lead to solid black skies, which don't work well for most images.

The situation is quite the opposite in natural, moonlit scenes. On clear nights, the exposure at ground level and the exposure for the sky are about the same. Of course the exposure times will be much longer if there is little or no moonlight, but even with only starlight to work with, it is possible to photograph in remote areas on clear nights. A cloudy night in an area with little or no ground-level illumination leads to an image with a bright white sky and a dark foreground

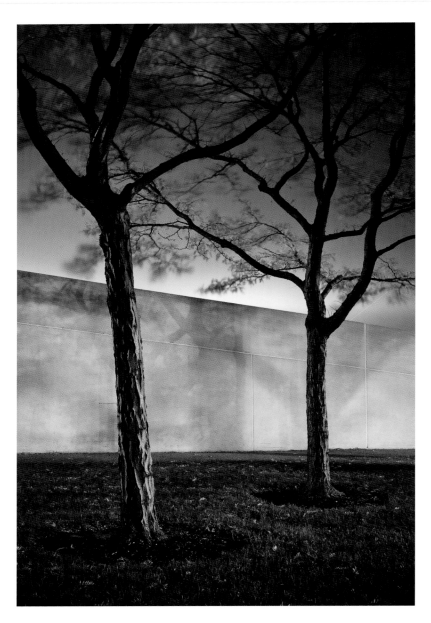

Lance Keimig, "JFK Library," Boston, Massachusetts, 2009

The JFK Library in Boston is a fantastic night photography location. The sheer white stone facades of the architecture act as giant reflectors, bouncing metal halide light softly onto the surrounding landscape. Farther away, the predominantly sodium vapor lighting of Boston provides a great contrast of color. These trees were shot on a very foggy night. Had the sky been clear, it would have been nearly black and much less interesting.

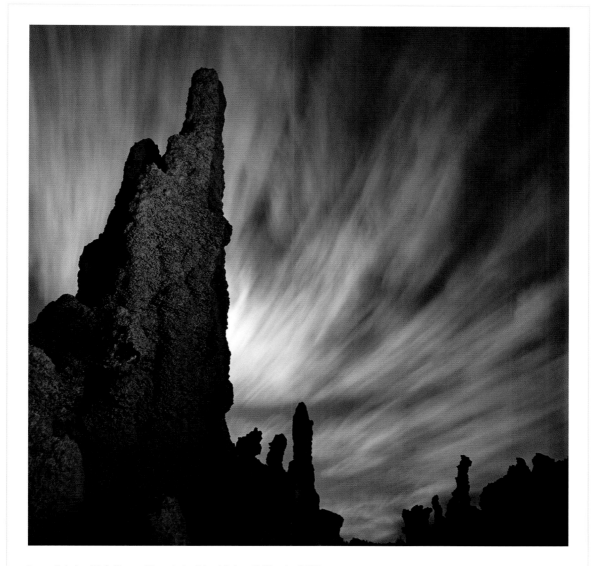

Lance Keimig, "Tufa Tower, Mono Lake," Lee Vining, California, 2003

Conditions were perfect on this full moon night at Mono Lake in the Eastern Sierra. The slow-moving clouds passed by at about a 45-degree angle to the camera as the Moon rose behind the tufa formation. The 15-minute exposure was timed to end just before the Moon peeked out from behind the rock. The tufa tower was gently lit with reflected flashlight to add some subtle detail. Without the added light, the rock would have been completely silhouetted. Hasselblad 500 C/M, 50 mm f4 Distagon lens, 15 minutes at f8. Fuji Neopan Acros developed in Xtol 1:1.

with low localized contrast, but there is a high global contrast between the sky and ground. One solution in this situation is to add light to the foreground with light painting, but just like solid black skies, pure white skies with no detail are not very appealing. Broken, moving clouds can add visual interest to any type of night photograph, urban or rural. Positioning the camera so that the clouds are moving perpendicular to, or at least at a 45-degree angle to, the image plane makes for a more dramatic image. Clouds moving parallel to the image plane tend to blur together and wash out, creating the white sky effect.

FLARE

Night photographs can be plagued by lens flare, which is caused by stray light shining directly on the lens from sources outside of the field of view. This unwanted light is scattered across the surfaces of lens elements and can manifest in different shapes. Flare can be hexagonal or octagonal shaped, reflecting the shape of the lens aperture, or it may appear as rings or star patterns. Flare sometimes appears as a haze that washes out the image and reduces contrast, especially when there is a light source just outside the frame. Wide-angle lenses and zoom lenses are especially prone to flare problems because their complex design and numerous elements provide many surfaces that can cause light to scatter inside the lens. Filters, especially dirty ones, are also frequent contributors to lens flare. Unless you are prone to dropping your gear or are working in windy or dusty environments, it's probably best to leave the filters at home when you go out night shooting. Lens shades or hoods are designed to prevent flare, but engineering compromises to accommodate for the variable focal length of zoom lenses reduce their effectiveness. It is often difficult to spot lens flare in the camera viewfinder, and because most SLR and DSLR viewfinders reveal only about 95–97 percent of the image, flare at the edge of the frame is particularly hard to spot. The best way to check for lens flare is to walk around in front of the camera and look at the surface of the lens, making sure not to cast your shadow on the camera or lens. If you can see any light falling directly on the lens—regardless of whether or not you are using a shade—chances are that your image will have some flare. In this case, the best solution is to shade the lens further with a black card, either held in your hand or attached to the camera with a tool like the Flare Buster mentioned in Chapter 2. It may also be possible to shade the lens by positioning your body between the offending light source and your camera. You'll need to be careful not to place the card in the field of view, especially with wide-angle lenses. Make sure you look closely at the image before moving the camera for the next shot, both for signs of flare and for the intrusion of your flare-blocking device. Lens hoods can also cause vignetting of the image if the hood does not match the lens or if it is not properly attached to the lens. Modern twist-on shades can accidentally be misaligned or put on the lens without being fully rotated into position. Both of these common mistakes will cause vignetting. In the absence of a lens shade or black card, a hat or even your hand can be employed to do the job, but it is best to use a dark-colored object that won't reflect light back into the lens.

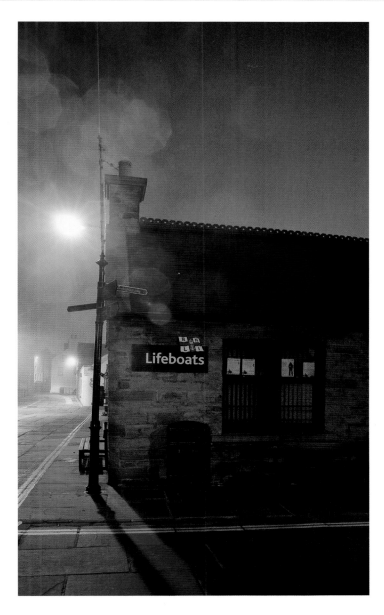

Lance Keimig, "Lifeboats, Stromness Harbor," Orkney, Scotland, 2007

Most of the time, lens flare is a problem we try to avoid as much as possible, and most of the time, it results from light sources just outside the frame. On this foggy night in Stromness, on Orkney in northern Scotland, the moisture in the air caused this mercury vapor streetlight to flare wildly. The resulting photograph is more interesting and colorful because of the flare. The old saying, "If you can't beat 'em, join 'em," certainly applies here.

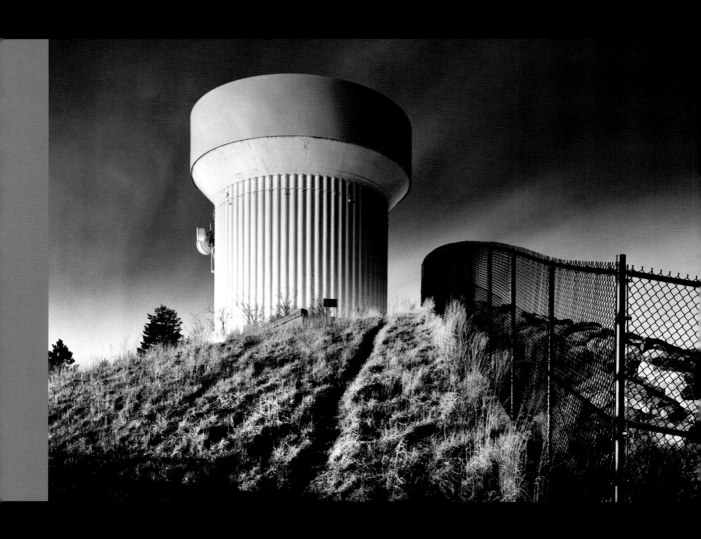

FILM-BASED
NIGHT PHOTOGRAPHY

4

DOI: 10.1016/B978-0-240-81258-8.00004-1

Most people are shooting with digital cameras these days, but there are still valid reasons to use film at night. Film provides high quality at a low cost, can produce very clean images (there is no noise), and with film it is possible to make multi-hour exposures. Although each new generation of digital camera produces less noise in long exposures, it is still impractical to extend exposures beyond about 20 or 30 minutes, except with expensive professional models. People who shoot film at night include those working with medium format and large format view cameras, alternative printing processes, toy cameras, or simply those who enjoy the process of working with film. The obvious disadvantage for film shooters is the lack of immediate feedback enjoyed by digital photographers, which makes having confidence in exposures a matter of experience or faith. Film also suffers from reciprocity failure, which makes it difficult to accurately determine exposure. Aside from personal preferences for one format over another, the greatest advantage of film-based night photography is the ability to do extremely long exposures. The only limitation to exposure length with film-based night photography is the duration of the night itself. In this chapter, we will explore working with film at night, with an emphasis on black and white.

FILM TYPES

There are three basic types of film available today: color transparency, color negative, and black and white negative. There is also infrared film, but this has no practical value for night photography because there is not much infrared radiation at night. Nighttime images shot on infrared film look like those shot on regular black and white film because infrared film is also sensitive to visible light. Black and white film is highly versatile, can be developed by the photographer, and will likely be around for a long time. Traditional gelatin silver prints made in a wet darkroom are virtually permanent when properly processed and are highly valued for their unique beauty. Color transparency (E-6) film, known as slide film in 35 mm format, has a restrictive exposure latitude of only about five stops, requires a complex and precisely controlled chemical process, and is becoming increasingly difficult to have developed. Color negative (C-41) film has a fairly wide exposure latitude (about 9 or 10 stops)

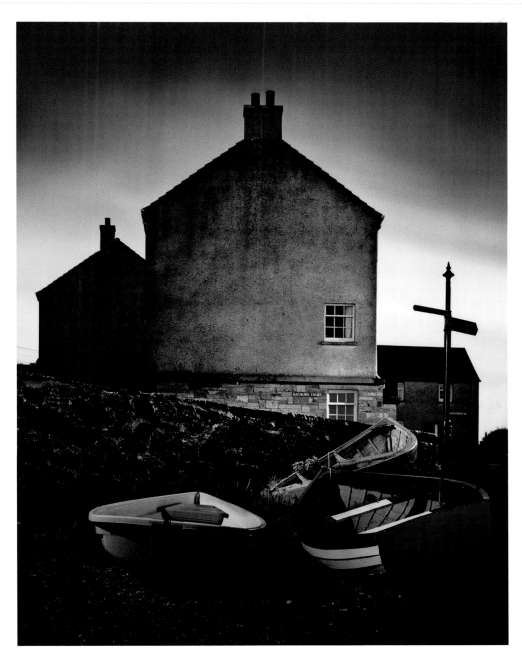

Lance Keimig, "The Poet George Mackay Brown's House," Stromness, Orkney, 2008

In high summer, it doesn't get dark until midnight on Orkney, and it starts to get light again about 2 a.m. This image was taken in that narrow window of darkness on an extraordinary night when conditions were perfect. Ebony 23SW camera with a Nikkor 65 mm f4 lens. Exposure unrecorded at f11. Fuji Neopan Acros film.

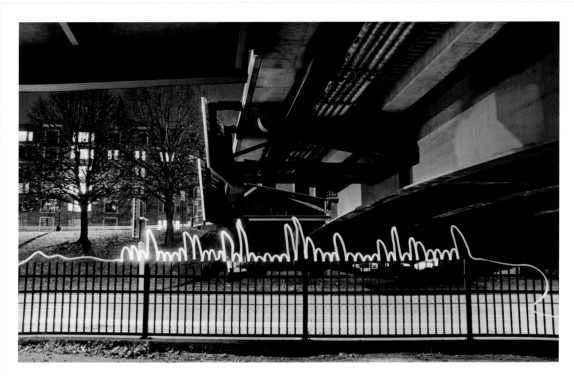

Satoru Imai, "Impulse," 2009

This image is part of a playful series that incorporates a dancing light that seems alive. A small flashlight is pointed toward the camera as it bounces along the railing. The photographer does not show up in the image because he was wearing dark clothing, did not stand still long enough to register on the film, and no direct light reached him. Fuji Neopan Acros, 2 minutes, f8. Developed in D-76 1:3 for 12 minutes.

that is useful for night photography, has been the most commonly used film by amateurs and the general public, and processing continues to be readily available, at least for the time being. The quality of contemporary DSLR cameras equals or surpasses the quality of 35 mm film, so most night photography film shooters take advantage of larger format film or alternative format cameras that do not use digital sensors.

Color slide and color negative films utilize standardized chemical processes regardless of film type, manufacturer, or the sensitivity of individual films. This uniformity of processing makes for relative ease of mechanized processing, but it means that the films are less flexible than black and white films. There are tremendous variations between black and white films depending on the specific film, type of developer, and method of processing. It is this variability that makes black and white film so useful because the film and developer selection can be tailored to specific

purposes. Black and white film can be developed in such a way as to compensate for extreme dynamic range, which of course makes it very useful for night photography. When exposure and development are precisely coordinated, black and white film can accommodate about 13 or 14 stops of exposure latitude, similar to the very best DSLRs.

RECIPROCITY FAILURE

All film suffers from reciprocity failure to some degree, meaning that the longer it is exposed, the less sensitive it becomes. Reciprocity failure is the breakdown of the constant relationship between light intensity and light duration on film. Under normal exposure conditions, a one-stop increase or decrease in the intensity of light reaching the film (controlled by opening or closing the aperture) can be compensated for by a one-stop adjustment in the duration of the exposure (the

BLACK AND WHITE FILM RECIPROCITY COMPENSATION FOR LONG EXPOSURES			
Indicated exposure	Actual exposure Tri-X/Plus-X HP5/FP4	Actual exposure T-Max 100/400 Delta 100/400	Actual exposure Fuji Neopan Acros
1 sec	1.5 sec	1 sec	1 sec
2 sec	4 sec	2 sec	2 sec
4 sec	12 sec	6 sec	4 sec
8 sec	36 sec	12 sec	8 sec
15 sec	1 min 30 sec	30 sec	15 sec
30 sec	3 min 30 sec	1 min	30 sec
1 min	8 min	2 min	1 min
2 min	18 min	5 min	2 min
4 min	40 min	10 min	6 min
8 min	1 hr 30 min	20 min	12 min
15 min	3 hr 30 min	50 min	25 min

shutter speed). When exposures reach a particular threshold, that reciprocal relationship begins to erode. To make matters worse, the rate of reciprocity failure accelerates as exposures get longer, necessitating still more exposure, which in turn reduces the film's sensitivity, which in turn requires more exposure. Worse still, reciprocity failure is not consistent from one film to another. Some films are much more prone to reciprocity failure than others.

Modern films are much less susceptible to reciprocity failure, but older film stocks like Kodak's venerable Tri-X and Ilford HP5 demonstrate substantial reciprocity failure. When the reciprocity failure is determined for each film stock, it can be compensated for with additional exposure, either by opening the lens aperture or by increasing the time even more. This variation from film to film and from one exposure time to the next makes it difficult to precisely calculate exposures. Fortunately, modest exposure miscalculations are not usually a big problem. For example, if the correct exposure is 20 minutes and you over- or underexpose by 10 minutes, it is only half a stop, which is not enough to ruin the shot. It is more important to expose your film accurately with shorter exposures, but shorter exposures suffer less from reciprocity failure and can usually be bracketed to compensate for error. Reciprocity failure does allow for extremely long exposures, and in some circumstances you may want to do an all-night exposure for long star trails or simply to capture a long period of time in a single image.

WHICH FILM TO USE?

Almost any film can be used for night photography, but understanding a film's characteristics can increase the chances of success. This should be fairly evident after viewing the reciprocity failure table on page 81. The cost difference between professional and consumer films is negligible, and professional films are more likely to be fresher and stored properly by the vendor. Additionally, consumer films tend to be higher in contrast and are not always manufactured to the same exacting tolerances as pro films. For transparency films, Fuji Provia F is an excellent choice, as are Kodak's and Fuji's ISO 64 tungsten-balanced films. My own preference is for Kodak 64T because I like the way it renders colors at night. For color negative films, both Kodak and Fuji make excellent ISO 160 and ISO 400 films in two versions. Kodak VC and Fuji C have lots of contrast and saturation and are designed for commercial work. Kodak NC and Fuji S are lower contrast versions designed for portrait and wedding work. Kodak NC and Fuji S are better suited for night photography in artificially lit environments.

There are many black and white films to choose from, but since 2001 I've used Fuji Neopan Acros exclusively. This film has the least reciprocity failure of any film, requiring only a half stop of exposure compensation for an indicated exposure of 15 minutes. It has extremely fine grain and very little base fog, which makes for shorter printing times in the darkroom. It can be developed in a wide variety of developers, including Diafine, which is discussed in the upcoming sections on

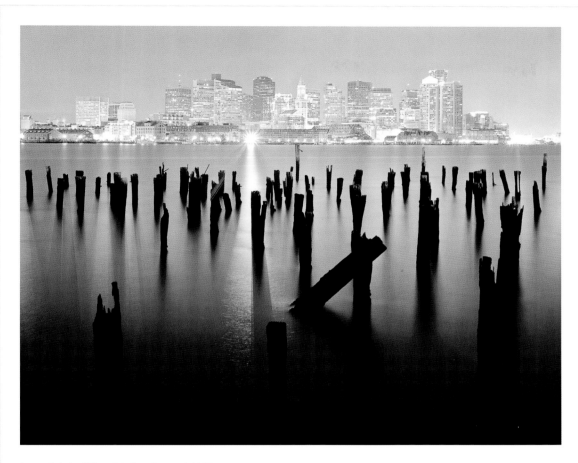

Lance Keimig, "Maverick, East Boston," 2008

This image of the Boston skyline is shot from East Boston. Ebony 23SW camera, Nikkor M 105 mm f3.5 lens. About 20 minutes at f16. Fuji Neopan Acros developed in Diafine.

film development. Kodak T-Max and Ilford Delta films are also good choices, but both require more exposure because of reciprocity failure. Kodak Tri-X and Ilford HP5 both produce excellent quality negatives but suffer from so much reciprocity failure that for longer exposures, these 400 speed films actually require longer exposures than the newer 100 speed films.

DETERMINING EXPOSURE

There are basically two approaches to determining exposure at night. The first is to try to gauge the exposure, using a meter when possible, and then add on a correction for reciprocity failure based on the film manufacturer's recommendations for the exposure length. The second

method is to simply estimate the exposure based on past experiences from similar situations, and consider reciprocity failure, film development, and lighting levels all at once. The second method is probably easier and works surprisingly well if you know the characteristics of your chosen film. For this reason, it is a good idea to pick one film and work with it exclusively to develop a good understanding of how it responds to long exposures. Consistent film processing is also critical, so try to use the same lab for all your color film, and if you develop your own black and white film, make sure to use the same developer under the same conditions each time. There are many variables in black and white film processing, and inconsistent timing, temperature, developer dilution, or agitation during development will have a dramatic effect on your results.

It is also important to keep a record of exposures and lighting conditions, and then compare them with your developed negatives. The photographer who keeps good notes and references them for future shoots will obviously have a higher success rate than one who makes random guesses at exposures and changes films based on what's handy. In short, there is a reasonable compromise between a systematic and organized approach and being so regimented as to take all of the fun and spontaneity out of night photography.

Determining night exposures without the advantage of an image preview and histogram is difficult for three reasons. First, in urban situations with many light sources in the frame, the camera meter is fooled into thinking the scene is brighter than it actually is by the small, bright points of light. Meters work by averaging all of the tones in the scene to middle gray, and light sources in the shot disproportionally raise the tonal average, causing the camera to underexpose. Second, light meters cannot compensate for reciprocity failure, which also results in underexposure. If you are establishing your exposure by metering, it is important to adjust the exposure to account for reciprocity failure after taking the meter reading. Third, most light meters are not sensitive enough to function in darker areas that are mainly illuminated by moonlight or starlight. There are a few handheld meters that can measure the light of the full moon, but they still do not account for reciprocity failure. In general, light meters tend to underexpose in areas with artificial lighting and usually don't work at all in very dark environments. More often than not, you'll be better off figuring out your exposures without the aid of your camera's meter, although it can serve as a starting point if you know how to interpret what it's telling you.

One way to determine exposures at night without a light meter is to divide different nighttime lighting scenarios into categories, do some exposure testing, and make a table to carry in your camera bag for future reference. There are a few basic situations commonly found at night, and although they may vary from region to region, a few general categorizations can provide

FILM EXPOSURE TIMES AT F8 IN DIFFERENT LIGHTING SITUATIONS

Film	Bright street scene/ lights in shot	Average street scene/ no lights in shot	Dark urban area	Moonlight within 1 day of full moon
Kodak 64T, Fuji T64	3 sec, 6 sec, 15 sec N-1 processing	5 sec, 10 sec, 20 sec N-1 processing	2 min, 4 min, 10 min N-1 processing	20–30 min
Provia F, Ektachrome 100	2 sec, 4 sec, 10 sec N-1 processing	3 sec, 6 sec, 15 sec N-1 processing	1 min, 2 min, 5 min N-1 processing	12–20 min
Fuji Neopan Acros 100	1 sec, 3 sec, 10 sec Compensating development	3 sec, 6 sec, 15 sec Compensating or 1:3 development	1 min, 3 min, 9 min 1:2 development	10–15 min
T-Max, Delta 100	1 sec, 4 sec, 10 sec Compensating development	4 sec, 10 sec, 20 sec Compensating or 1:3 development	2 min, 6 min 1:2 development	8–12 min
ASA 160 color neg	1 sec, 4 sec	2 sec, 10 sec	1 min–4 min	10–15 min
ASA 400 color neg	1/2 sec, 2 sec	1 sec, 4 sec	30 sec–2 min	6–10 min
Tri-X, HP5	2 sec, 5 sec, 40 sec Compensating development	10 sec, 30 sec, 2 min Compensating or 1:3 development	5 min, 15 min 1:2 development	30–60 min
T-Max, Delta 400	1/4 sec, 1/2 sec, 2 sec Compensating or 1:3 development	1 sec, 2 sec, 6 sec Compensating or 1:3 development	30 sec, 1 min, 4 min 1:2 development	8–12 min

reasonable starting points that can be fine tuned with experience. This system, developed and taught by Steve Harper in the 1980s, has proven to be reliable over many years of use. I revised and modified Steve's guide many times over the years as films changed and my developing habits matured. The following table can be used as is, but you should adapt it to your own shooting style based on your experiences and film choices. The multiple exposure times are suggestions for bracketing, which is discussed next.

A FRAME OF REFERENCE FOR BRACKETING

As mentioned in Chapter 3, it is helpful to have at least one fixed point on which to base your exposure, and maintaining a constant aperture serves that purpose well. There is no shutter speed or exposure time that will work in every situation, so selecting one aperture that gives you a reasonable depth of field with most lenses makes sense. I've always used f8 for 35 mm and f11 for 120 film because the larger film format requires a smaller aperture to achieve the same depth of field relative to 35 mm film. There are times a different aperture will be required to achieve more or less depth of field, but starting at f8 or f11 gives a familiar reference point to determine the exposure. The suggested exposure times in the previous table are all based on f8. You'll notice that these exposure times do not follow a linear progression and that the times for some films increase differently from others due to the varying reciprocity failure and latitude of each film. Because slide, color negative, and black and white film all have different latitudes and reciprocity characteristics, each type of film should be exposed and bracketed according to its nature. Bracketing is simply a means of taking a series of different exposures to have several to choose from. Films with narrow latitudes should be bracketed in small exposure increments of one stop or less, but more accommodating films can be bracketed in larger increments of 1½ to 2 stops.

It's wise to bracket transparency (E-6) film no more than one stop apart, plus an allowance for reciprocity failure. Transparency film is the most critical film to expose correctly, considering its narrow exposure latitude. If the middle exposure is the best one, you're doing a good job of estimating exposures. If not, make a note and adjust your table for the next time. In high-contrast situations, better results will be obtained by *pulling*, or underdeveloping, the film by one stop, which has the effect of restraining highlight development while allowing the darker areas to fully develop. This is indicated by asking for N-1 development from a professional photo lab. Minilabs and most mail-order facilities are not able to pull your film, so if you are going to go to the trouble of shooting slides, it is best to use a pro lab. Note that pulling transparency film adds a slight bluish cast to the images; in the case of urban night shots, this is usually a good thing. Because most urban areas are lit primarily with sodium vapor lighting, the blue color cast in the film will help counteract the overpowering orange of the sodium vapor.

Color negative films (C-41) have a much wider exposure latitude and are especially tolerant of overexposure. The table indicates two exposures for each lighting scenario for C-41 film, about 1½ to 2 stops apart. It does not make sense to bracket C-41 film in smaller increments because an exposure difference of less than 1½ stops will be barely noticeable. C-41 film does not respond well to underdevelopment, so pulling to lower contrast is not advisable. Both Kodak and Ilford make black and white C-41 process films, and these are great options for people who don't want to develop their own film. Kodak's version, BW400CN, has the characteristic orange base of color negative films and is best for printing on traditional color photo paper, the types used in

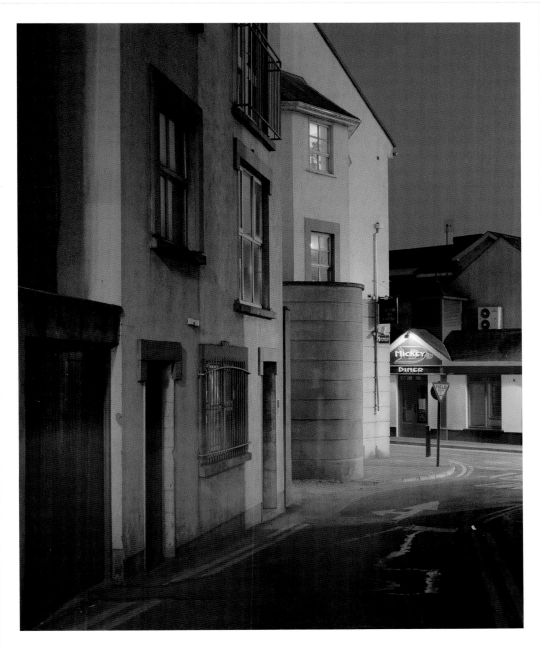

Lance Keimig, "Mickey D's," Ennis, Ireland, 2005

There are no McDonald's in Ennis, but there is a Mickey D's. This image was shot just as the last twilight was fading from the sky at 30 seconds, f11, on Fuji NPL. The rapidly fading blue light reflected off the windows,‡ contrasted with the glow of sodium vapor streetlights, is what drew my eye to this scene. The same image shot a few minutes later had a black sky, monochromatic yellow color, and super high contrast, and was much less interesting.

1-hour labs and drug stores. This is a convenient consumer-oriented film. Ilford's black and white C-41 film is quite different. It is intended to be printed in the darkroom on black and white photo papers and therefore lacks the orange base tint of color films. Both of these films feature the wide exposure latitude of C-41 film and the convenience of mechanized processing. Both films can be scanned and printed digitally.

BLACK AND WHITE FILM

Traditional black and white film and gelatin silver printing have a wide and delicate tonal range and are capable of producing images of extraordinary beauty. It is hard work and takes a long time to master the skills required to produce prints of real quality, but for those who make the effort, it is worth every minute. Black and white film is very versatile and can be manipulated in many ways to control the tonal range of the negative and, ultimately, the print. Each film has its own unique personality, and when it is matched with an equally pliable developer in just the right combination, the results can be breathtaking. The most important aspect of black and white film photography to come to terms with is that exposure and development are completely interdependent. Unlike color negative film, which is processed the same regardless of exposure or film sensitivity, black and white film development is customized based on the conditions of exposure and type and speed of the film. Perfectly exposed film is useless if it is not processed appropriately. The two primary variables affected by development are negative density and contrast.

It is a common mistake for novice photographers to want to *push*, or overdevelop, black and white film shot at night to increase density in the shadows, or least exposed areas of the negative. In low-light situations where it may not be possible to use a tripod, it is sometimes necessary to overdevelop the film to compensate for underexposure. This is basically an emergency technique that can be useful in certain situations. However, the overdevelopment works unevenly on different parts of the negative, favoring the highlight areas that have more exposure to begin with. This increases the overall contrast, which of course is the opposite of what we want. The often repeated adage of "expose for the shadows and develop for the highlights" is the key to good black and white negatives. In essence, this means you should overexpose and underdevelop your black and white film. In the following pages, we will look at several ways of doing just that. Important considerations are finding the right film and developer combination, finding the right amount of exposure, and which variable(s) to adjust to restrict the development process.

CONTROLLING CONTRAST THROUGH EXPOSURE AND DEVELOPMENT

Photographers who employ Ansel Adams's Zone System use a spot meter to measure the light of both the shadows and highlights of a scene, base the exposure on maintaining shadow detail, and then develop the film to preserve highlight detail. If the contrast range is too great,

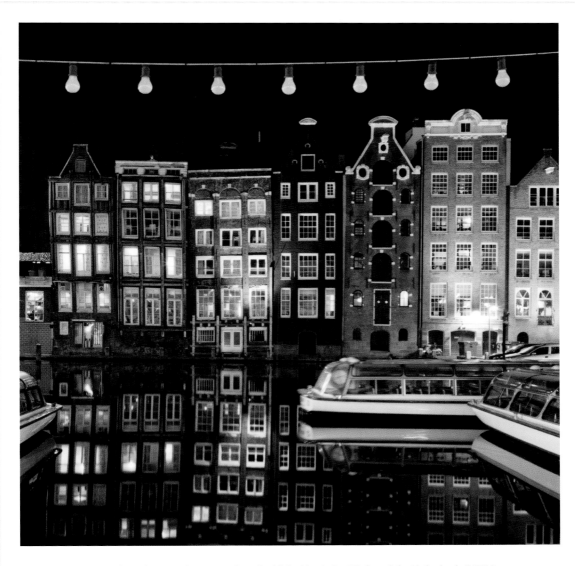

Lance Keimig, "Amsterdam, the Damrak, 11 p.m., Saturday Night After Ireland Defeated the Netherlands," 2004

I had been contemplating this shot for a week but did not get around to taking it until my last night in the city. You'd never know it from the photo, but there were thousands of people milling about when this photograph was taken. Amsterdam is a party town; bring together the perfect storm of a football match, Saturday night, beer, and Irish footballers, and there's bound to be mayhem. Unfortunately for me, to get the shot I had to set up my view camera in the middle of the sidewalk on Amsterdam's busiest street. Each one of the 11 exposures I made were the longest 5 minutes of my life. It took 11 attempts before I managed to get an exposure where somebody did not kick my tripod, jump up and down in front of the camera insisting on being in the photograph, or threaten to throw my camera in the canal if I didn't move it. Perseverance paid off, and I finally got the shot. It has been one of my most popular images ever since. Shot with an Ebony 23SW camera and Nikkor 65 mm f4 lens, 5 minutes at f16. Fuji Neopan Acros film developed in Xtol 1:3.

the development is modified to produce a more printable negative. If you have ever seen an original Adams print, it is obvious that his system works quite well, but it is not so easy to apply to night photography, especially when the shadow areas are usually too dark to be measured. Using the Zone System also requires real dedication. Film testing, record keeping, and system calibration require more time than most people are willing to spend. The Zone System is best suited for large-format photographers whose individual sheets of film can be processed one at a time.

Zone System photographers reduce negative contrast by overexposing the film by one, two, or three stops and then reducing the development time by 15 percent for each stop of overexposure. This is the technique described as *pulling* in the discussion of E-6 film, but where transparency film can only be pulled by a maximum of 1½ stops, black and white film can be pulled up to 3 stops. Development shouldn't be reduced by more than 45 percent of the base time to avoid film that is streaked and unevenly developed. If you can reasonably approximate the exposure and then bracket around that exposure to ensure that you have different options to work with, this part of the Zone System can be utilized even without being able to meter. This technique has two major limitations, however; the film can only be pulled by three stops, and the entire roll of film must be processed the same way. There are frequent situations when three stops of contrast compression will not be adequate, so pulling film is not appropriate for the most contrasty scenes. This second limitation applies to all methods of contrast control through development modifications, so care should be taken to ensure that everything on the roll has a similar contrast range. Sometimes it is worth sacrificing a half roll of film by pulling it out of the camera before it is finished if the next shot to be taken has significantly different contrast from the previous shot. For this reason, some photographers choose to roll their own film in short rolls of 10 to 20 exposures from hundred-foot bulk rolls of film. Medium format films are convenient in that they allow for a relatively small number of exposures.

In addition to reducing development time, contrast can be controlled by increasing the dilution of the developer and by limiting agitation during development. A diluted developer favors the less exposed parts of the negative, which requires less chemical energy to be fully developed. The purpose of agitation during film development is to bring fresh chemistry into contact with the film emulsion because only the chemistry that immediately surrounds the film has any affect on it. Again, the highly exposed parts of the film have a huge appetite for developer, so reducing agitation during the development stage of processing is essentially putting the highlights on a diet while the less exposed, or thinner, parts of the image continue to slowly develop with the available chemistry. The highlight areas rapidly exhaust the adjacent chemistry, and the shadow areas consume it more slowly. This method of contrast control can be used with most developers, but my own preference is for Kodak Xtol developer because it is less toxic to the environment than most developers.

Katherine Moxhet, "Mouse's View," Boston, Massachusetts, 2007

"Mouse's View" was taken below Boston's Southeast Expressway on a hot summer night. The extreme low angle of the image makes the shot, and it was achieved by forgoing the tripod and placing the camera on a granite ledge. In this case, if Moxhet had not forgotten her tripod quick-release plate, the image would be quite different. Sometimes absentmindedness can work in one's favor! Yashica Mat-124 G, Fuji Neopan Acros 100, exposure unrecorded.

The accompanying table lists diluted development recommendations for Xtol and D-76 developers for several films. All of the development times listed here assume exposure based on the table on page 85. Agitate for the first 30 seconds, then do four or five inversions every 2 minutes for the remainder of the time, and use a temperature of 21C (70F) for all developer - film combinations.

Pyro developers are another highly effective way to reduce negative contrast, but this chemistry is highly toxic to both humans and the environment and needs to be handled with extreme

DILUTED DEVELOPMENT RECOMMENDATIONS

21C (70F)	D-76 1:2	D-76 1:3	Xtol 1:2	Xtol 1:3
Fuji Neopan Acros	13 min	17 min	12 min	14 min
Kodak T-Max 100	12 min	15 min	10.5 min	13.5 min
Ilford Delta 100	11 min	15 min	10 min	12 min
Ilford HP5	12.5 min	14 min	12.5 min	14.5 min
Kodak Tri-X	12 min	13 min	10 min	12 min
Ilford Delta 400	14 min	18 min	13 min	15 min
Kodak T-Max 400	12 min	15 min	11.5 min	14 min

care. I recommend avoiding this type of chemistry altogether, but if you choose to pursue it, lab-quality ventilation, a respirator, goggles, nonporous gloves, and other safety equipment are required. If you wish to explore the use of pyro development, read *The Book of Pyro* by Gordon Hutchings.

DIVIDED DEVELOPERS

My preferred method for reducing contrast in black and white negatives is the use of a two-bath, or divided, developer. Divided developers work either by separating the developing agent completely from the accelerator or, more commonly, by partially developing the film in the first bath and then allowing the shadow areas to continue to develop in a second alkali bath. Because the second bath does not contain any developing agents, only developer that has been absorbed by the emulsion in the first bath can have any affect on the film. As with the dilute developer and minimal agitation method, the chemistry working on the shadow areas continues to work after the developer in the highlights is exhausted. Two bath developers have been around for a long time but are not widely used because, with one exception, they must be mixed from scratch. The commercially available divided developer is called Diafine, and it is a truly remarkable product. Not only does it restrain highlight development for lower contrast negatives, but the same times are used for all films, and it is not greatly affected by variations in temperature. This makes Diafine

Lance Keimig, "Totem Pole and Picket Fence," Ocean Beach, San Francisco, 2001

The strange juxtaposition of the totem pole, the picket fence, and the ocean was just too good to pass up. The square format makes for a simple and elegant composition. Hasselblad 500C/M, 80 mm f2.8 lens, exposure unrecorded. Ilford HP5 film, developed in Diafine. There is plenty of detail in both the shadows and highlights.

extremely easy to use and convenient. Diafine is also very stable and has an unusually long shelf life. While most developers oxidize within a month or two of being mixed and become unusable, Diafine can be used up to 2 years after mixing without a noticeable deterioration in negative quality.

The instructions on the Diafine package call for 3 minutes in each solution, except for Fuji Neopan Acros, for which 4 minutes is suggested. However, I find 3 minutes to be adequate for the way I expose this film. Some development does take place in the first solution, and leaving it in part A too long can negate the compensating effect of this developer. Different films can be developed together in Diafine because the timing is essentially the same for every film. Unlike other developers, the temperature is not critical, and anything between 68F and 80F can be used. The instructions also stress gentle agitation, but being too gentle can lead to unevenly developed film. I find four or five inversions per minute to be sufficient. With such a short time in each solution, it is especially important to tap the developing tank to dislodge air bubbles when setting it down after agitation because bubbles trapped against the film by the reel will lead to underdeveloped spots on the film.

With a little bit of care, Diafine will give excellent results for any film shot under moderate to very high contrast situations. It is not the best developer for films shot under low contrast situations. I don't recommend it for moonlit landscapes, which can usually be processed with normal film development. As long as Diafine is commercially available, it is probably the best option for most people who want to use a divided developer. For those who would like to experiment with homemade divided developers, please see the following tables that give the formulas for four different divided developers, including an approximation of Diafine. All of these developers have some alkali in the first solution (sodium sulfite or bisulfite) and will begin to develop in the first bath. It will take some testing to determine which times, temperature, and agitation will give you the best results based on your film and shooting style. Three or 4 minutes in each solution with four or five inversions per minute at 70F is a good starting point for all of them. After these developers are used, they can all be returned to the original container with the unused portion and reused for a total of 12–15 rolls per liter of solution. You should use warm distilled water to mix these developers for best results; stir continuously until all chemistry is dissolved, and mix at least 12 hours before using. Note that solutions mixed from scratch will not be as stable or long lasting as Diafine, which will develop about 20 rolls per liter. Replenishing or replacing part B of all these developers with fresh chemistry after 10 rolls will double their useful lives.

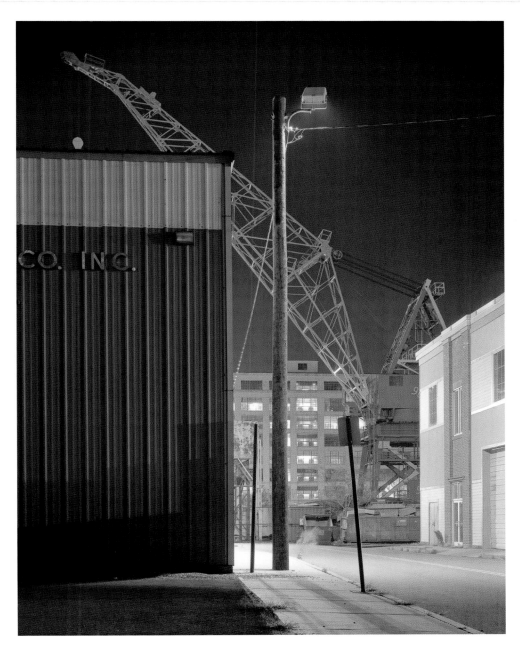

Lance Keimig, "Crane," South Boston, 2008

This scene in South Boston is a complex arrangement of lines, shapes, and tones. The combination of perfect exposure and development holds it all together. Note the detail in the building windows. Ebony 23SW camera with a Nikkor 65 mm f4 lens. Exposure unrecorded at f11. Fuji Neopan Acros film developed in Diafine. After a while, it is fairly easy to guesstimate good exposures at night. Brassaï is said to have timed his exposures by the length of time it took him to smoke a cigarette.

The Stöckler formula has the least contrast of all four divided developer formulas.

The Barry Thornton formula is a slightly More active developer.

The Ansel Adams D-23 formula is the most active of the three Metol-based developers.

The Diafine substitute formula is an approximation of the proprietary Diafine recipe. It gives similar results, but the formula is not as long lasting as the commercial formula. Note that the primary developing agent is hydroquinone, not Metol. The tiny quantity of Phenidone is important

STÖCKLER FORMULA
FOUR MINUTES IN EACH SOLUTION AT ABOUT 21C (70F)

Solution A	Grams	Solution B	Grams
Metol	5	Borax	10
Sodium sulfite	100		
Water to make	1 liter	Water to make	1 liter

BARRY THORNTON FORMULA
FOUR MINUTES IN EACH SOLUTION AT ABOUT 21C (70F) FOR ROLL FILM; FIVE MINUTES FOR SHEET FILM

Solution A	Grams	Solution B	Grams
Metol	6.25	Sodium metaborate	12
Sodium sulfite	85		
Water to make	1 liter	Water to make	1 liter

and makes all the difference with this developer. If you do not have a scale accurate enough to measure 0.2 grams, a concentrate solution can be made with 2 grams of Phenidone, 6 grams of sodium bisulfite as a preservative, and water to make 1 liter. Use 100 ml of this solution to make 1 liter of the Diafine recipe. As long as Diafine is available, it makes more sense to use the commercial formula.

ANSEL ADAMS D-23 FORMULA

THREE MINUTES IN EACH SOLUTION AT ABOUT 21C (70F) FOR ROLL FILM; FOUR MINUTES FOR SHEET FILM

Solution A	Grams	Solution B	Grams
Metol	7.5	Sodium metaborate	10
Sodium sulfite	100		
Water to make	1 liter	Water to make	1 liter

DIAFINE SUBSTITUTE FORMULA

THREE MINUTES IN EACH SOLUTION AT ABOUT 21C (70F)

Solution A	Grams	Solution B	Grams
Hydroquinone	6	Sodium sulfite	65
Sodium bisulfite	6	Sodium metaborate	20
Sodium sulfite	35		
Phenidone	0.2		
Water to make	1 liter	Water to make	1 liter

to capture extraordinary detail in darker areas and retain extreme highlights, conveying depth. Contrast control is an important consideration with night shooting because of the inherent high contrast situations, especially in the urban areas where I typically shoot.

I almost always shoot in color because I enjoy the balance and interplay of the different colors of modern industrial lighting, such as sodium, mercury vapor, tungsten, fluorescent, and other high-discharge lamps. My goal is to get the most perfectly exposed transparency or negative as possible using color correction or split neutral density filters at the time of the exposure. Viewing a perfectly exposed LF transparency on a light box is a reward in itself, knowing you have honed your skills as a photographer, but it also has a practical value. It lets the professional printer know your intention and previsualization for color and density, and thus it makes scanning and printing the film much easier.

LF gives more ability to adjust perspective. It was a logical step for me to take view cameras out at night. With the massive industrial and architectural structures that I shoot, LF enables me to correct for the vertical keystone effect (the structures appearing to lean in at the top as the camera is tilted upward). Also, with the movement capabilities of the view camera, one can change the linear perspective of an image. I use these movements frequently, rarely using the camera without adjustments.

At the time of this writing, scanning backs are only available for 4×5 cameras. They are different than the sensor in a DSLR in that they use a scanning head the moves back and forth during the exposure (like a typical flatbed scanner). They work fine for stationary objects and with short exposures, but they don't work well with any sort of movement in the image during a time exposure, such as star trails, clouds, or moving leaves at night. Therefore, I still shoot sheet film, both transparency and negative, in 4×5 and sometimes 8×10.

I have my transparencies and negatives scanned to be able to make prints as large as 30×40 inches. All fine tuning of density and color balance, manipulations such as traditional dodging and burning, and the removal of dust spots and the like are done in-house with Photoshop. I rarely need to do any other Photoshop work. The final image file is then sent to a photo lab for printing. My computer monitors are calibrated with the photo lab's to ensure color accuracy in the print. This final digital file is kept on file at both my office and the lab for future prints, as needed.

When shooting at night, I typically take fewer exposures than during the day because of the longer exposures. Working with an LF camera is a deliberate and methodical process. It makes you slow down and compose the image carefully. I find the LF process Zen-like when studying the scene, picking the correct lens and exposure, making perspective adjustments, etc. Changing

Tom Paiva, "Chemical Plant #5," 2009

This image, taken in a chemical plant in Long Beach, California, was made with available light. The green in the foreground is from a clear mercury vapor lamp high overhead. This lamp is so green that I chose to use a magenta filter on the lens to balance some of the green in the image. This turned the sky a mustard yellow, but there was still plenty of green in the foreground. I was able to turn off the lamp on the right (a lucky option that is not usually available). This image looks just like the original transparency. 4 × 5 camera, 90 mm lens, 8 minutes at f16, CC30M filter, Kodak E100VS transparency film.

Tom Paiva, "Water Tanks," 2009

This is an available-light image and a study in mixed lighting that I shot in Colusa, California. I chose Fuji NPL for its long tonal scale to save the deep shadows and preserve the highlights. It is shot in 4 × 5 with 2 inches of front rise to make the tanks appear as massive as they are. The lights on the bottom of the tanks reflect the different light sources in the area. 4 × 5 camera, 90 mm lens, 30 minutes at f11, Fuji NPL color negative film.

the camera position just a few inches can make the difference between a mediocre image and an iconic one.

With LF photography, there is a trade-off because of having to carry a somewhat cumbersome camera when shooting on location. There is also the need to bring a handheld light meter, view a dim ground glass, and carry and load film holders in the field. Most of the time I do not find this restrictive because I frequently work within a few feet of my car. When I pack for travel, I carry a lighter tripod and use QuickLoads or Readyloads (prepackaged, light-tight individual sheets of film), which frees me from having to carry heavy film holders. Often my camera bags weigh less than the bags of some digital photographers because I think through every aspect of minimizing bulk and weight.

In the final analysis, the value of LF is in its ability to go to large prints. Masters like Ansel Adams, Walker Evans, and Edward Weston all used large format view cameras. Contemporary photographers Joel Meyerowitz, Stephen Shore, Joel Sternfeld, and Richard Misrach still shoot 8 × 10 in color, and much of Misrach's and Meyerowitz's work is shot at night. When you see the extraordinary detail and tonality of their large prints at a gallery or museum, the advantages of the LF negative become obvious.

In the end, it all comes down to the final image, regardless of whether it was shot with a modern camera or an older one and regardless of the format—film or digital capture. The LF camera gives me the perspective control, subtle tones, extreme resolution, and quality that I demand in an image, especially for a large print.

DIGITAL CAPTURE

5

DOI: 10.1016/B978-0-240-81258-8.00005-3

Photographing at night using digital cameras has four main advantages over film-based night photography. First, the camera's image preview reveals whether or not you have composed the image as intended and gives you the opportunity to adjust the framing and improve the composition. Second, the histogram provides valuable information about the exposure and dynamic range of the scene. The third advantage is that digital cameras do not suffer from reciprocity failure, which makes long exposures shorter than they would be on film and allows for high-ISO testing in moonlight conditions. Finally, with high-end professional DSLRs it is now possible to shoot at very high ISOs and render stars as points of light rather than the trails of light that are recorded in long exposures. Shooting at a high ISO also presents the opportunity to use short exposures to photograph people without added light in relatively bright night environments. The biggest disadvantage of digital night photography is the potential for noise, which makes it difficult to do extremely long exposures. In this chapter, we'll learn how to optimize the exposure and minimize noise for the best image quality, and we'll establish the preferred camera settings and features for night photography.

OPTIMAL EXPOSURE

There is an old adage in black and white film-based photography that says "expose for the shadows and develop for the highlights." The idea is to have as much information in the shadows as you can by giving the maximum exposure that allows you to recover important highlight detail in development. By overexposing the film in-camera and then chemically restricting the development of the highlights, it is possible to compress a high-contrast scene and record it so that it can be printed with full detail in the darkroom. In essence, optimal exposure for digital photography follows a similar principle. The ideal RAW file pushes the histogram to the right where the sensor is tonally rich. Such an exposure will probably appear overly bright straight from the camera, but it will have the information necessary to make a quality print. A RAW file is like a film negative—it contains a wealth of information that can be interpreted in many different ways. The great advantage of RAW files over film is that they can be preserved in their original form

Lance Keimig, "Terlingua," 2009

indefinitely and reinterpreted at any time. As you become more proficient working with your chosen software, or as that software improves in future versions, the original RAW file will always be available for you to work with.

The single most important technical aspect of digital night photography is optimizing the exposure for RAW capture and development. There is certainly much more to successful night photography than technical perfection, but having the best possible exposure will provide you with the most artistic freedom and creative control to interpret the image according to your vision. An optimal RAW file contains the maximum possible ratio of image information (signal) to data that is an unwanted by-product of capture and processing (noise). This is known as the signal to noise ratio (SNR). Noise is inherent to all electrical processes, including digital photography, and it can distort or block the signal (your image). To achieve the highest quality image, you need to achieve the highest possible SNR. Providing the sensor with the greatest possible exposure without clipping important highlights is the way to ensure the best SNR.

THE CAMERA SENSOR

Digital photography is a complex process, and of course it is not necessary to understand how a camera works to use it. However, a basic understanding of how photons of light passing through a lens and falling on a digital sensor is translated into a photograph will clarify the concept of optimal exposure. Your camera's sensor is an array of millions of pixels (1 megapixel = 1 million pixels). Each pixel has photosites that collect and store photons of light during an exposure. These photons accumulate during an exposure, and some photosites catch many photons and become saturated. These saturated photosites become the highlights of the image. Photosites that become so full that they overflow into surrounding areas cause a phenomenon known as sensor *blooming*, which is a problem that commonly occurs when light sources are included in an image. Some photosites catch only a few photons of light during the exposure, and these become the shadows. In deep shadow areas, noise can be confused with the signal data. The threshold of shadow detail is the point where background noise can be distinguished from signal data.

RAW files concentrate information in the highlight values of the images. Half of the total potential brightness levels or tones are located in the brightest stop of the camera's dynamic range. Half of the remaining potential tones are contained in the next brightest stop of dynamic range. The pattern repeats until the few remaining tones in the darkest levels become confused with the noise inherent in the sensor and detail is no longer distinguishable. Larger sensors with fewer megapixels can record a wider dynamic range with less noise than smaller, higher megapixel sensors.

HISTOGRAMS

A histogram is a graphic representation of a digital exposure. When reviewing images on the camera monitor, the histogram is enabled to provide additional information about the image and

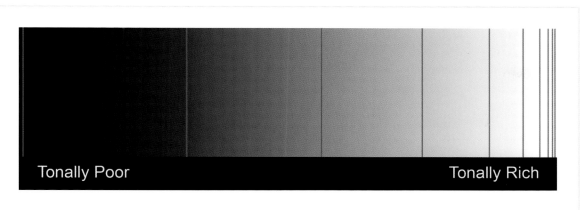

Tonally Poor Tonally Rich

Linear encoding

Linear encoding means that the camera sees a very dark image that has to be lightened a great deal for it to look normal to us humans. The effect is that most of the tonal information in a RAW file is concentrated in the highlight values. An image with lots of exposure can be darkened, redistributing some of that information into the shadow areas. This is great for night photography and leads to rich shadow detail and color. Conversely, lightening an underexposed image spreads data that was already thin over a wider area and will lead to poor image quality. The red lines in this image represent linear bit depth in the tonal range.

helps to determine if the exposure is adequate. It is an essential tool for the digital photographer and should be used faithfully if optimal image quality is important. Luminance, or light intensity, is expressed on the X (horizontal) axis of the histogram, and the Y (vertical) axis represents the relative quantity of light at any given intensity, that is, how much of each tone is present in the image. The histogram describes the tonal range of the image. Most cameras can display both a luminosity histogram that shows overall brightness and an RGB histogram that provides different mapping for each color channel. Both are useful, but in different ways. The luminosity histogram gives a better indication of overall exposure and whether or not there is any significant clipping in either shadows or highlights. The RGB histogram shows if there is color clipping in any of the red, green, or blue color channels. In most lighting situations, the luminosity histogram gives reliable exposure guidance, but at night when there are a variety of different light sources with very strong color casts, the RGB histogram is invaluable. It will indicate clipping in a single color channel that may go unnoticed with the luminosity histogram alone.

In addition to showing the tonal range of an image, a histogram can also describe dynamic range. A high-key image will have most of the information on the right side, and a low-key image will be bunched up to the left. A high-contrast image without many midtones will be shaped like a bowl, and a moderate-contrast image with no bright highlights or deep shadows might show a histogram that has a hump in the center, or a bell shape. An image where the distribution of shadows, midtones, and highlights is relatively even will display a histogram without many sharp peaks. When the histogram is touching, or pushed up against, the left side of the graph, this indicates underexposure and shadow clipping. When it is bunched up against the right side, there

is highlight clipping. Both are problematic and should be avoided whenever possible. Shadow clipping means there is not enough detail present in the shadows, and highlight clipping means that pixels have become pure white, hold no detail, and cannot be recovered. Highlight clipping can be especially hard to detect in the histogram because it may be represented by a very narrow spike against the right wall of the histogram. Shadow clipping is usually more obvious because there are usually larger volumes of dark tones to form a more distinct peak in the histogram. The histogram and image preview should always be considered together in the context of the scene being photographed because together they provide more information than either one alone.

THE FLASHING HIGHLIGHT INDICATOR

The histogram does not show *where* the image is clipped. The flashing highlight indicator function, also known as the *blinkies*, serves as a warning that highlights are being clipped, and it shows where they are. This feature should be enabled and used as an additional indication that there is highlight clipping somewhere in the image. The blinkies are overlaid on top of the image preview and show exactly which part of the image is clipped. Typically in night photographs, highlight clipping occurs when light sources are included in the scene. In this case, clipping is usually unavoidable. Highlight detail in light bulbs is not particularly important, but the blinkies will show if there is also clipping in the areas *surrounding* the light sources. If there is, you may want to reduce the exposure to preserve detail in this part of the image. Differentiating between important and unimportant highlight detail is a big part of determining optimal exposure.

The histograms and flashing highlight indicators are based on the JPEG preview of the image displayed on the monitor, not the RAW data itself. They are not 100 percent accurate but still provide the best gauge of exposure that we have. The preview image and histograms are also affected by picture styles and any custom functions that may be enabled, but RAW files are generally not affected if you use a third-party RAW converter like Aperture, Adobe Camera RAW (ACR), or Lightroom. When shooting in RAW mode, setting the picture style to neutral and disabling custom functions that affect the image, *other than* long-exposure noise reduction, will provide more accurate preview data. The picture style parameters include settings for sharpness, contrast, saturation, and tone, and they offer a way to customize the look of JPEG images in-camera. Canon Digital Photo Professional and Nikon Capture NX do recognize the actions of custom function settings, which are applied to the RAW files as metadata and executed when the file is opened on the computer.

DYNAMIC RANGE

Dynamic range is the ratio between the brightest and darkest tones. It can describe a scene, a capture device (such as a camera or a scanner), or a display (such as a computer monitor or a print). Tonal range describes the number of tones within the dynamic range. There could be many tones within a narrow dynamic range or relatively few tones within a wide dynamic range.

A greater tonal range means smoother color transitions, and a greater dynamic range means there is more difference between the brightest and darkest tones.

A camera's dynamic range spans the range of tones that a sensor can capture between saturation (when a pixel becomes pure white) and when texture is indistinguishable from background noise (which is almost, but not quite, black). A scene's dynamic range often exceeds the capability of the camera to record it, especially at night. Any time there are lights or specular highlights in the scene, it will have a large dynamic range. Making the determination of which highlights are important to preserve is critical to optimal exposure. If a scene that includes light sources is exposed to prevent all clipping, the remainder of the image will be so underexposed that there will be significant shadow clipping in the rest of the image. Underexposure and shadow clipping can dramatically increase noise and lower the SNR. In this situation, it is better to allow the light sources to clip and restrict the exposure just enough to prevent extensive sensor blooming around the clipped highlights. Sometimes the dynamic range of a scene can be reduced by recomposing to eliminate lights from the scene (Chapter 3), or sometimes multiple exposures and combining layers in Photoshop or HDR (Chapter 7) may be the best solution.

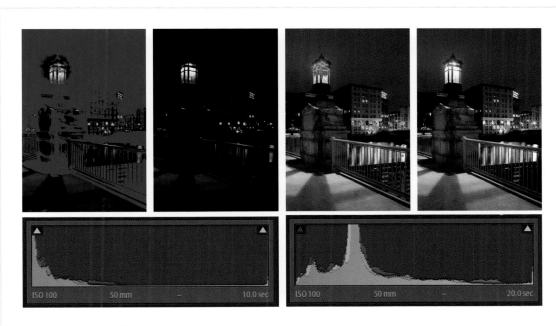

Unavoidable highlight clipping

In these images of the Congress Street Bridge in Boston, even a severely underexposed image like the one on the left has some highlight clipping. (Shadow clipping is shown in blue, and highlight clipping in red) The frame on the right has only one additional stop of exposure and has been processed in such a way that most of the important highlights are preserved. The light sources are still clipped after processing, but this is the best that can be achieved without combining multiple exposures. Any more exposure would have led to more significant blooming that could not be recovered.

EXPOSE TO THE RIGHT

Understanding histograms is paramount to successful digital photography, whether it be daytime or nighttime photography. Determining optimal exposure is based on an evaluation of luminosity and RGB histograms, the preview image, the flashing highlight indicator, and analysis of the scene based on experience. There is no such thing as an ideal or perfect histogram because it is simply a description of tones in an image. However, a right-biased histogram—one where the bulk of the data is on the right side—is more flexible and apt to make a better quality print. Camera meters provide an exposure reading based on 18 percent reflectance, assuming that all of the tones that make up the image will average out to middle gray. Exposing for middle gray probably yields the best exposure for JPEG shooters, but RAW files benefit from additional exposure. How much?

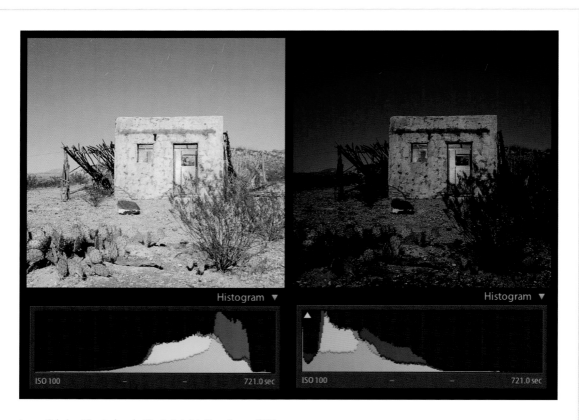

Lance Keimig, "Contrabando Movie Set," Lajitas, Texas, 2009

This image looks severely overexposed, but the histogram shows that it has the maximum possible exposure without highlight clipping. The exposure was reduced by a little more than 1½ stops in development. The overexposure ensures that the shadows are free of noise and full of detail. The frame on the left shows the image upon import into Lightroom, and the frame on the right shows the same image after development. Canon 5D, 28 mm Nikkor PC lens, 12 minutes at f8, with three pops of an orange-gelled flash inside the building.

An optimal RAW file is given as much exposure as possible, and the histogram is pushed as far to the right as possible, without clipping important highlights. A good deal of compromise is often required to balance the need for a right-biased histogram with the need to preserve highlights.

SET IMAGE QUALITY TO RAW

To produce the highest quality images possible, you'll need to set your camera to save RAW files rather than JPEGs. RAW files preserve all of the image data that the camera records. When an exposure is made, light falling on individual pixels, or photosites, is registered as a voltage level, which is then converted to either a 12- or 14-bit digital signal, depending on the camera circuitry. Cameras that record 14-bit files can express 2^{14} (16,384) potential tones, or brightness levels, per pixel. If the camera is set to save JPEG files, each pixel can represent 2^8 (256) different tones. The 14 bits of data in the capture file are compressed into 8 bits in the JPEG file. Having 16,384 brightness levels available to work with in an image is certainly preferable to 256 because it allows for more flexibility when the image is processed. It is a misnomer to say that a camera is set to shoot JPEGs because the camera always shoots, or captures, RAW image data. The difference lies in what happens to the data after it is captured. A camera set to RAW mode creates a tag for each image with camera settings (like white balance) and picture style settings (like contrast, sharpening, and saturation). This metadata does not actually change the image; it is like a set of instructions for the software used to open the RAW file.

Camera manufacturers' RAW converters, such as Nikon Capture NX or Canon Digital Photo Professional, will apply the picture style settings to the RAW file when it is opened. Third-party applications, like Adobe Camera Raw or Lightroom, will apply the white balance setting but ignore the picture styles. With RAW files, these settings are temporary until the image is saved as a TIFF, JPEG, PSD, or other type of rendered file. A camera set to JPEG mode applies these settings in-camera, permanently embedding them in the file. JPEG files are developed in-camera and compressed to save storage space. The files are ready to print directly from the camera. The compression method used by the JPEG compression algorithm is lossy, meaning that some original image information is lost and cannot be restored. In some situations, like news photos, image content takes priority over image quality, so JPEG files might be preferable to larger RAW files that must be processed before being printed. A RAW file can be compared to the latent image on a piece of film that has yet to be developed. Unlike a piece of film, a RAW file can always be preserved in its original form. Simply put, RAW files contain more data, are more malleable, and provide the photographer with more flexibility—especially to bring out shadow detail.

NATIVE ISO SETTINGS

Every camera has a native ISO setting that will produce the best images. For Canon and many other cameras, 100 is the native ISO. Most Nikons have a native ISO of 200, and Leica cameras have a native ISO of 160. Increasing the camera's ISO setting has a detrimental effect on image quality by lowering the ratio of image information relative to background noise. When a digital exposure is made, photons of light fall on the individual pixel sites or light wells in the sensor and

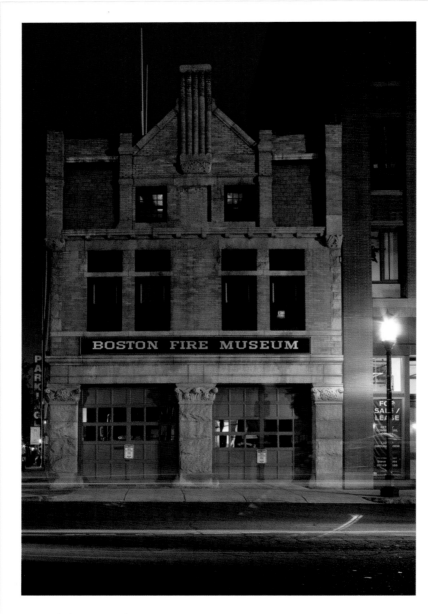

Lance Keimig, "Boston Fire Museum," 2009

Sometimes rules are meant to be broken. I was able to keep the overexposure from the streetlight to a minimum in this 10-second f8 exposure shot with a Canon 5D Mark II and Nikkor 28 mm PC lens. A car passed in front of the camera during the exposure, and rather than block the lens, I decided to let it go and see what happened. This shot looks much better than the other frames without the lights from the passing car. The PC lens allowed me to keep the vertical lines of the building parallel.

are converted to an electrical voltage by an amplifier. This analog voltage is then converted to a digital equivalent in the form of a number that represents a specific brightness level. At the native ISO setting, the analog input is directly converted to digital output. When the ISO setting is raised, the sensor does not become more sensitive. Instead, the analog signal is amplified, resulting in a brighter picture and more noise. Perhaps surprisingly, lowering the ISO below the native setting can also negatively impact image quality. The brightness values from the signal input are digitally reduced—halved in the case of switching from 200 to 100 or 100 to 50—and this permanent loss of information reduces the dynamic range of the sensor. Continually improving technology has brought significant improvements in image quality from higher ISO settings, but whenever possible, it is best to use the camera's native ISO setting.

WHITE BALANCE

White balance is the camera function that corrects for color variations in photographs due to varying types of light. Our eyes do a remarkable job accommodating different light sources, and we normally perceive white objects as white regardless of the lighting. DSLRs have a selection of white balance settings that includes an automatic selection (AWB), a setting that allows the user to set the color temperature on the Kelvin scale (K), and a custom setting that adjusts the white balance based on a white or gray card placed in front of the camera. There is a tungsten and generic fluorescent setting that adjusts the white balance both on the yellow–blue color temperature scale and on a second axis that ranges from green–magenta. The remaining white balance settings include daylight, flash, cloudy, and shade. The AWB setting works well in most natural and artificial light situations, but it is not completely reliable, especially in tungsten or mixed lighting environments. When multiple light sources are present, the AWB setting averages all of the light in a scene, which does not truly correct for any of the light sources. In situations where the multiple sources are separated in different parts of the image, it may be preferable to balance for one of them rather than use an average setting that does not fully correct for any of them.

It is true that the white balance can be easily adjusted in any RAW conversion software, but setting the white balance in-camera as close as possible to what you think it should be can provide useful information in the histogram. Light sources with strong color shifts will produce quite different RGB histograms at different white balance settings, although the luminosity histogram will not change significantly. This is important because there may be unrecognized single-channel color clipping with some white balance settings but not with others, even with the same exposure. For example, a street scene illuminated with sodium vapor lights will clip in the red channel first, and then in the green channel, but rarely in the blue channel unless there is massive overexposure. In these circumstances, there may be a good deal of clipping if the white balance is set to daylight, but none if it is set to tungsten. Because of the unusual lighting conditions encountered at night, it is often informative to do several test exposures with different white balance settings simply to get a sense of what the scene will look like.

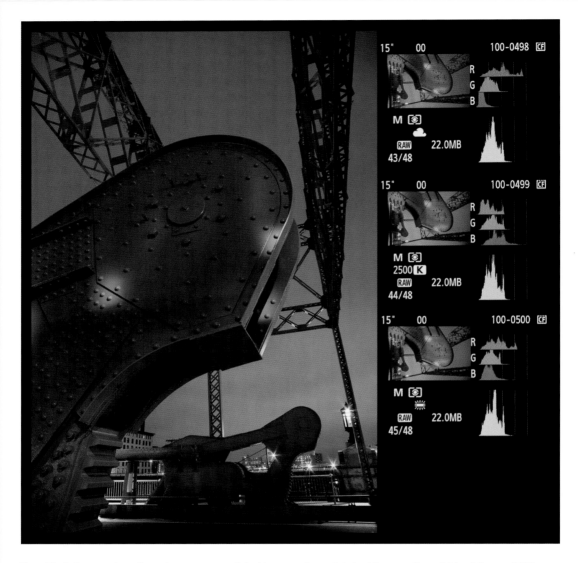

The white balance setting affects the appearance of the histogram. Lance Keimig, "Congress Street Bridge," Boston, 2009

The Congress Street Bridge in Boston was shot on a cloudy night with three different white balances to show the effect of white balance on the histogram. The top image was taken with the white balance set to shade, the middle exposure had the white balance set to 2500 K, and the bottom image was shot on the fluorescent white balance setting. The final image utilized the fluorescent exposure with hue, saturation, and luminance (HSL) adjustments to bring out the blue. Notice in the histograms that the green stays relatively unchanged, but the blue, and the red in particular, change dramatically with the white balance shift.

White balance can be a subjective choice in night photography. Removing all color casts may not be the ideal solution for a photograph, and in the case of mixed lighting situations, it may not be practical. Having the flexibility to tweak the white balance in postprocessing reiterates the need to shoot RAW images. Changing the white balance setting can completely change the mood of an image. Most of the time, there isn't a right or wrong white balance. There is a wide range that will give varying effects.

MINIMIZING NOISE AT THE SOURCE

Noise is unwanted information. It is a by-product of electrical processes that receive or transmit signals. Noise can have several sources and is present in all images to some degree. It can be independent of the image and therefore relatively easy to separate and remove, or it can be integral to the image, which makes it harder to deal with. Noise generally detracts from the image quality, but a small amount of noise can enhance apparent sharpness in a photograph. The best way to minimize noise is to eliminate it at the source. There are five key ways to minimize noise in night photographs. In the real world, you won't be able to use all of them, but if you are aware of the sources of noise, you can take measures to minimize it.

The main contributors to noise are the following:

- Small sensors: A full-frame sensor adds considerably to the cost of a DSLR, but it offers several distinct advantages, including noticeably less noise than cropped APS-C sensors. Although full-frame sensor cameras are beyond the budget of most amateur photographers, professionals and anyone intent on making large-scale prints should seriously consider a full-frame DSLR.
- High ISOs: Shooting at your camera's native ISO setting will probably have the greatest impact on noise levels. There are times when higher ISOs are called for, but the native setting should be used whenever possible.
- High ambient temperatures: Ambient temperature also has a definite influence on noise levels. The impact of temperature will vary from one camera model to the next, but the hotter it is, the more noise you will encounter in your images.
- Long exposures: Results vary widely by generational and price point differences in cameras, but regardless of which model you use, the longer the exposure, the more noise you'll see.
- Underexposure: Inadequate exposure will also increase noise levels, especially in the shadow areas (the least exposed part of the image). Noise stands out more in the shadows because there is less image detail to obscure it. Along with using native ISO, exposing for a right-biased histogram is the other controllable factor that will dramatically reduce noise levels in your images.

Most cameras seem to perform noticeably better at temperatures below about 50 F (10 C), but for the best results you should test your camera to determine the longest exposure your camera will tolerate at different temperatures. When factors like nonnative ISO and exposure length are combined with high temperatures, the noise gets exponentially worse.

One of the best and most overlooked ways to avoid noise in night photography is to utilize image stacking. Not only are the base frames cleaner due to their shorter exposures, but applying noise reduction to each of the frames, and possibly to the final combined image, can be quite effective. Image stacking leads to a far cleaner final product that can be worth the extra effort. There is no fixed exposure length when stacking shorter exposures becomes the best solution, and stacking won't work in every situation. In general, stacking is mostly used in very dark environments when exposure lengths are quite long. Images produced with only the earliest DSLR models will benefit from stacking exposures of less than 5 to 10 minutes. Because newer, high-end models should produce clean images at 30 minutes or longer, stacking is usually unnecessary with these cameras.

There are several sources of noise. Photon noise is the result of sampling error when the photons of light are converted to digital information. Photon noise is generally limited to the deep shadows and tends not to be a significant problem unless the shadow levels are greatly increased in postprocessing. Amplifier, or *readout*, noise is largely the result of higher ISO settings and is fairly predictable. Higher ISO settings artificially boost both the input signal and the inherent noise in an image, which is the trade-off in image quality for using higher ISOs. Random noise has many variables and is electrical in nature. Because it is unpredictable, random noise is the most difficult to remove. Fixed pattern noise, also known as *hot pixel noise*, is largely a factor of sensor imperfections, long exposures, and heat. Fixed pattern noise is relatively easy to remove from images because it is consistent from one photograph to the next if the exposure length and environmental conditions remain the same. Fixed pattern noise is specific to each individual camera, and thus in-camera long-exposure noise reduction (LENR) does a great job at reducing fixed pattern noise. Long exposures also generate some random noise, and LENR also helps to minimize it.

Noise manifests itself as chrominance noise (think colorful pixels) or as luminance noise (think black and white film grain). Although chrominance noise is universally considered to be a bad thing, luminance noise, in modest quantities, is not nearly as detrimental to an image. Chrominance noise is fairly easy to eliminate in postprocessing, but luminance noise can be harder to reduce because images tend to lose sharpness when it is removed. In postproduction, noise reduction can be applied during RAW file development and to final rendered files. We will discuss these options further in Chapter 6.

LONG-EXPOSURE NOISE REDUCTION

Long exposures can generate substantial noise that is exaggerated by high temperatures. Most of this noise is fixed pattern noise, and it is consistent from one exposure to the next in images of the same length taken in the same atmospheric conditions. Because the noise pattern is reproducible, it is relatively easy to separate from the image. In-camera LENR uses a technique

Noise resulting from heat. Lance Keimig, "Balanced Rock" Big Bend National Park, 2009

The inset shows severe noise resulting from the combination of a long exposure and high ambient temperature, even with LENR enabled. The ambient temperature was 105 F at 11 o'clock on a May night when this photo was taken at Grapevine Hills in Big Bend National Park. The noise is worse in the shadows, but even the brighter parts of the image and sky show both luminance and chrominance noise. The full image was processed to remove noise in Lightroom. Canon 5D, 14 mm f2.8 lens, 15 minutes at f8.

known as dark frame subtraction to remove noise. When it is enabled, LENR creates a dark frame after each exposure, which is essentially a second exposure of equal length, except that the shutter is not opened. The dark frame contains the same noise as the original exposure. The two frames are combined together, and the noise is subtracted from the image. This process results in a doubling of the exposure time, which can cut down on productivity in the field. With LENR enabled, a 10-minute exposure means that the camera is inoperable for about 20 minutes. LENR also has features that help to minimize random noise.

Most cameras have either an on or off option for LENR, but some have a third auto setting that analyzes the image on the fly and determines whether or not LENR is needed. It can be left on all the time, and it will be applied only when noise is detected. The performance of in-camera LENR varies from camera to camera, and whether or not to use it involves an evaluation of the trade-off between lost shooting time and improvements in the image. There is considerable debate about whether noise reduction is best achieved in-camera, in postproduction, or a combination of the two. Testing your own camera can facilitate making the decision of which approach to take. To do this, make a series of exposures of varying lengths from 1–30 minutes both with and without LENR, both in summer and winter. When you process the images in your RAW conversion software, you may find that you only need to use LENR over a certain temperature or exposure length and that postcapture software is adequate most of the time.

HIGH-ISO NOISE REDUCTION

Newer cameras also have an adjustable high-ISO noise reduction feature with several levels of noise reduction. RAW files are tagged with the high-ISO noise reduction data from the camera, but only the camera manufacturer's proprietary software will recognize the tags. This metadata will be applied as a default setting when you open an image in Capture NX or Digital Photo Professional, but it can be overridden by utilizing the adjustment sliders. Those using third-party applications, like ACR or Lightroom, will not notice any difference in RAW files shot with high-ISO noise reduction. ACR, Lightroom, or other RAW converters will apply their own defaults regardless of camera metadata.

HIGHLIGHT TONE PRIORITY, AUTO LIGHTING OPTIMIZER, D-LIGHTING, AND PICTURE STYLES

Canon and Nikon offer features that aim to expand dynamic range with a combination of exposure modification and in-camera processing. Canon's Auto Lighting Optimizer function and Nikon's D-Lighting are designed to boost underexposed areas in backlit images with a wide dynamic range. Canon's Highlight Tone Priority restricts the exposure to preserve highlight detail and applies processing to further enhance the image.

Lance Keimig, "Welcome Amigos," Terlingua, Texas, 2009
This smartly painted little building marked the entrance to a trailer park in Terlingua, Texas. The other side was painted with a sombrero-wearing chili pepper and said "Welcome Amigos!" Canon 5D, 50 mm f3.5 macro lens, 9 minutes, f8. A small amount of light was added to the building with a flashlight from off to the side and out of the frame.

These features are useful primarily for JPEG shooters—not for night photographers who *always* shoot RAW files. As with high-ISO noise reduction, RAW files are tagged, but only the camera manufacturer's software will recognize the tags. One thing that may not be obvious is that the image preview on the back of the camera does not represent the RAW data. It is processed JPEG, with all activated camera settings reflected in the image. If you have D-Lighting or Highlight Tone Priority activated, you'll see the effect in the preview image but not necessarily in the RAW file.

OTHER CAMERA SETTINGS

Every camera has a different set of features and functions, and choosing which camera settings to use is a matter of personal preference and working methods. Spending some time familiarizing yourself with your own camera's functions, and how to access them can increase both the efficiency and enjoyment of your shooting experience.

Exposure Mode

Exposure mode is normally set to either manual (for exposures up to 30 seconds) or bulb (for exposures longer than 30 seconds). Unfortunately, camera manufacturers do not program shutter speeds longer than 30 seconds, and auxiliary timed releases are required for long exposures. Manual and bulb modes give full control of both aperture and shutter speed to the photographer and are simpler and more efficient than aperture or shutter priority modes that often need to be overridden with exposure compensation. Many midrange and almost all professional cameras offer at least one custom exposure mode that allows the user to program frequently used combinations of settings. Custom modes are extremely useful because they allow you to save and quickly switch to your night photography settings. It is especially helpful to have multiple custom modes because one can be set for high-ISO testing, one for moonlight conditions, and one for urban nighttime environments. The main difference between moonlight and urban settings would be the white balance, and perhaps manual exposure mode would be used for urban environments where exposures tend to be shorter, and bulb exposure mode would be used for moonlight.

Live View

Live view is a terrific focusing feature, as discussed in Chapter 3, and should be employed for critical focusing when possible. It does consume considerable battery power, so it is best to turn it on only when focusing rather than leave it on continuously.

Mirror Lockup

Mirror lockup is one of the few features that has carried over from film cameras. It is occasionally useful in low-light photography but is generally not necessary at night. When mirror lockup is enabled, the mirror used to reflect the image through the prism and into the viewfinder is flipped up out of the image pathway in advance of the shutter. This reduces vibrations from the movement of the mirror, which can result in a loss of image sharpness. Mirror lockup is useful for exposures ranging from about {1/15} of a second to 2 seconds, especially with telephoto lenses or images focused at macro distances. It is unnecessary for exposures longer than 1 or 2 seconds.

LCD Brightness

The LCD brightness is set to medium on most cameras by default. In low-light conditions, it is best to turn the LCD brightness down 1–3 levels. While you will be judging your exposures primarily by reading the camera's histogram, it is easy to be fooled by an overly bright image preview. The appearance of the image on the LCD is relative to ambient illumination. An image that looks well exposed in-camera in the moonlight may turn out to be grossly underexposed when loaded into a RAW converter. Turning down the LCD brightness also saves battery power for more exposures. The LCD screen is the single largest consumer of battery power, and turning down the brightness makes a big difference in how long the battery will last.

CAMERA SETTINGS FOR NIGHT PHOTOGRAPHY

- RAW: Use the RAW mode instead of JPEG to preserve the maximum amount of data.
- Native ISO setting: Use your camera's native ISO setting whenever possible for the best image quality.
- White balance: Set the white balance as close as possible to the desired color temperature for the most accurate histograms.
- Manual or bulb exposure mode: Use the manual exposure mode to maintain full control over your camera settings.
- Long-exposure noise reduction: Consider using LENR with older cameras, cameras that allow continuous shooting with LENR enabled, and when the temperature is above 50 F (10 C).
- Histograms: Enable both the RGB and luminance histograms, or toggle between them for the most accurate exposure information. Base your exposure on the image preview and the histograms.
- Highlight indicator: Enable the blinking highlight indicator to be warned of highlight clipping.
- LCD brightness: Consider reducing the LCD brightness on par with the ambient light level and to save battery power.
- Custom functions: Picture styles and other custom functions do not affect RAW files unless you use your camera manufacturer's RAW converter.

SUMMARY

The guidelines in this chapter are oriented toward producing the best quality images possible. If your images will only be displayed online or will never be printed larger than 8.5 × 11, you have considerably more leeway with camera settings than those who want to make large prints. ISO is the only setting that is critical for night photographers or anyone who shoots RAW files. An optimal RAW file exposure has a right-biased histogram and no highlight clipping in important details. The camera meter provides a starting point for exposure, which is refined by using a combination of the image histogram, the highlight clipping indicator, and situational analysis based on experience.

White balance settings are saved as metadata tags in RAW files and are recognized by all RAW conversion software. It is useful, but not essential, to set the white balance precisely when shooting RAW files. In-camera long-exposure noise reduction is useful for removing noise due to long exposures and exaggerated by heat. LENR effectively doubles the exposure length, which can be an issue with very long exposures. Similar noise reduction can usually be achieved in postprocessing, but if it can be done in-camera without disrupting your shooting, it is good to remove noise in-camera. Most custom function settings do not affect RAW files. You should consult your camera manual to be sure. Finally, having a solid understanding of your

Lance Keimig, "Tres Cruces," Terlingua, Texas, 2007

The town of Terlingua in west Texas is a ghost town where mercury mine workers, primarily from Mexico, lived until the 1950s. In the town cemetery, the families of the dead place candles and sugar skulls on the graves every year on the Day of the Dead. The orange glow in this image is from those candles, which are out of sight of the camera, hidden by the scrub brush. Canon 5D, 28 mm Nikkor f3.5 PC lens, 5 minutes, f5.6, ISO 100.

camera's settings and functions frees your attention to focus on the creative aspects of night photography.

Christian Waeber: What If It Moves?

I love the way long exposures strip the images from the fleeting details, simplifying the image, thereby focusing the viewer's attention on the essential elements of the scene. This also has the practical advantage that one does not have to worry too much about walking in front of the

camera (to add some light to different parts of the image, for example). But every so often there is a moving object in the scene that one wishes could be frozen—a flag, a rabbit-shaped cloud, the Abominable Snowman. Unfortunately, after several minutes of exposure, these subjects will be at best a blur, at worst completely invisible. There are, however, several techniques you can use to capture this kind of subject at night. First, hire a crew of about 40 people (location scouts, gaffers, grips, the works), ask the local police to shut down the street, hang your lights from a couple of cherry pickers and add a few fog machines for good measure. When everything is in place, snap a few 8 × 10 frames. In a nutshell, this is the very unique approach used by Gregory Crewdson. I love his work, but this level of control on image creation is simply not within the reach of the rest of us.

This does not mean that photographing moving objects at night cannot be done. The information here will probably be most relevant to night portraiture. If you are using film, you might have to add some light to get good results. Several portable strobe systems are available for less than the cost of a good DSLR. But then again, if you had that kind of money, you might have bought said DSLR. Despair not, it is also possible to rent these systems. I have managed to connect a monolight (a self-contained strobe that does not depend on a centralized power supply as a pack and head system does) to an uninterruptible power supply (one of the battery backups used to protect computers or other electrical equipment). I don't know how many flashes one might get out of these batteries, but with good planning they might be good enough to get the image you want. There are also plenty of battery-powered strobes you can rent—up to 2000 watt seconds.

But you are probably using a digital SLR, and this opens a lot of new possibilities. For one thing, you can now shoot at ISO 800 without much fear of noise creeping up in your images. This means that even a normal flash bounced off an umbrella or a reflector will have enough power to light a portrait at f8. But it will obviously not do very much for your background. This is where the advantages of digital photography really shine—you can combine multiple exposures in Photoshop (one for your subject, one for the background, maybe other exposures for the foreground). One potential problem if you take the long exposure with your live, breathing subject in place is that, no matter how hard he or she tries, there will always be some movement over the course of a few minutes. This will be particularly visible as blurred edges. I have found it easier to ask my subject to move out of the way during the long exposure. It is then a matter of Photoshop skill to select the subject photographed with the flash, cut it, and paste it into the long exposure image.

A variation on this theme, again taking advantage of the incredibly low noise of recent DSLRs at high ISO, is to take two images, neither with flash. The first image is shot at a low ISO (100 or 200) without the subject. The second image is taken with the subject at the highest ISO setting your camera can use (this will depend on several factors: the final size of your print, the size of the subject with respect to the whole print, how good your noise reduction software is). You

Christian Waeber, "Michael," 2008

For this image, the model asked me to take a few portraits of him at night for his portfolio. Knowing that none of the prints would have to be larger than 8 × 10, I thought I would be able to get away with existing light and relatively long exposures. This image was shot at f4 for 0.6 seconds at ISO 400 with a Canon 5D (the building in the background with the American flag was taken at {1/8} second, and the top left area was easily layered in with Photoshop). Although a 0.6 second exposure is indeed OK for an 8 × 10 print, the model's face is not as sharp as I would like it to be. It's too bad because I like this image and I would like to print it larger. If I had to redo it, I would push the ISO setting to 1600 (I now own a Canon 5D Mark II), or I would bring some supplemental lighting gear.

might even consider opening the lens by a stop or two (make sure the focusing distance is the same for both exposures, though). The idea is to minimize the time your subject has to stay frozen in front of the camera. Again, how long an exposure is reasonable depends on several factors; you can get away with a longer exposure if the subject occupies a smaller section of the frame, if he or she can use some kind of support, or if your model is well-versed in the discipline of ashta-anga-yoga. The advantage of this method over the use of a flash is that it may be difficult in Photoshop to deal with the shadow cast by the flash. The drawback is that even for relatively short exposures (a couple of seconds), it will be difficult to keep your subject sharp. There is a silver lining to this; because the image of the subject is not very sharp in the first place, you can crank up your noise reduction fairly high (which means that you can set the ISO fairly high).

And while you are at it, you might as well have some fun. Why don't you have one friend show up in different places of the image? We did this a few years ago at a workshop I was teaching. Our model was covered with bright fabric, and we had her move from one place to another, adding light briefly every time with a powerful flashlight. Because she was always in front of dark backgrounds (black burnt trees), it seemed that she had been at each location for the whole exposure. Had she been in front of a bright background, it would have shown through, and she would have looked like a ghost. You could even make a Hitchcockian appearance in your own images by standing in the field of view for part of the exposure (how long depends on the brightness ratio between you and the background and how obvious or subliminal you want the effect to be).

Among moving objects, stars are in a class of their own in the heart of many night photographers. For the vast majority of us, *stars* are synonymous with *star trails*. They are a wonderful compositional element, their circles are so beautifully poetic; however, I have often wondered whether they were the night photography equivalent of an inside joke—we like them because *we* know what they are, but I have often had viewers ask me what they are. For a very different take on photographing the night sky, and if you are not familiar with his work, I suggest you look up Neil Folberg. He uses a film camera mounted on an equatorial mount to photograph the sky for up to an hour. Because the system precisely tracks the stars, they appear as very bright and sharp dots (even those invisible to the naked eye). He then digitally combines these images with scanned negatives of Middle Eastern landscapes at night. The results are dazzling. Of course, some of us don't have an equatorial mount and drive in our camera bag. I have recently tried to photograph landscapes under a starry night, setting my camera at ISO 1600. Using a 21 mm lens, a 20-second exposure is about as long as you can get away with and still have stars that look like

Wendell Delano, "Nina," 2006

The model in this image appears in multiple places, remaining still only long enough to be lit with a powerful flashlight. Her images appear solid rather than ghostlike because each time she stood in front of a dark background, assuring that no light would burn away her image. The location was a burnt forest of Jeffrey pine trees near Mono Lake in California.

dots rather than commas. I was using a Zeiss Distagon wide open (f2.8), which is known for its amazing sharpness at this aperture (I would not try this with a suboptimal lens). The result is a far cry from Folberg's images. But I have to say that star-looking stars are growing on me, while star trails are beginning to lose their appeal. Who knows where sensor technology will be 5 years from now? Maybe noise-free images at ISO 6400 will be routine, opening a whole new realm of possibilities for night photographers.

NIGHT PHOTOGRAPHY IMAGING WORKFLOW

6

DOI: 10.1016/B978-0-240-81258-8.00006-5

BASIC WORKFLOW PROCEDURE

Technical proficiency and efficiency in all aspects of the photographic process enables the photographer to concentrate on the creative side of photography. When one is bogged down by technical difficulties and fixing mistakes, photography can become tedious and a chore. If you can get to the point where the craft becomes second nature, there's much more room to play and experiment, and your work will flourish. Some people find themselves in the opposite situation and become so focused on technical perfection that they lose site of the subject and composition. Like everything in life, there has to be a balance.

Many photographers overlook the basic steps necessary to build a reliable and efficient workflow. Establishing a good routine in the field as well as in the wet and digital darkrooms is mostly a matter of developing good working habits. All that's required is a bit of discipline and conscious intent. Digital photography requires a new set of skills in addition to the basic principles of photography. Organizing and managing an archive of thousands of photographs is no small task, and many people find themselves in the position of trying to organize their digital images after several years of accumulating them in a hodgepodge of disorganized folders, CDs, and hard drives. Fortunately, it is never too late to develop a system for managing your files.

Digital workflow is a broad topic, well beyond the scope of this book. But because it is such a critical part of any photographer's process, I have included this brief chapter on workflow for issues specific to night photography.

MEMORY CARDS, BACKUPS, DNG, AND KEYWORDS

Your workflow begins before you begin to photograph, at the time when you insert the memory card into your camera. You should format your card every time you insert it before making images. Formatting is the best way to ensure that your photographs are going to be there when you take the card out of the camera to load them onto your computer. Memory cards have their own native file structure, which is different from your computer's file structure. Any time you transfer images from card to computer,

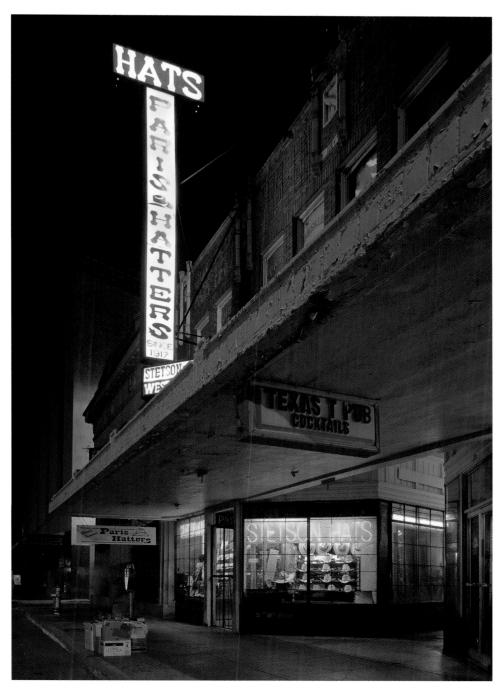

Lance Keimig, "Paris Hatters," San Antonio, Texas, 2009

the card must be formatted in-camera to minimize data loss. It is also good practice to leave a little space on the card rather than filling it completely. It is fine to edit in-camera and delete files as you go, but deleting images from a full card (as opposed to reformatting it) to make space for more images can lead to card failure and should be avoided. Avoid the temptation to use super-high-capacity memory cards because they can lead to heartache when they fail. Imagine losing 16 or 32 gigabytes worth of images if your memory card fails. Although compact flash is remarkably stable and reliable, the cards don't last forever. I recommend 1 or 2 gigabyte cards for less than 10 megapixel cameras, 2 or 4 gigabyte cards for 10–14 megapixel cameras, and 4 or 8 gigabyte cards for 15–25 megapixel cameras. Some cameras have multiple card slots and can simultaneously record images on two cards at once for added security.

It is also essential to back up your files after you load them onto your computer. All hard drives will eventually fail, so scheduling regular backups is critical. Manually copying files is not a reliable method of backing up your data. Simply dragging files to copy them on a second drive can leave data behind. It is much better to use a backup utility like SuperDuper or the Windows backup utility. These applications back up your data bit for bit and then verify that the two copies match exactly. Apple's Time Machine can also be used, but this method creates file archives, keeping copies of every version of every file you create, which takes up much more storage space on your hard drive. How often you back up your data depends on how often you add files to your hard drive. Backups can be scheduled overnight on a regular basis when the computer would be otherwise inactive. Don't take any chances with an "it won't happen to me" attitude. Eventually it will, and if you have backed up your data, it will only be an inconvenience rather than an epic disaster. Lightroom's catalog backup function only backs up the catalog, not the actual images.

Because we are shooting and saving RAW files on our computers, it is possible to maintain an enormous library of images on a single hard drive. Preserving your photographs in RAW format serves two important purposes: you'll always have the original RAW data containing all of the information that was present at the time of capture, and RAW files are much smaller than rendered TIFF or PSD files. RAW converters, such as Lightroom or Adobe Camera Raw (ACR), are parametric editors, as opposed to Photoshop, which is a pixel editor. Parametric editors save changes as metadata, in essence a list of instructions of how the file is supposed to look when it is printed or exported. Pixel editors actually change an image pixel by pixel, which is more cumbersome and slower, uses huge files, and most importantly can lead to image degradation and workflow inefficiency.

Camera manufacturers use their own proprietary RAW formats such as NEF, CR2, or CRW. These formats are further differentiated each time a new camera is released, and RAW software needs to be updated to recognize the files from the new camera. The camera manufacturers all have their own RAW software, but most users prefer a third-party application like Capture One, ACR, or Lightroom. Of concern to photographers is whether or not their proprietary RAW files will continue

to be supported by future generations of software. There's not much point in saving RAW files if they cannot be opened. A relevant comparison is Adobe's recent decision not to support PowerPC-based Apple computers with the release of Lightroom 3 and CS5. It is conceivable that RAW files from older cameras may not be supported by future software. The solution lies in Adobe's universal RAW format called digital negative (DNG) format. Hopefully, all camera manufacturers will adopt the archival DNG format as a camera standard to preserve the integrity of all our images. Pentax, Leica, and Samsung have already done so, as has Sinar for their large format scanning backs.

There are several ways to convert to DNG upon import into Lightroom, within Lightroom, or with Adobe's free DNG converter utility. I use Lightroom for my workflow, and I convert my files to DNG upon import and discard the proprietary RAW file. It is also possible to make a DNG copy and save the original, but this is unnecessary and takes up valuable storage space on your hard drive. DNG files are often 5–20 percent smaller than either NEF or CR2 files, yet they contain all of the original information. This may not seem like a huge advantage until you consider the combined effect on an archive of thousands of photographs. Another huge advantage to the DNG format is the ability to write metadata directly to the file, making XMP sidecar files unnecessary. With proprietary RAW files, the processing instructions and other metadata must be kept separately either in the catalog or in a sidecar file stored alongside the RAW file. If the metadata is separated from the image, all development settings will be lost. The only disadvantage is that Canon's and Nikon's RAW applications do not support DNG.

One other aspect of workflow that is often overlooked by amateur photographers is the importance of keywords. Keywords are metadata tags that describe your images, making them much easier to find via a search in the future. Adding keywords to all of your images upon import is simple and efficient. It can be a tedious process to add keywords to an image library after the fact, but it is essential as our libraries increase in size. Visually searching through a few hundred thumbnails is not problematic, but looking for a specific image amongst thousands can be a daunting task without keywords. It is helpful to think of keywords on different levels—global (night, landscape, California), local (San Francisco, full moon), and micro (Golden Gate Bridge, fog, traffic).

ADOBE LIGHTROOM FOR RAW FILE DEVELOPMENT

There are many different RAW applications to choose from, including Canon Digital Photo Professional, Nikon Capture NX2, Aperture, Capture One, DxO Optics, ACR, and Lightroom. I use Lightroom in my own workflow and will present RAW file development with Lightroom in this chapter. A question that often arises in classes and workshops is, "What is the difference between the Lightroom workflow and Bridge–ACR–Photoshop workflow?" The answer lies within the question. Why use three applications when you can do almost everything you need in one? Bridge is an image browser; it is a simple interface for viewing files. ACR is the same RAW engine that is integral to Lightroom. Photoshop is an enormous pixel-based file editor that has evolved

into an application that is used not only by photographers, but many different types of scientists, designers, and other professionals as well. Although the ACR plug-in and Bridge application have been added to Photoshop to meet our modern needs, Lightroom was written from the ground up as one all-inclusive application designed exclusively for the modern digital photographer. Lightroom is a database-driven RAW processing application that creates a catalog of photographs, and it can include archives on separate volumes. Lightroom's catalog can be thought of as the card catalog at your local library, and your photographs are the library's holdings. Your keywords are how the catalog organizes and finds your photographs on the shelves. The application is divided into modules that each serve a different purpose. There are Library, Develop, Slideshow, Print, and Web modules. There are still occasions when Photoshop provides a better solution than Lightroom, as in the cases of image stacking or creating HDR files or panoramas. It is easy to open files in Photoshop directly from Lightroom and then save the rendered files back to your Lightroom catalog.

There is a learning curve when getting started with Lightroom. I recommend Seth Resnick and Jamie Spritzer's *The Photoshop Lightroom Workbook*, published by Focal Press, or Martin Evening's *Adobe Photoshop Lightroom* as comprehensive guides to this application. The following section is intended to be a brief overview of the Lightroom Develop module specifically as it applies to night photography.

RAW PROCESSING PROCEDURE

If you follow the exposure guidelines in this book and the development workflow in this chapter, most of your images should not need additional processing outside of Lightroom. The goal is to maximize the efficiency of your workflow to allow for more time behind the camera and less time at the computer.

Histogram

RAW processing software groups together sets of tools that are intended to be used in a particular order. Lightroom's and ACR's tools are arranged that way, and I encourage you to work with them in that order, from the top down. At the very top of the Tools panel is a real-time (live) histogram, which also shows ISO setting, focal length, shutter speed, and aperture. In the upper-left and upper-right corners of the Histogram panel are two small triangles that can be moused over or clicked to show shadow and highlight clipping. When activated, shadow clipping appears as blue, and highlight clipping appears as red. Monitoring the histogram during development provides useful information about the range of tones and their placement along the scale from black to white. Directly below the histogram are the local adjustment tools. They are extremely useful, and we'll come back to them after reviewing the other panels. The Histogram panel illustration shows the other tool panels in their closed state. They are opened by clicking the triangle to the right of the name. The square to the left of each panel turns each tool set off and on so you can preview the effect of those tools.

Histogram panel. The pink circles show the clipping indicators in the histogram, the tabs for opening tool panels, and the on/off switch for each panel.

Basic Adjustments

In the Basic panel you can switch between color and grayscale, but it is best to do the basic adjustments in color and convert later. The first adjustment in the Basic panel is white balance. There is a drop-down menu with white balance presets, sliders for color temperature (blue to yellow) and tint (magenta to green), as well as the ever-useful White Balance Eyedropper tool. Although

Lightroom Basic panel in the develop module. The White Balance eyedropper tool is indicated with a pink circle.

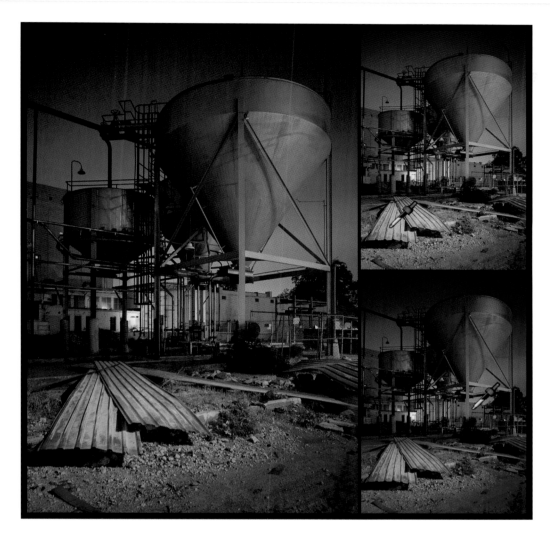

Lance Keimig, "Giant Funnels," San Antonio, Texas, 2009

In this image of giant grain funnels at San Antonio's Pearl Brewery, the white balance was set to tungsten in-camera. Knowing that there was a cool mercury vapor light in the foreground and warm sodium vapor light in the background, I first clicked the gray metal in the foreground with the Eyedropper tool, which gave the sky a reddish color. Next, clicking the building in the background neutralized the color cast there and introduced lots of blue to the foreground and sky. The white balance in the final image was tweaked manually using the sliders. The white balance works by adding an opposite or complimentary color to neutralize a color cast.

setting the white balance as close as possible in-camera is always a good idea, it makes even more sense to refine it in development. With the White Balance Eyedropper tool you can click any part of an image to neutralize it. This tool is especially useful for images that have multiple light sources because clicking an area illuminated by one source affects other areas as well. The White Balance

Eyedropper tool will eliminate as much color as possible from the area that is selected unless the color temperature is below the 2000 K minimum in Lightroom or ACR. For this reason, low-pressure sodium vapor lights cannot be completely neutralized.

The all-important Tone sliders are next. They set your white and black points, as well as midtone and global contrast. The Exposure slider sets the white point in the image, and although it can be adjusted up or down by up to four stops, adjustments of two or more stops are likely to be unattractive. Holding down the Option/Alt key reveals any areas that are clipped. Lower the exposure of overexposed images with the Option/Alt key held down until there are no colored pixels showing, but ignore any white areas or pixels because they are clipped in all three color channels and may not be recoverable. It is important to ignore midtone density when adjusting the white clipping point with the Exposure slider. You will be able to adjust midtone density with the Brightness slider momentarily. Although the Recovery slider can be used to add density to the highlights of overexposed images, it is rarely useful on well-exposed images. The Fill Light slider lightens shadows and is particularly useful with underexposed images. Both the Recovery and Fill Light sliders should be used sparingly, if at all, because they can reduce the overall contrast and introduce noise and unnatural tonality if used excessively. Well-exposed images without extreme contrast are unlikely to benefit from use of the Recovery and Fill Light sliders. The Blacks slider sets the black clipping point in the image. As with all of the sliders in the Basic panel, the Option/Alt key will indicate any clipping when it is held down in conjunction with the slider. Set the black point so that there is a very small amount of shadow clipping. Having a little bit of solid black in an image will make a stronger print. The Brightness slider controls the midtone density of an image. The Exposure and Brightness sliders are often confused and used interchangeably, but there is a very real difference between them. The Exposure slider moves the entire exposure up or down from the white point, and the Brightness slider only affects the midtones. Always adjust the Exposure slider before the Brightness slider. In Photoshop terminology, the Exposure and Blacks sliders are like moving the endpoints in Levels, and the Brightness slider is like moving the middle gray triangle in Levels. Moving the Contrast slider to the right will lighten the highlights and darken the shadows, expanding the histogram and increasing the global image contrast. Moving this slider to the left will darken the highlights and lighten the shadows, contracting the histogram and lowering image contrast.

The Clarity slider changes the local contrast between adjacent areas, which adds apparent sharpness to the image. It should be used at 100 percent magnification, and halos should be avoided along the edges. The Clarity slider is generally moved to the negative side of the adjustment scale only to hide skin imperfections in portraits. The Vibrance slider increases the saturation of less-saturated colors; it has less of an effect on more saturated colors to prevent clipping as colors approach full saturation. The Saturation slider increases the saturation or intensity of all colors equally. Sliding all the way to the left reduces an image to monochrome, and sliding all the way to the right doubles the color saturation.

Ideally, all of the adjustments in the Basic panel should deviate from the default setting as little as possible. This is particularly true of Recovery, Fill Light, Clarity, and Saturation. Excessive changes with these tools can lead to increased unnatural tonality, noise in the shadows, and artifacts like halos or banding. Places where there are strong tonal transitions, like a horizon line or a tree branch against the sky, should be inspected for undesired effects.

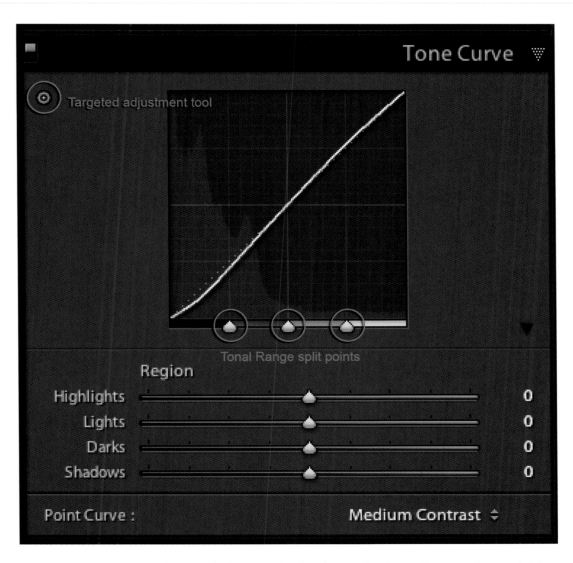

The Lightroom Tone Curve panel. The targeted adjustment tool and tonal range split points enable more precise control of the tone curve adjustment.

Tone Curve

Brightness and contrast can be precisely controlled within specific tonal regions in the Tone Curve panel. Most images may not need adjusting with the Tone Curve panel at all, but it can be a useful tool to make subtle tonal adjustments with greater precision than the basic tools allow. The Tone Curve panel is displayed on a graph, with the tones of the images represented by the horizontal axis and changes to the tones represented by the vertical axis. A straight diagonal line means that no changes have been applied to the image. The default Medium Contrast preset simulates a film curve that we have come to expect and love. Although the Linear preset represents colorimetric linearity, it would be unusual to prefer its effect. Use the Strong Contrast preset on images that really need a strong boost in contrast. For night photographs, this would be mainly moonlit landscapes. Moving a point on the curve up lightens those tones, and moving a point down darkens them. Moving the slider to the right lightens the selected region, and moving it to the left darkens it. The points on the curve will rise and fall correspondingly with the slider movement. The Targeted Adjustment tool can be placed anywhere in an image to raise or lower specific tonal regions. Click the target and then click and drag it to the desired place in the image. This tool offers precise control by allowing you to raise or lower the values using the visual references in the image. Even more refined adjustments can be made with the Tonal Range split point adjustments at the bottom of the curve graph. They can be used to expand or contract the range of tones affected by each of the Tone Curve sliders. The Tone Curve sliders should always be used after the basic adjustments have been completed and only if the basic adjustments are insufficient to achieve the desired results.

Hue Saturation Luminance

The HSL/Color/Grayscale panel provides precise control over color in the way that the Tone Curve panel allows very specific adjustments to luminosity. In this panel, you can toggle back and forth between adjustments for hue, saturation, and luminance, color, and grayscale. Converting to black and white (grayscale) is best achieved in this panel, after the basic and tone curve adjustments have been completed, rather than in the Basic panel. If you are switching to grayscale, adjust the individual color sliders to simulate color lens filtration, which changes the luminosity of different colors when they are converted to grayscale. When adjusting color images, the HSL mode features the Targeted Adjustment tool that we saw in the Tone Curve panel, which makes it more useful for our purposes. Because night photographs often contain multiple light sources with strong color casts, setting the white balance for one light source may adversely affect another light source. Because the white balance can only be set for one light source, or compromised to give an approximate average white balance, it is handy to have an additional way to adjust colors in an image with mixed lighting. HSL adjustments are especially useful when multiple light sources do not overlap in the image. Modest adjustments are best because extreme adjustments can lead to unattractive edge effects.

The Lightroom HSL/Color/Grayscale panel. This panel also features the Targeted Adjustment tool.

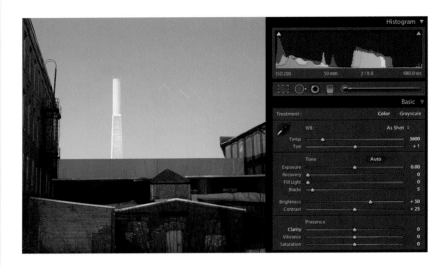

Image appearance on import

This image of an abandoned textile mill was taken in Lawrence, Massachusetts. The main source of illumination was moonlight, but intensely yellow sodium vapor lights were illuminating the smokestack. This is how the image appeared upon import to Lightroom.

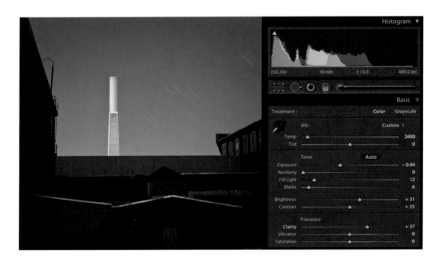

Appearance after basic adjustments

This is how the image looked after the basic adjustments. The white balance was set for moonlight by using the Eyedropper tool on the gray wall below the smokestack. It is a big improvement, but in this case I'd like to have a more natural appearance to the brick smokestack. Lowering the color temperature further to compensate for the yellow light would make the rest of the image too blue.

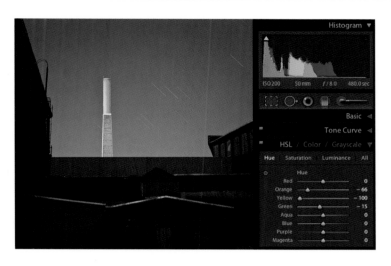

Appearance after hue adjustment

Using the Targeted Adjustment tool (TAT) on the brick smokestack, I scrolled down, which moved the Orange slider toward red and the Yellow slider toward orange. The Green slider also moved slightly toward yellow and away from aqua. The Green slider did not change as much as the others because there was only a little green in the image. These colors change because they are the ones where the TAT was placed. The result is somewhat improved, but it still doesn't look natural.

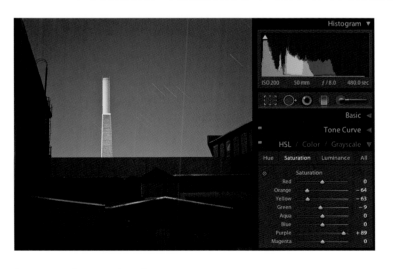

Appearance after saturation adjustment

Repeating the process with the Saturation slider reduces the saturation of the same two colors–orange and yellow. The smokestack is starting to look more natural, but now it is too light.

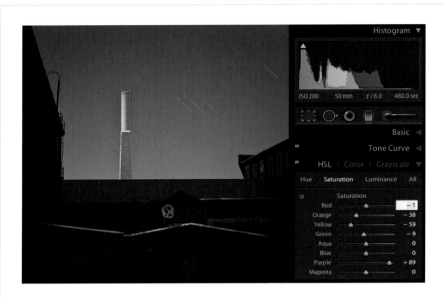

Appearance after luminance adjustment

By placing the luminance TAT over the smokestack and scrolling down, the orange and yellow tones are darkened. Now the light on the smokestack looks fairly neutral, as does the rest of the image, which has not changed much during the HSL adjustments because there was very little yellow and orange elsewhere in the image. At this point, it is a good idea to look at the entire image at 100 percent magnification to check for edge artifacts and manually adjust any of the sliders as needed or desired.

Detail

The tools in the Detail panel include Sharpening, Noise Reduction, and Chromatic Aberration. The most important thing to remember about the Detail panel is that images must be viewed at 1:1 magnification or greater when any of these tools are used. A warning in the shape of a triangle with an exclamation point appears in the Detail panel if you do not have the image set to 1:1. Click this triangle to instantly switch to 1:1. The effects are not seen when the image is viewed at lower magnifications, but each of them can greatly improve print quality when used correctly.

Sharpening

There are two sharpening functions in Lightroom, and they address different needs. Capture Sharpening compensates for the loss of sharpness that occurs during image capture. Output Sharpening compensates for the loss of sharpness during printing. Capture and Output Sharpening work together to provide sharpness consistency throughout the workflow. It is also worth noting that Capture Sharpening is applied in-camera to JPEG files, but RAW files will need sharpening applied in development. In Lightroom there are default sharpening levels applied to every image, as well as two sharpening presets—one for portraits and one for landscapes, the latter being more

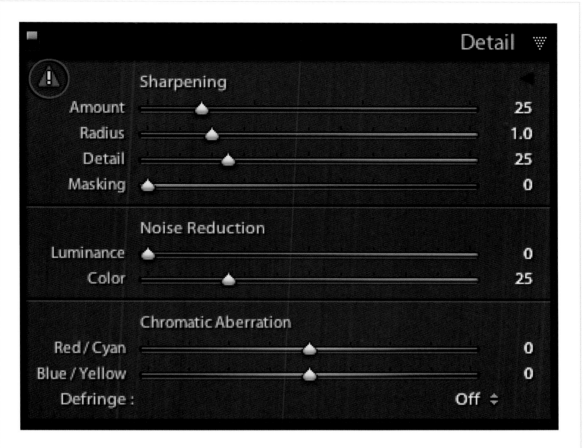

The Lightroom Detail panel. The explanation mark in the triangle is a warning that the image must be viewed at full size to see the effect of the adjustment.

useful for night photography. The presets are good starting points, but learning how sharpening works and applying the settings manually will allow you to tweak your images to perfection. One of the great things about Lightroom sharpening is that it is applied to luminance data only, not color information. This provides a higher-quality sharpening effect that prevents enhancing color artifacts. Finally, you can best view the effect of all of the detail adjustments by holding down the Option/Alt key while applying them.

The Amount slider simply controls the amount of sharpening applied to the image, as the name implies. The Radius slider controls how much of an area gets sharpened around high-contrast lines. When the Detail slider is set to maximum, the sharpening is applied to the entire image. A lower detail setting will suppress sharpening in smooth areas like skies and avoid adding texture in the

smooth areas. The Masking slider creates an edge mask based on the image content and protects areas that won't benefit from being sharpened. Bay Area night photographer Joe Reifer suggests masking out the sky in night photos by Option/Alt clicking while moving this slider to the right until only the star trails are visible. This sharpens the star trails without adding sharpening to any noise that may be present in the sky.

Noise Reduction

Noise reduction in Lightroom is simple and straightforward; it is adjusted with two sliders. The Luminance noise reduction slider has a default setting of zero, and the Color slider's default setting is 25. Luminance noise has a salt-and-pepper appearance of gray and black specks. The Luminance slider will decrease sharpness in the image, and anything more than minimal use of this tool should be accompanied by an increase in sharpening. It takes a while to find the proper balance between the two. Again, view the image at 100 percent or greater magnification to use the noise reduction sliders. Pay particular attention to smooth tonal areas like the sky to determine if adequate noise reduction has been achieved. Fine detail areas should be carefully observed to check for overcorrection. Texture and fine detail tend to obscure noise, but they suffer the most from noise reduction because luminance noise reduction blurs details like texture. The Color slider can be used more aggressively if needed, but going overboard with color noise reduction can lead to reduced saturation in the final image.

Images with severe noise may benefit from additional noise reduction using third-party software. One advantage to these applications is that the more sophisticated ones will apply noise reduction more aggressively in selected areas where it is most needed using wavelet-based frequency analysis technology. Applications that function as Photoshop plug-ins can be applied to manually selected areas or in layers that can be masked or reduced in opacity. Plug-ins can also be used for batch processing with actions. These applications also rely on noise profiles for different camera models and ISO settings that are either formulated from an image on the fly or loaded from a collection of profiles that are downloaded with the software.

There are numerous noise reduction applications, and most of them are available for limited trial downloads. If you find yourself needing more noise reduction than your RAW application can provide, it would be worthwhile to download and try several applications before purchasing. Things to consider when choosing a noise reduction application are effectiveness, preservation of image detail, user interface, speed, availability as a plug-in, and cost. Neat Image, Noise Ninja, Noiseware, Define, DeNoise, and Grain Surgery are the main options, but there are others. There is a fair amount of trial and error involved in finding the best adjustment for an image, so choosing an application with a straightforward user interface and good support is important.

Chromatic Aberration

The last tools in the Detail panel are used to correct chromatic aberration (CA). The different colors of light do not always converge at the same position on the sensor plane after passing through

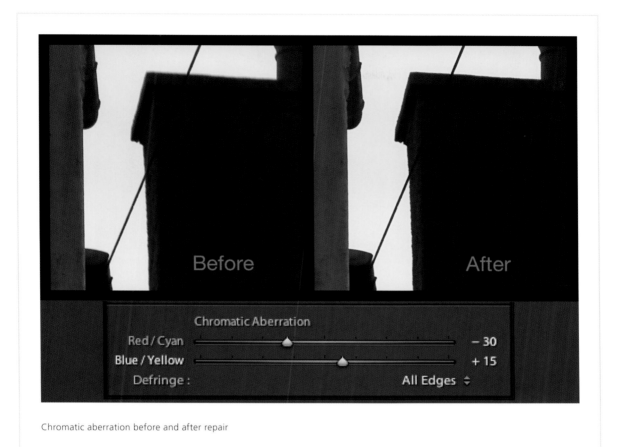

Before After

Chromatic Aberration
Red / Cyan — 30
Blue / Yellow + 15
Defringe : All Edges ⬍

Chromatic aberration before and after repair

a lens. CA appears as color fringes along the transition points between light and dark edges in photographs, especially near the edges of the frame. It often manifests near horizon lines and with tree branches or leaves against a bright sky. CA often appears as complimentary bands of color on opposite edges of an object, and although it may not be obvious unless viewed on screen at 100 percent, it does show up readily in prints. Sensor overload, or blooming, can also cause fringing in digital captures. Although this is not technically CA, it can have a similar appearance and is compensated for with these defringe tools.

There are two sliders to correct for CA: Red/Cyan and Blue/Yellow. While viewing the image at full magnification, adjust the sliders until the CA is minimized. Holding down the Option/Alt key hides corrections made by the other slider. If the sliders are unable to remove all of the CA, try one of the defringe options in addition to the sliders. Try the Highlight Edges option first, and if that results in gray lines replacing the CA, try the All Edges option instead.

NIGHT PHOTOGRAPHY

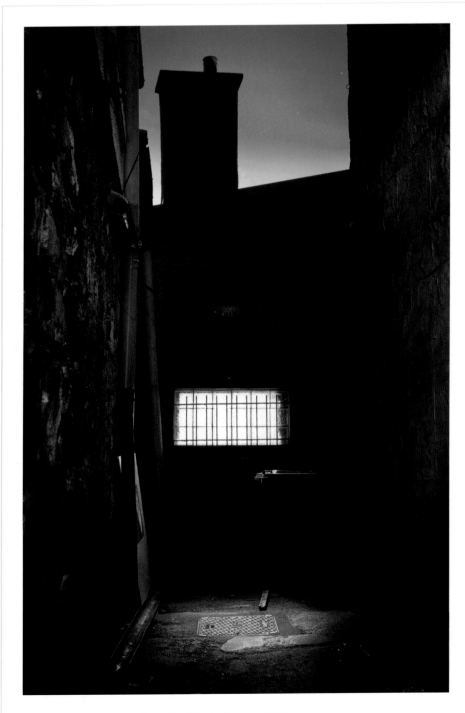

Lance Keimig, "Stornoway Alley," Isle of Lewis, Scotland, 2009

The Vignettes panel tab in Lightroom's Develop module.

Vignettes

Lens vignetting is a darkening, loss of sharpness, and loss of saturation around the edges of an image. It occurs most often at the wide-angle end of poor quality zoom lenses. Using the wrong lens shade or mounting a lens shade incorrectly can also cause vignetting. There are two vignette tools in Lightroom: Lens Correction, which is used to correct for unintentional lens vignetting; and Post-Crop, which is used for creative effects. The Lens Correction sliders should only be used on images that will not be cropped, but the Post-Crop sliders can be used on cropped or uncropped images. There are four sliders in Post-Crop: Amount, Midpoint, Roundness, and Feather. Amount controls how light or dark the vignette will be. Midpoint determines how far into the image the vignette extends. Roundness determines the shape of the vignette, and Feather softens or hardens the transition area of the vignette. The best way to use the vignette feature is to experiment with different settings. A little vignetting will draw attention to the center of the image, but it is easy to get carried away and add too much. It is purely a matter of personal taste.

Local Adjustment Tools

Earlier in this chapter, we skipped the local adjustment tools, which are located directly below the Histogram panel in the Tool Strip. The Crop Overlay and Straighten tool allows you to crop an image freely or with constrained proportions, and you can also rotate the image. Red Eye Reduction is

Lightroom's Tool Strip contains tools that can apply effects to selections or parts of an image.

self-explanatory and is rarely used by night photographers. The Spot Removal tool is primarily for removing sensor dust and other small blemishes, and it has two modes: Clone and Heal. Clone applies an exact copy of the sampled area to the destination area; it works best in tight corners where there is other detail nearby. Heal blends the sampled area to match the destination area in texture, color, and tone. The Heal mode needs open space to work because it samples from an area considerably wider than the destination spot being healed. The Heal mode is typically preferred over

the Clone mode. In Lightroom 2, the Spot Removal tool is only available in circular form. Hopefully, future versions will have this function in brush form, which will make it easier to remove telephone wires and the like.

The real gems of the local adjustment tools in Lightroom 2 are the Graduated Filter and Adjustment Brush. These masking tools are customizable and offer the following adjustments: exposure, brightness, contrast, saturation, clarity, sharpness, and color. You can apply them one at a time or in any combination with either tool, and the best part is that these adjustments are completely nondestructive and remain editable forever. Selecting either of these tools opens the Tool Drawer, directly below the Tool Strip. The Tool Drawer contains sliders or buttons for the various adjustments.

The Graduated Filter is most commonly used to lighten or darken large areas of an image. After applying the Graduated Filter, you can refine the effect by changing the amounts of the adjustments, or you can change the size and position of the gradient, expanding or collapsing it by dragging the leading or trailing edge. You can rotate the gradient by moving the center line. Holding down the Shift key keeps the gradient level, and the H key hides and then reveals the boundary markers, but not the effect. In the center of the gradient is the Pin, which appears either as a white circle (to indicate a deselected gradient position) or a white circle with a black center (to indicate an active gradient). You can apply as many gradients as you like to an image, each with its own adjustments.

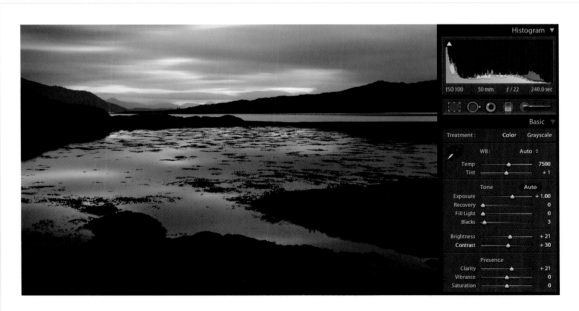

Basic adjustments
This image of Loch Duich in Scotland shows the basic adjustments in Lightroom. It looks good, but it could use more punch.

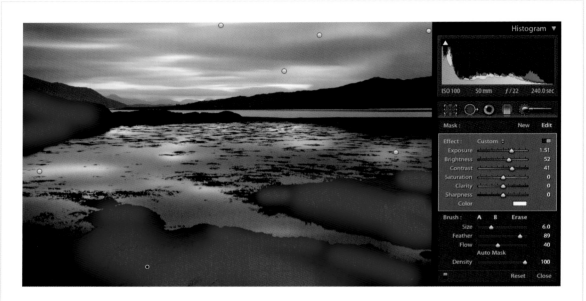

Land mask

The Adjustment Brush has been used to lighten the land areas. Notice that the exposure, brightness, and contrast have all been increased, and the brush has heavy feather, modest flow, and maximum density settings applied. The red area reveals the area lightened with the adjustment brush.

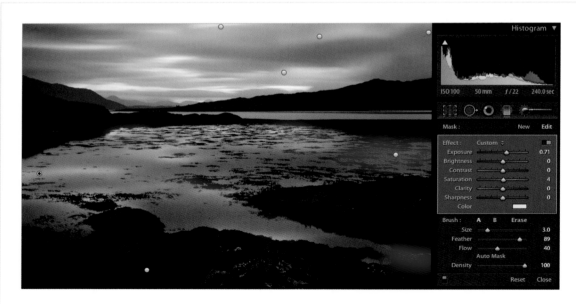

Water mask

Here the Adjustment Brush has been used to lighten spots in the water. A smaller-size brush was used this time, and only the exposure was increased.

The Adjustment Brush is a highly manipulable masking tool for applying corrections to part of an image. Adjustment Brush selections have the same Pin as gradients. When a local adjustment is active, pressing the O key will reveal the mask, which can then be further refined. You can add to or remove part of the mask by clicking the Option/Alt key while applying the brush. As with the Graduated Filter, the H key will hide and reveal the adjustment Pins. There is also an Erase button in the Tool Drawer, which works in the same way as the Option/Alt key. In addition to the adjustment sliders in the Tool Drawer, the Adjustment Brush also has controls to regulate the size, feather, flow, and density of the brush, along with an Auto Mask feature that confines masking areas to adjacent areas with similar tonality. There are two variable presets for brushes, so you can toggle back and forth between two different sizes or styles of brushes. As with the Graduated Filter, you can add additional masks and change them at any time. When a brush stroke or gradient is selected (a black circle appears in the center of the Pin), the Delete key will cause that adjustment to disappear. Mac users will see the Pin disappear in a cloud of smoke, reminiscent of the Apple Newton PDA from years ago.

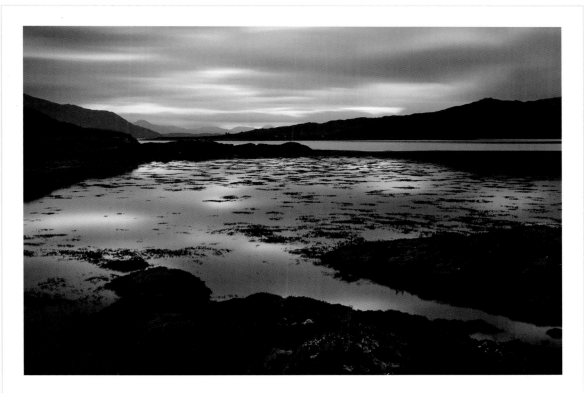

Final image. Lance Keimig, "Loch Duich at midnight," Scotland, 2009

In the final image, there's more detail in the foreground, and the color of the seaweed starts to come through. The spots in the water that were reflecting bright clouds have been lightened to enhance the moonlight effect. Loch Duich is near the Isle of Skye on the west coast of Scotland, and this 4-minute exposure was taken at midnight near the summer solstice.

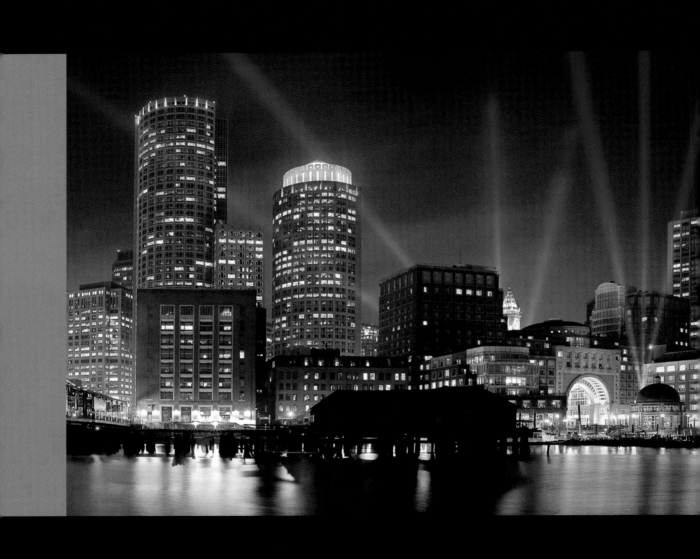

HIGH DYNAMIC RANGE IMAGING

7

DOI: 10.1016/B978-0-240-81258-8.00007-1

In situations where the dynamic range of the scene exceeds the ability of the camera to record it, there are several high dynamic range (HDR) workflow alternatives. All approaches combine multiple exposures of the same scene to capture a larger dynamic range than any single exposure can. In this chapter we'll explore three HDR methods.

One method is to manually combine different exposures in Photoshop as layers and use any number of techniques to blend them. Guest contributor Christian Waeber presents his own workflow for combining exposures in scenes that have many small highlight areas. Another method of combining multiple exposures is with HDR features and tone mapping using software from HDRsoft. Dan Burkholder presents this method in the second section of the chapter. A third HDR method fits perfectly into a Lightroom-based workflow and allows for HDR creations without leaving the application. We'll explore this option last.

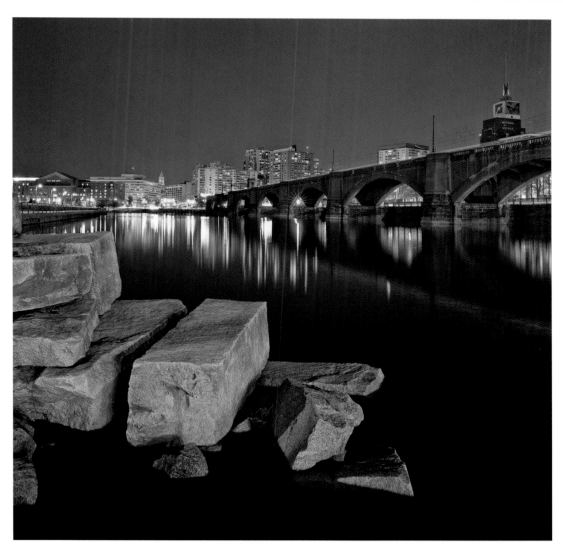

Lance Keimig, "Boston Granite," 2009

Including light sources in an image is one of the most challenging aspects of night photography. In this instance, the lights are a small part of the frame and far enough away that their being overexposed does not present a significant problem. This image is composed of two horizontal frames blended together using Photomerge, a feature of Photoshop used for creating panoramic images. Most often Photomerge is used to create wide horizontal panoramic images, but it can be also used to create square images as shown in this example.

Christian Waeber: Basic HDR with Manual Layer Blending

The major difficulty with photographing at night is not the lack of light, it is the extreme dynamic range of the light. Film photographers have invented countless recipes to increase the dynamic range of silver-based materials, with excellent success. Standing development in highly diluted Rodinal has allegedly been used to squeeze 16 stops of tonal range out of a negative. But the dynamic range of a given sensor is fixed and cannot be tweaked. Although it has significantly improved over the last few years, and will no doubt continue to advance in future cameras, night photographers have had to rely on techniques such as high dynamic range (HDR) imaging to keep detail and texture in both the deepest shadows and brightest highlights of their images. HDR is currently done using third-party software, such as Photomatix, and the HDR workflow is cumbersome and not always practical. There are times when it is simply not possible to take the number of images required for HDR processing (for example, because I only have a little time until the Moon will appear behind a building). When this happens, I always try to get at least two exposures that enable me to significantly expand the dynamic range captured in my image. First I get a short exposure for the highlights, usually two to three stops less than the shadows exposure. Then I get my shadows exposure. With these two images secured in my memory card, I know that the workflow explained in this section will give me a good image. If I have more time, I then get extra shots, particularly longer exposures, so that I have the option to process my images with

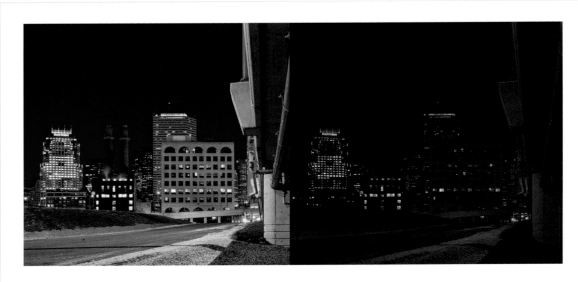

Long exposure (left, 26 seconds) and short exposure (right, 4 seconds)

them later on. Why am I so concerned about getting a short exposure for the highlights, rather than a long exposure for the shadows? Because recent digital SLRs produce exceptionally clean (i.e., noise-free) shadows, but clipped highlights without detail don't look particularly attractive in final prints. Now that the stage has been set, let's look at a concrete example to see how two exposures can be combined to retain an amazing amount of highlight detail.

I first open the shadows exposure image (which in this case was shot for 26 seconds at f8, ISO 100) in Adobe Camera Raw (ACR). I am trying to have a good overall look without paying much attention to the fact that the highlights are out of range. I then use the same settings to open the image I took for the highlights (shot for 4 seconds at f8), but when I'm in ACR, I push the recovery slider way to the right (I left it low, around 15, for the shadows exposure) and decrease the contrast (which was quite high, at +50). I also lower the contrast in the Tone Curve tab. The idea is to make sure that the highlight clipping warning does not light up anywhere in your image (or in as few areas as possible). Lowering the overall contrast will also make it easier to blend the edges of the selected highlights when they are pasted into the background image. Although it might not be obvious in the previous figure, the shadows exposure image shows no visible detail in the windows of the building on the left, but the 4-second exposure image has retained full detail. You might also note that the steam venting under the two smoke stacks has a very different shape in both exposures. In my experience with HDR processing, Photoshop makes a complete mess of areas that significantly differ between exposures. Although dedicated HDR processing software might deal better with moving subjects such as clouds, this is another reason to stick with the simple procedure described here.

Effect of the adjustment curve on the highlights layer; note how it affects only the dark and midtone areas

When both images are opened in Photoshop and combined into a single layered file, I first concentrate on the dark image. Using the Magic Wand, I select, one by one, every single window in the left building—take your time, call me when you're done (just kidding). Photoshop purists may have nicknamed this tool the "Tragic Wand," but if you uncheck the Continuous box above the image before you start selecting the bright areas in the windows, the Magic Wand will actually make quick work of selecting all bright areas in your image. First select the brightest areas, using a tolerance of about 20, and slowly click less and less bright areas, holding down the Shift key to add to the selection. Of course, you should be working at 100 percent or 200 percent magnification, and make sure that your sample size is 1 or 3 (as set in the Eyedropper tool). When all the bright areas have been selected, navigate to Select > Modify > Expand to expand the selection by 1 or 2 pixels (or more, depending on the size of the selected areas), and feather the selection by about 4 to 10 (again, it all depends on the size of the selected areas). Copy the selection, paste it into the other image, and drag it into place. This new layer certainly gives a lot of detail to the highlights, but it does not look very natural—the highlights layer must be brightened. This can be done by grouping an adjustment layer with the highlights layer. You can group an adjustment layer by Option/Alt clicking the line between the adjustment layer and the underlying layer. I suggest using a curve similar to the one in the previous figure, which shows the effect of this adjustment curve on the highlight layer (this is because some of your feathered selection contains relatively dark areas that should be lightened much more than lighter areas). Select luminosity as the blend mode. This adjustment curve should already improve things, but chances are that the darkening of the highlights is still a bit heavy-handed. Dialing down the opacity of the highlights layer to about 50 percent should take care of this. The following image shows the lit windows in the building on the left, with the highlight layer turned off (left) and on (right).

Highlight layer turned off (left) and on (right); the effect is subtle, you want to keep it that way!

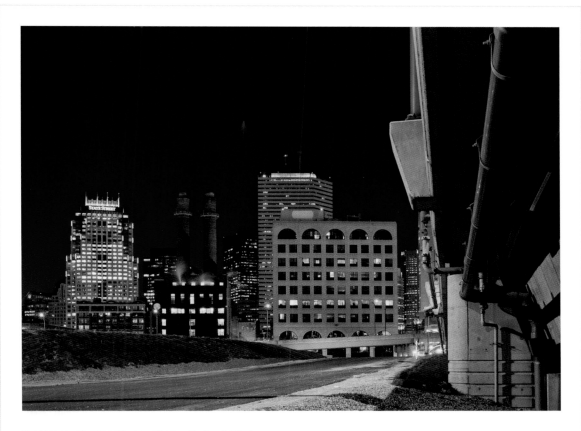

Final image. Christian Waeber, "Boston Skyline," 2008

"There is more than one way to skin a cat" is such a ghastly saying, isn't it? But it sure does apply to Photoshop. There are many other ways to make your selection, refine its edges, and blend it over the background image, not to mention the endless possible slider settings in ACR. Combine these and you get hundreds of possibilities, all yielding similar final prints. Hopefully, this section will give you a general idea of how different exposures can easily be combined to capture night photographs with a wide dynamic range.

Christian developed his technique over a long period of time with lots of experimentation, and it works well for him. If you've worked with Photoshop for any length of time, you know that there are many different ways to achieve similar results. You can blend exposures with layer masks, paint and erase layers with varying opacities, or combine exposures using curves

and different blending modes. If you use Photoshop in your workflow, try as many different solutions as you can imagine. Share your experiences with other users. Photoshop is such a large and complex application that there will always be a new trick to learn and someone who can show you a new way to accomplish your goals. The right solution is the one that works for you. Now let's look at high dynamic range imaging using Photoshop and Photomatix with Dan Burkholder.

Dan Burkholder: Making Darkness an Asset Instead of a Liability

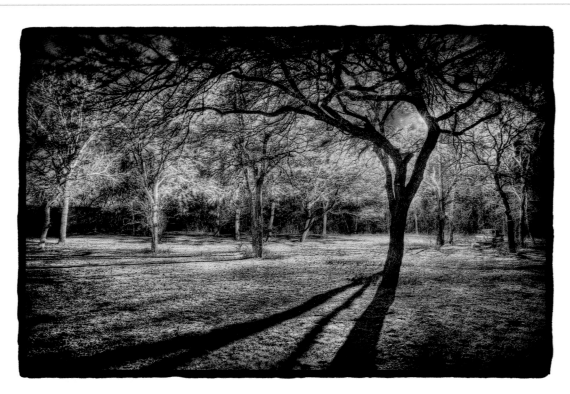

Dan Burkholder, "Trees and Truck at Midnight," Texas, 2008
The final print is platinum–palladium on vellum over gold leaf print.

What Is High Dynamic Range Imaging?

Just in case you've been sleeping through the last several years of photography's evolution, high dynamic range (HDR) has impacted the photography world in a major way. Some are even claiming that HDR is the newest cliché in photography. No matter what you think of HDR, it can be a terrific tool for night photography. Let's take a look.

Dynamic range refers to the luminance range in the subject, from the darkest blacks (deep shadows under a wet log, for example) to the brightest highlights (like sunlight on a white painted wall). Ever since Niépce captured the first photographic image in 1826, one of the medium's recurring challenges has been to capture that entire dynamic range on photosensitive materials. Each photographic capture medium, be it film or digital sensor, has a limit to how much viable information it can record in both shadow and highlight areas. But no matter what capture medium you use, you'll run into situations that overtax its capabilities, sometimes making you put your camera away with a shrug and a sigh, "I love the direction of light in this scene, but there's just no way I can get detail in all the areas I want." Sound familiar? HDR will let you keep shooting when you would have given up before.

Without going into a discussion of how film and sensors compare, I recommend resorting to HDR when *no single capture*—film or digital—can possibly hold detail in both ends of the scene's dynamic range. You do not need HDR if a single capture successfully holds tones throughout the image. In other words, reserve HDR for those high dynamic range shooting conditions that really need it. If you shoot only in foggy or moonlit conditions, the dynamic range in your scenes will be low, therefore you needn't worry about HDR. Night photography that includes artificial light, on the other hand, can offer up very high dynamic range conditions, making it difficult to capture both ends of the tonal scale in a single exposure.

Various methods of dynamic range control have been employed during the last 185 years of photography. *Control* could mean providing supplemental light (fill flash, reflectors, or other lights) to reduce the contrast range. Film shooters have utilized the Zone System in which they combine judicious exposure with carefully calculated film development to produce a negative that can print both shadows and highlights in the darkroom. HDR is just the latest—and best—way to successfully tackle high dynamic range scenes in front of your camera.

At the Heart of HDR

As you've probably guessed, at the heart of HDR is shooting a bracketed series of images, changing only your shutter speed. This series should have detail at both ends of the luminance range; your darkest exposure should have midtone highlights, and your lightest exposure should have midtone shadows. Read that sentence again if need be; the message is that you want very detailed highlights and very open shadows in your bracketed series.

How Many Bracketed Exposures Do You Need?

The most common question in HDR is, "How many bracketed exposures should I make?" Like most things in photography (and life), the answer is, it depends. The dynamic range in your scene will determine the number of exposures needed. I've done as few as three exposures and as many as 16 (the latter in a particularly dark and contrasty interior in post-Katrina New Orleans). And most recently, I have used a new crop of digital cameras that will rapidly take different exposures and automatically combine them into a single HDR image.

How Should I Bracket?

Some cameras have very good auto bracketing. Nikon's more advanced cameras allow for up to nine bracketed exposures automatically. Canon's pro cameras provide seven exposures, which might seem like a failing compared to Nikon's until you look at the whole picture. When you take into account that Nikons can only bracket maximally in one-stop increments (giving you ± four stops in that nine-stop bracket) and Canons can do up to three-stop increments (offering ± *nine* stops in a seven-exposure bracketed series), the balance shifts.

What Kind of Exposure Increment Should I Use for My Bracketed Series?

Ask enough photographers and you'll get every possible answer on the issue of how far apart your exposures should be. For casual daylight landscape shooting, a simple three-exposure bracket—normal, two stops over, and two stops under—can often do the trick. For my most serious work, I prefer to bracket in one-stop increments. This approach follows the advice that "the more information you give Photoshop, the better the results." I recommend that students of HDR run some tests of their own, shooting in single-stop increments, two-stop increments, and three-stop increments. Comparing your results from real shooting situations will give you the best feel for what increments match your subject matter and camera.

Shooting Guidelines for Making Successful HDR Captures

To make a successful HDR image, you combine special shooting techniques in the field with software steps in your digital darkroom. Let's look at some shooting tips first. I have compiled a set of guidelines that will help steer you in the right direction in the field. These are things I've observed during my years of capturing HDR images, but it is by no means a complete list, so feel free to add to it as you discover other shooting tips that enhance your HDR captures.

1. Use a solid tripod and quick release clamp. You won't use a tripod unless it's easy, fast, and convenient to do so.

2. Use a remote release. Get a better (more expensive) one that has an LCD screen that lets you set long exposure times easily. The LCD should also be illuminated to make setting long exposures easier. Carry a spare battery for the remote release.

3. Turn off autofocus or set your camera so it only focuses when you push a button on the back. You don't want it to try to focus every time you half-press the shutter release or remote release.

4. Use aperture priority or manual exposure mode. You want your aperture to stay constant; only your exposure time should vary.

5. Use the native ISO on your camera. This doesn't necessarily mean the absolute lowest ISO. The Canon 5D, for example, has an extended range that offers ISO 50. Sadly, that lower ISO has a dynamic range lower than the native ISO of 100. Make sure auto ISO is off!

6. Shoot your sequence in one-stop increments. I'm not saying that larger increments don't work; I just know that a one-stop bracket increment works very well.

7. Auto bracket may give you enough exposures on some cameras, but not on others. Use auto bracketing when adequate.

8. Start your exposure bracketing sequence with the short underexposures. This way, if you are interrupted and have to stop shooting, you will have more exposures under your belt than if you start on the looooong exposure end.

9. Turn off image stabilization, even if the manufacturer says it is OK to leave it turned on when shooting on a tripod. Using mirror lockup is a good idea for exposures of a few seconds or less.

10. Turn long-exposure noise reduction to on, not auto or off. Don't worry about high-ISO noise reduction as it has no bearing in your HDR work.

11. Bring a stopwatch if you don't have the more expensive remote release.

12. Be patient. Remember, most cameras require an amount of time for long-exposure noise reduction that's equal to the exposure itself. That is, if your exposure time is 4 minutes, the camera will take an additional 4 minutes to perform noise reduction after the shutter closes. This means you have a total wait time of 8 minutes.

13. Try to set up to avoid having direct light (sun, streetlights, etc.) in the frame or hitting the lens. HDR can't magically fix optical problems like flare and ghosting.

14. Dust, fingerprints, and smudges on your lenses will degrade your tonality and make for additional flare and ghost problems. Clean the front and rear elements of your lenses.

15. Make sure your battery is fully charged, and bring spares.

16. Remember the adage, "You can never be too thin, too rich, or have too many bracketed exposures." It's better to go overboard with exposures that seem overly light and overly dark than to get home and find you don't have enough highlight or shadow detail.

17. Have fun. And remember the words of Gordon MacKenzie: "Orville Wright did not have a pilot's license."

How I Actually Shoot a Scene

Now that you've read the guidelines, here's a synopsis of how I set up and shoot an HDR scene myself. This is pretty much the same for any scene, day, night, interior, etc.

1. Position the camera and tripod solidly, paying attention to level and tilt.

2. Try to avoid having direct light hit the lens (use your shade).

3. Focus via magnified live view (preferred) or autofocus. For night or other dim-light focusing, use the center autofocus area in your camera because it is usually more sensitive than the peripheral focus spots in the viewfinder.

4. Choose an aperture that suits the subject and depth of field needs.

5. Make a high-ISO test exposure.

6. Evaluate the test exposure for focus, depth of field, and composition. Also, you'll get a feel for the dynamic range of the scene via your histogram and the image on the LCD.

7. Begin the bracketed series with the shortest, darkest exposures, working toward the longer, lightest ones.

A Typical HDR Night Assignment

The "Trees and Truck at Midnight" image that began this section was a particularly dynamic landscape. I made this image in late 2008 while visiting family in north Texas. A lone streetlight up in the trees provided strong backlight for the main subjects—the truck and live oak trees. There was no way a single exposure was going to capture detail in both the bright highlights and deep shadows, so HDR was perfectly suited for this image.

The following figure shows six images in the order in which they were exposed. The first frame in the upper left is my test shot. If you read the exposure information below the thumbnail, you'll see that it is 30 seconds at f4. It is dark, but most meters (including mine) stop working at anything over 30 seconds, so in this case I used this longest non-bulb exposure as a guide for depth of field and to get a feel for how hot the highlights were. The test shot told me two things:

- I should stop down to 5.6 to get a smidge more depth of field.

- My highlights were too hot and would need a couple stops less exposure to hold detail in the final image.

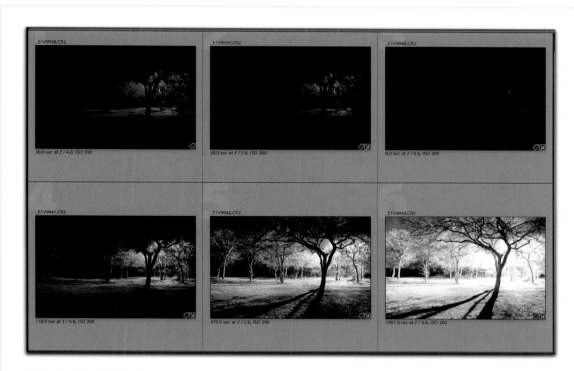

Test shot and bracketed series

Gleaning information from that first test shot will help you get a better HDR series, so don't skip that step.

In the figure, you can see that the color rendition difference between the first *test* shot frame and the other images is because of the white balance changes applied to the remaining five captures that were used in the HDR processing. The next thing to notice is that after the 30 seconds at f5.6 exposure (top row, middle frame), I reduced the exposure time to 8 seconds (two stops less) to be sure I had plenty of highlight detail. Juggling exposure intervals like this is fine and will cause no problem with the software you're about to use to meld the series together.

I continued to increase exposure times in two-stop increments until I had sufficient detail in the dark tree bark in the foreground. Normally I would expose a wider range of bracketed images, but in this case I knew that I needed just a bit of shadow detail in the nearly silhouetted tree trunks for the final image I visualized.

Use Your Camera's Custom Modes

Most enthusiast and professional DSLR cameras have custom modes (or sets) that can be saved for easy recall. These are like memory banks that hold a specific group of camera settings, making it fast and easy to get your camera in the right mode for specific kinds of shooting, like HDR.

On my camera, I have reserved two of its three custom sets for HDR shooting. One is for auto bracketing scenes that don't need an extensive set of manually bracketed images. The other puts my camera into manual shooting mode with mirror lockup engaged, my favorite ISO and aperture (yes, I have a favorite aperture), and it includes all the other shooting specs I employ for HDR exposing. For example, my camera does not focus with a half press of the shutter button, ensuring that autofocus will not throw my bracketed series out of registration.

Things to Do in Development Prior to Combining HDR Exposures

Because you're relying on the bracketed series to provide the tonal richness in your final image, you don't need to jump through processing hoops with your RAW captures. There are a few things you should do in your RAW processor of choice before melding the bracketed series into an HDR image:

1. Correct the white balance.
2. Retouch sensor dust, flare, or flaws you never want to see again.
3. Correct chromatic aberrations (CA).
4. Employ noise reduction.

As you see, it is not a long list, but it is an important one. Taking the time in your RAW processing to fix these problems will pay off in big time savings later. Chromatic aberration, in particular, is aggravated by the HDR steps, so correcting it before you start HDR processing is a step you don't want to forego. Other adjustments like exposure are a no-no at this stage.

The Importance of Tone Mapping

When high dynamic range scenes are first composited into a lower dynamic range, the tonality can appear quite flat. Tone mapping is a technique that we utilize to make the tonality of HDR images more pleasing. Sometimes people process their HDR images with a heavy hand, creating an edgy HDR look that probably should be referred to as a tone mapped look. Whether you choose to apply a gentle amount of tone mapping for a natural look or a lot of tone mapping for an edgy look, you'll need tone mapping for your HDR images. Here's a breakdown of some of the software options you have to meld the rich range of tonality you've harvested.

Using Third-Party Software

Though Adobe may upgrade their HDR module in CS5, CS4's processing is so awkward (and just plain terrible) that you *must* invest in additional software if you want to competently process HDR images. Nearly everyone working in HDR is using software from HDRsoft (www.hdrsoft.com). In fact, every image in my book, *The Color of Loss* (University of Texas Press, 2008), was processed with the HDRsoft Tone Mapping plug-in. The dark, moldy interiors of post-Katrina New Orleans that I documented in the book required exposures running up to 16 minutes to capture shadow detail.

Other HDR applications and plug-ins include Topaz Adjust (www.topazlabs.com) and LR/Enfuse (www.photographers-toolbox.com). Timothy Armes's LR/Enfuse is an exciting new Lightroom plug-in that combines multiple exposures very quickly for a surprisingly streamlined process without fussing with complicated tone mapping options. LR/Enfuse is discussed at the end of this chapter.

Although these are the most notable tools at the time of this writing, I won't be surprised when RAW processing applications eventually include HDR compositing with tone mapping capabilities and eliminate the need for third-party software altogether.

Merging the Bracketed Frames into a 32-Bit HDR Image

Photoshop's "Combine as HDR" versus Photomatix Pro for combining HDR exposures

Photomatix Pro has big advantages in dealing with alignment issues or subject movement. Say you have tree branches moving in your bracketed series. Photomatix Pro has a nifty option to better blend the branches, saving you retouching headaches later on. Or what if your tripod was slowly sinking in the sand as you shot your series? Photomatix Pro can do near-magic alignment on your bracketed images to eliminate any misalignment problems.

If you decide to use Photoshop's "Combine as HDR" you can use HDRsoft's Tone Mapping Photoshop plug-in afterwards and do all of your HDR work in Photoshop. I prefer this option when I'm not faced with issues of alignment or subject movement. In fact, for the New Orleans images, because everything in the series was static and stable, this workflow let me work from within Photoshop with nary a thought to launching other software. It saved me time and energy compared to using the stand-alone Photomatix Pro application.

Bottom line: Use Photoshop's "Combine as HDR" and HDRsoft's Tone Mapping plug-in if everything is steady, and use Photomatix Pro if you have subject movement issues to deal with.

You can merge the bracketed series of images into a 32-bit HDR image in Photoshop. Let's look at doing this from Lightroom and Bridge.

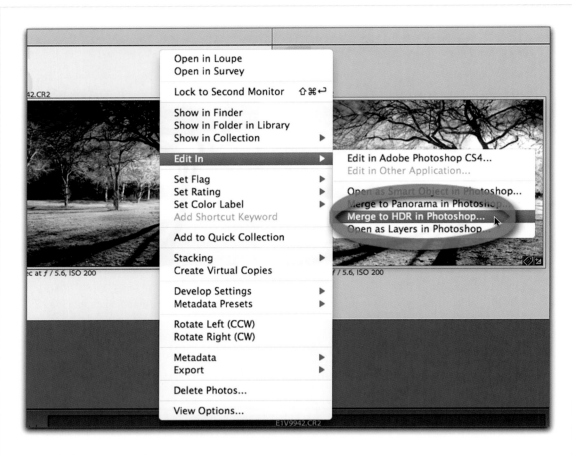

Merging the bracketed series from Lightroom

The previous figure shows how I merge the series of five images (remember, one is a test shot only) into a 32-bit image from Lightroom. The steps for Bridge are similar, as shown in the next figure.

Both of these merging methods will bring you face to face with the Merge to HDR dialog box as shown in the figure on page 172. Yes, you are now in the land of Photoshop.

Sometimes things are nice and simple. See the circled-in-red OK button? The *one and only* thing you have to do with this dialog box is click that button! Don't bother messing with anything else—you'll just be spinning your wheels. (Geek alert: There must be something nerdy you can do

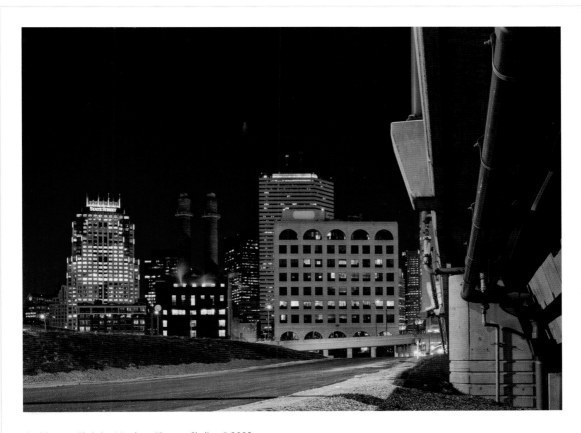

Final image. Christian Waeber, "Boston Skyline," 2008

"There is more than one way to skin a cat" is such a ghastly saying, isn't it? But it sure does apply to Photoshop. There are many other ways to make your selection, refine its edges, and blend it over the background image, not to mention the endless possible slider settings in ACR. Combine these and you get hundreds of possibilities, all yielding similar final prints. Hopefully, this section will give you a general idea of how different exposures can easily be combined to capture night photographs with a wide dynamic range.

Christian developed his technique over a long period of time with lots of experimentation, and it works well for him. If you've worked with Photoshop for any length of time, you know that there are many different ways to achieve similar results. You can blend exposures with layer masks, paint and erase layers with varying opacities, or combine exposures using curves

and different blending modes. If you use Photoshop in your workflow, try as many different solutions as you can imagine. Share your experiences with other users. Photoshop is such a large and complex application that there will always be a new trick to learn and someone who can show you a new way to accomplish your goals. The right solution is the one that works for you. Now let's look at high dynamic range imaging using Photoshop and Photomatix with Dan Burkholder.

Dan Burkholder: Making Darkness an Asset Instead of a Liability

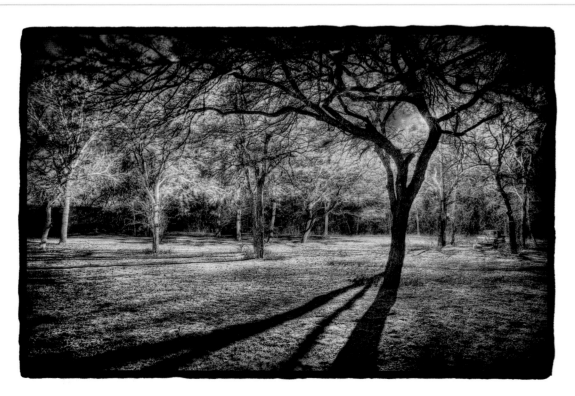

Dan Burkholder, "Trees and Truck at Midnight," Texas, 2008
The final print is platinum–palladium on vellum over gold leaf print.

What Is High Dynamic Range Imaging?

Just in case you've been sleeping through the last several years of photography's evolution, high dynamic range (HDR) has impacted the photography world in a major way. Some are even claiming that HDR is the newest cliché in photography. No matter what you think of HDR, it can be a terrific tool for night photography. Let's take a look.

Dynamic range refers to the luminance range in the subject, from the darkest blacks (deep shadows under a wet log, for example) to the brightest highlights (like sunlight on a white painted wall). Ever since Niépce captured the first photographic image in 1826, one of the medium's recurring challenges has been to capture that entire dynamic range on photosensitive materials. Each photographic capture medium, be it film or digital sensor, has a limit to how much viable information it can record in both shadow and highlight areas. But no matter what capture medium you use, you'll run into situations that overtax its capabilities, sometimes making you put your camera away with a shrug and a sigh, "I love the direction of light in this scene, but there's just no way I can get detail in all the areas I want." Sound familiar? HDR will let you keep shooting when you would have given up before.

Without going into a discussion of how film and sensors compare, I recommend resorting to HDR when *no single capture*—film or digital—can possibly hold detail in both ends of the scene's dynamic range. You do not need HDR if a single capture successfully holds tones throughout the image. In other words, reserve HDR for those high dynamic range shooting conditions that really need it. If you shoot only in foggy or moonlit conditions, the dynamic range in your scenes will be low, therefore you needn't worry about HDR. Night photography that includes artificial light, on the other hand, can offer up very high dynamic range conditions, making it difficult to capture both ends of the tonal scale in a single exposure.

Various methods of dynamic range control have been employed during the last 185 years of photography. *Control* could mean providing supplemental light (fill flash, reflectors, or other lights) to reduce the contrast range. Film shooters have utilized the Zone System in which they combine judicious exposure with carefully calculated film development to produce a negative that can print both shadows and highlights in the darkroom. HDR is just the latest—and best— way to successfully tackle high dynamic range scenes in front of your camera.

At the Heart of HDR

As you've probably guessed, at the heart of HDR is shooting a bracketed series of images, changing only your shutter speed. This series should have detail at both ends of the luminance range; your darkest exposure should have midtone highlights, and your lightest exposure should have midtone shadows. Read that sentence again if need be; the message is that you want very detailed highlights and very open shadows in your bracketed series.

How Many Bracketed Exposures Do You Need?

The most common question in HDR is, "How many bracketed exposures should I make?" Like most things in photography (and life), the answer is, it depends. The dynamic range in your scene will determine the number of exposures needed. I've done as few as three exposures and as many as 16 (the latter in a particularly dark and contrasty interior in post-Katrina New Orleans). And most recently, I have used a new crop of digital cameras that will rapidly take different exposures and automatically combine them into a single HDR image.

How Should I Bracket?

Some cameras have very good auto bracketing. Nikon's more advanced cameras allow for up to nine bracketed exposures automatically. Canon's pro cameras provide seven exposures, which might seem like a failing compared to Nikon's until you look at the whole picture. When you take into account that Nikons can only bracket maximally in one-stop increments (giving you ± four stops in that nine-stop bracket) and Canons can do up to three-stop increments (offering ± *nine* stops in a seven-exposure bracketed series), the balance shifts.

What Kind of Exposure Increment Should I Use for My Bracketed Series?

Ask enough photographers and you'll get every possible answer on the issue of how far apart your exposures should be. For casual daylight landscape shooting, a simple three-exposure bracket—normal, two stops over, and two stops under—can often do the trick. For my most serious work, I prefer to bracket in one-stop increments. This approach follows the advice that "the more information you give Photoshop, the better the results." I recommend that students of HDR run some tests of their own, shooting in single-stop increments, two-stop increments, and three-stop increments. Comparing your results from real shooting situations will give you the best feel for what increments match your subject matter and camera.

Shooting Guidelines for Making Successful HDR Captures

To make a successful HDR image, you combine special shooting techniques in the field with software steps in your digital darkroom. Let's look at some shooting tips first. I have compiled a set of guidelines that will help steer you in the right direction in the field. These are things I've observed during my years of capturing HDR images, but it is by no means a complete list, so feel free to add to it as you discover other shooting tips that enhance your HDR captures.

1. Use a solid tripod and quick release clamp. You won't use a tripod unless it's easy, fast, and convenient to do so.

2. Use a remote release. Get a better (more expensive) one that has an LCD screen that lets you set long exposure times easily. The LCD should also be illuminated to make setting long exposures easier. Carry a spare battery for the remote release.

3. Turn off autofocus or set your camera so it only focuses when you push a button on the back. You don't want it to try to focus every time you half-press the shutter release or remote release.

4. Use aperture priority or manual exposure mode. You want your aperture to stay constant; only your exposure time should vary.

5. Use the native ISO on your camera. This doesn't necessarily mean the absolute lowest ISO. The Canon 5D, for example, has an extended range that offers ISO 50. Sadly, that lower ISO has a dynamic range lower than the native ISO of 100. Make sure auto ISO is off!

6. Shoot your sequence in one-stop increments. I'm not saying that larger increments don't work; I just know that a one-stop bracket increment works very well.

7. Auto bracket may give you enough exposures on some cameras, but not on others. Use auto bracketing when adequate.

8. Start your exposure bracketing sequence with the short underexposures. This way, if you are interrupted and have to stop shooting, you will have more exposures under your belt than if you start on the looooong exposure end.

9. Turn off image stabilization, even if the manufacturer says it is OK to leave it turned on when shooting on a tripod. Using mirror lockup is a good idea for exposures of a few seconds or less.

10. Turn long-exposure noise reduction to on, not auto or off. Don't worry about high-ISO noise reduction as it has no bearing in your HDR work.

11. Bring a stopwatch if you don't have the more expensive remote release.

12. Be patient. Remember, most cameras require an amount of time for long-exposure noise reduction that's equal to the exposure itself. That is, if your exposure time is 4 minutes, the camera will take an additional 4 minutes to perform noise reduction after the shutter closes. This means you have a total wait time of 8 minutes.

13. Try to set up to avoid having direct light (sun, streetlights, etc.) in the frame or hitting the lens. HDR can't magically fix optical problems like flare and ghosting.

14. Dust, fingerprints, and smudges on your lenses will degrade your tonality and make for additional flare and ghost problems. Clean the front and rear elements of your lenses.

15. Make sure your battery is fully charged, and bring spares.

16. Remember the adage, "You can never be too thin, too rich, or have too many bracketed exposures." It's better to go overboard with exposures that seem overly light and overly dark than to get home and find you don't have enough highlight or shadow detail.

17. Have fun. And remember the words of Gordon MacKenzie: "Orville Wright did not have a pilot's license."

How I Actually Shoot a Scene

Now that you've read the guidelines, here's a synopsis of how I set up and shoot an HDR scene myself. This is pretty much the same for any scene, day, night, interior, etc.

1. Position the camera and tripod solidly, paying attention to level and tilt.

2. Try to avoid having direct light hit the lens (use your shade).

3. Focus via magnified live view (preferred) or autofocus. For night or other dim-light focusing, use the center autofocus area in your camera because it is usually more sensitive than the peripheral focus spots in the viewfinder.

4. Choose an aperture that suits the subject and depth of field needs.

5. Make a high-ISO test exposure.

6. Evaluate the test exposure for focus, depth of field, and composition. Also, you'll get a feel for the dynamic range of the scene via your histogram and the image on the LCD.

7. Begin the bracketed series with the shortest, darkest exposures, working toward the longer, lightest ones.

A Typical HDR Night Assignment

The "Trees and Truck at Midnight" image that began this section was a particularly dynamic landscape. I made this image in late 2008 while visiting family in north Texas. A lone streetlight up in the trees provided strong backlight for the main subjects—the truck and live oak trees. There was no way a single exposure was going to capture detail in both the bright highlights and deep shadows, so HDR was perfectly suited for this image.

The following figure shows six images in the order in which they were exposed. The first frame in the upper left is my test shot. If you read the exposure information below the thumbnail, you'll see that it is 30 seconds at f4. It is dark, but most meters (including mine) stop working at anything over 30 seconds, so in this case I used this longest non-bulb exposure as a guide for depth of field and to get a feel for how hot the highlights were. The test shot told me two things:

- I should stop down to 5.6 to get a smidge more depth of field.

- My highlights were too hot and would need a couple stops less exposure to hold detail in the final image.

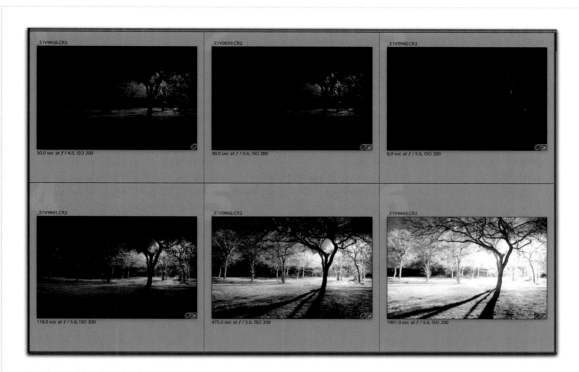

Test shot and bracketed series

Gleaning information from that first test shot will help you get a better HDR series, so don't skip that step.

In the figure, you can see that the color rendition difference between the first *test* shot frame and the other images is because of the white balance changes applied to the remaining five captures that were used in the HDR processing. The next thing to notice is that after the 30 seconds at f5.6 exposure (top row, middle frame), I reduced the exposure time to 8 seconds (two stops less) to be sure I had plenty of highlight detail. Juggling exposure intervals like this is fine and will cause no problem with the software you're about to use to meld the series together.

I continued to increase exposure times in two-stop increments until I had sufficient detail in the dark tree bark in the foreground. Normally I would expose a wider range of bracketed images, but in this case I knew that I needed just a bit of shadow detail in the nearly silhouetted tree trunks for the final image I visualized.

Use Your Camera's Custom Modes

Most enthusiast and professional DSLR cameras have custom modes (or sets) that can be saved for easy recall. These are like memory banks that hold a specific group of camera settings, making it fast and easy to get your camera in the right mode for specific kinds of shooting, like HDR.

On my camera, I have reserved two of its three custom sets for HDR shooting. One is for auto bracketing scenes that don't need an extensive set of manually bracketed images. The other puts my camera into manual shooting mode with mirror lockup engaged, my favorite ISO and aperture (yes, I have a favorite aperture), and it includes all the other shooting specs I employ for HDR exposing. For example, my camera does not focus with a half press of the shutter button, ensuring that autofocus will not throw my bracketed series out of registration.

Things to Do in Development Prior to Combining HDR Exposures

Because you're relying on the bracketed series to provide the tonal richness in your final image, you don't need to jump through processing hoops with your RAW captures. There are a few things you should do in your RAW processor of choice before melding the bracketed series into an HDR image:

1. Correct the white balance.
2. Retouch sensor dust, flare, or flaws you never want to see again.
3. Correct chromatic aberrations (CA).
4. Employ noise reduction.

As you see, it is not a long list, but it is an important one. Taking the time in your RAW processing to fix these problems will pay off in big time savings later. Chromatic aberration, in particular, is aggravated by the HDR steps, so correcting it before you start HDR processing is a step you don't want to forego. Other adjustments like exposure are a no-no at this stage.

The Importance of Tone Mapping

When high dynamic range scenes are first composited into a lower dynamic range, the tonality can appear quite flat. Tone mapping is a technique that we utilize to make the tonality of HDR images more pleasing. Sometimes people process their HDR images with a heavy hand, creating an edgy HDR look that probably should be referred to as a tone mapped look. Whether you choose to apply a gentle amount of tone mapping for a natural look or a lot of tone mapping for an edgy look, you'll need tone mapping for your HDR images. Here's a breakdown of some of the software options you have to meld the rich range of tonality you've harvested.

Using Third-Party Software

Though Adobe may upgrade their HDR module in CS5, CS4's processing is so awkward (and just plain terrible) that you *must* invest in additional software if you want to competently process HDR images. Nearly everyone working in HDR is using software from HDRsoft (www.hdrsoft.com). In fact, every image in my book, *The Color of Loss* (University of Texas Press, 2008), was processed with the HDRsoft Tone Mapping plug-in. The dark, moldy interiors of post-Katrina New Orleans that I documented in the book required exposures running up to 16 minutes to capture shadow detail.

Other HDR applications and plug-ins include Topaz Adjust (www.topazlabs.com) and LR/Enfuse (www.photographers-toolbox.com). Timothy Armes's LR/Enfuse is an exciting new Lightroom plug-in that combines multiple exposures very quickly for a surprisingly streamlined process without fussing with complicated tone mapping options. LR/Enfuse is discussed at the end of this chapter.

Although these are the most notable tools at the time of this writing, I won't be surprised when RAW processing applications eventually include HDR compositing with tone mapping capabilities and eliminate the need for third-party software altogether.

Merging the Bracketed Frames into a 32-Bit HDR Image

Photoshop's "Combine as HDR" versus Photomatix Pro for combining HDR exposures

Photomatix Pro has big advantages in dealing with alignment issues or subject movement. Say you have tree branches moving in your bracketed series. Photomatix Pro has a nifty option to better blend the branches, saving you retouching headaches later on. Or what if your tripod was slowly sinking in the sand as you shot your series? Photomatix Pro can do near-magic alignment on your bracketed images to eliminate any misalignment problems.

If you decide to use Photoshop's "Combine as HDR" you can use HDRsoft's Tone Mapping Photoshop plug-in afterwards and do all of your HDR work in Photoshop. I prefer this option when I'm not faced with issues of alignment or subject movement. In fact, for the New Orleans images, because everything in the series was static and stable, this workflow let me work from within Photoshop with nary a thought to launching other software. It saved me time and energy compared to using the stand-alone Photomatix Pro application.

Bottom line: Use Photoshop's "Combine as HDR" and HDRsoft's Tone Mapping plug-in if everything is steady, and use Photomatix Pro if you have subject movement issues to deal with.

You can merge the bracketed series of images into a 32-bit HDR image in Photoshop. Let's look at doing this from Lightroom and Bridge.

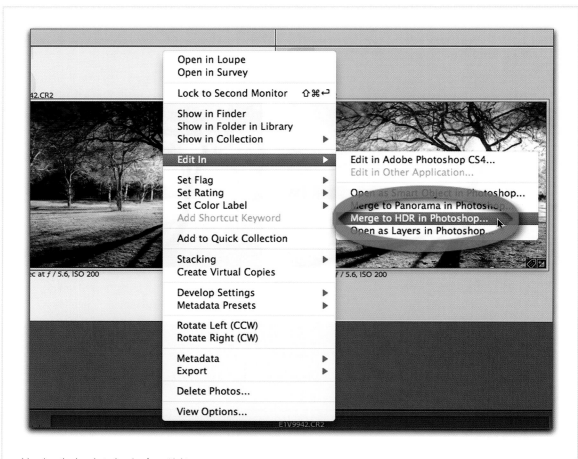

Merging the bracketed series from Lightroom

The previous figure shows how I merge the series of five images (remember, one is a test shot only) into a 32-bit image from Lightroom. The steps for Bridge are similar, as shown in the next figure.

Both of these merging methods will bring you face to face with the Merge to HDR dialog box as shown in the figure on page 172. Yes, you are now in the land of Photoshop.

Sometimes things are nice and simple. See the circled-in-red OK button? The *one and only* thing you have to do with this dialog box is click that button! Don't bother messing with anything else—you'll just be spinning your wheels. (Geek alert: There must be something nerdy you can do

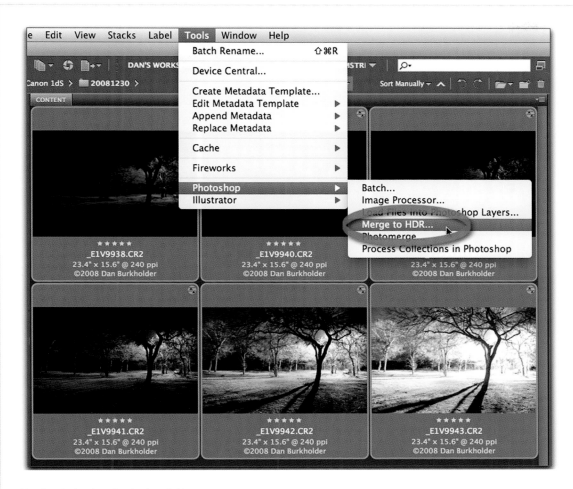

Merging the bracketed series from Bridge

with the Response Curve option, but I have no idea what it is.) After clicking the OK button, your merged exposures open in Photoshop as a 32-bit image as in the figure on page 173.

Caution: Important Step Ahead!

This is really important, so listen up. What Photoshop just did while you sat back and watched was an amazing bit of computation. It took all that tonal information from your bracketed series and melded it into a special deep-bit image called a 32-bit image. But in the midst of all that

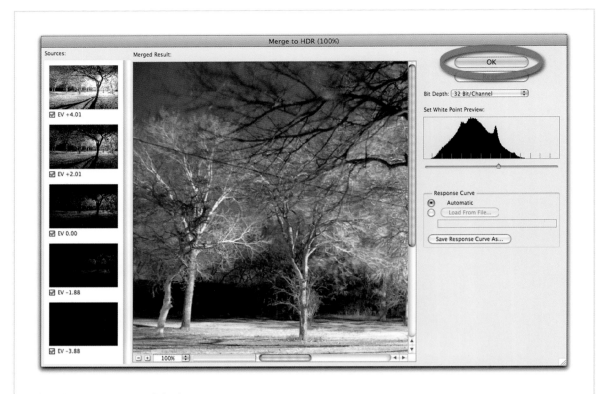

Photoshop's Merge to HDR dialog box

wonder, it did one thing we don't want. Notice the circled item in the following figure. This is the bad thing that Photoshop did. Fortunately the fix is easy. Just access your History panel and click the Image Size step immediately above the unwanted 32-Bit Preview Options. All you're doing is shedding that last step.

When you shed that unwanted History state, your image will usually darken a bit. Compare the tonality of the image in the figure on page 174 with the History in its desired state.

At this point you might be tempted to exclaim, "but my image looks like poop!" (odds are your choice of words will be more colorful). Fear not, what you're seeing on your monitor is an uncorrected 32-bit image that will never look pretty. Tone mapping will take care of that.

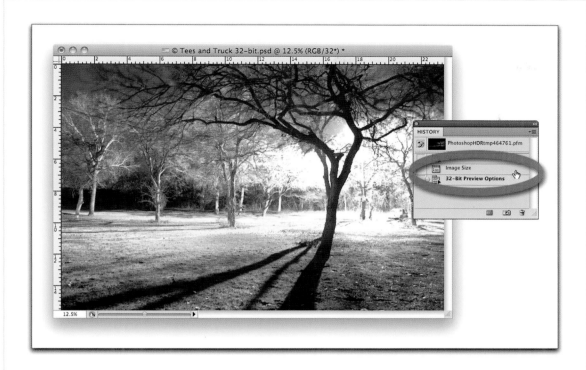

Shedding the 32-Bit Preview Options in the History panel

Using the Tone Mapping Plug-In

Before going any further, I should mention that the Tone Mapping plug-in (as well as the stand-alone application, Photomatix Pro) costs money. But believe me, it'll be the best expenditure you can make if you're going to do HDR imaging!

A strange thing the Tone Mapping plug-in does is to *remember* the last settings you used, which is supposedly doing you a favor by having the dialog box open with your previous settings selected. If you happen to shoot and process exactly the same subjects over and over, this might actually save you some time. Speaking for myself, I hardly ever want to repeat the previous setting, so I always click the Default button as shown in the figure on page 176.

One thing you should notice in the figure is how much better the image looks, even without fine-tuning the various sliders and options in the Tone Mapping dialog box. I like to compare the Tone

Image after shedding the 32-Bit Preview Options in the History panel

Mapping dialog box to the story of Goldilocks, where there was a bed that was too large, a bed that was too small, and a bed that was just right. The Tone Mapping dialog feels just right. It's not too basic, and it's not overly complicated.

Some Guidelines to Tone Mapping

To help you get oriented with your tone mapping adventures, here's a short list of things to click, slide, and observe in the Tone Mapping dialog box. Though the cosmetics will be slightly different, you'll find that the stand-alone Photomatix Pro has pretty much the same set of controls as shown in the figure on page 177. Follow along as we discuss niftily numbered items.

1. Unless you're working with a screen resolution so low that it would embarrass the typical 8-year-old, you will probably want to increase the image size by choosing either the 768 or 1024 setting

Executing the Tone Mapping plug-in

The Tone Mapping dialog box

at the top of the dialog box, just to the left of the OK button. It would be nice if this setting stuck, but alas, it will revert to the lowly 512 size each and every time you open the tone mapping filter.

2. The Show Original button is invaluable. Clicking this repeatedly provides a before-and-after preview of your tone mapping results. You'll want to use this button often as you check to see if your adjustments are good or if they are taking the image in bad directions.

Controls within the Tone Mapping dialog box

3. We're jumping down to the histogram for a minute because it is so crucial that you watch it as you make all your adjustments. Just as any other histogram is an all-revealing thesis about the tonality of your image, here too you'll use it to detect blown highlights, clipped shadows, and the distribution of midtones.

4. Strength is our first and most important control. If you want an on-the-fly description of what this and other controls do, just hover over the slider or radio button for a moment to

get a pop-up note. As the pop-up note says, this slider controls the strength of contrast enhancements. If you take the strength too low, you'll lose much of your tone mapping effect. If it's too high, you might get an exaggerated look (see the advice on the grunge look later on). I'm usually in the upper half for strength.

5. Color Saturation is a tricky one. My personal feeling is that I have much more control over saturation in Photoshop, so I usually move this slider only if the color in the tone mapped image looks especially flat or oversaturated. More times than not, I don't even touch this adjustment.

6. Light Smoothing is critical. It really should be called halo control because we use Light Smoothing to minimize (usually) a telltale halo around areas of varying tonality. Judging by much of the HDR imagery we're currently seeing on the Web, many practitioners love to move this slider all the way to the left, resulting in an artificially puckered look. In almost 4 years of tone mapping, I've never used the 2 setting; I'm usually at 0 or 1.

7. Luminosity works predictably, lightening or darkening the shadows accordingly. Dial this one in visually and you can't go wrong. But you might find yourself revisiting this (and other) controls as you tweak other things like Microcontrast (to be explained shortly).

8. The Tabs section is divided into Tone, Color, Micro, and S/H (Shadow/Highlight). Let's look at the subset of controls in each of these tabs, starting with the Tone tab, as selected in the previous figure.

White Point is used to control highlight clipping. Look closely at the right side of the histogram in the previous figure and you'll see that there is a spike representing blown highlights. Moving the White Point slider to the left would tame this clipping easily. Similarly, moving it to the right will extend the histogram to the right to compensate for flat images. Black Point is used to control the black point in the image. I adjust this about one-fifth as often as the white point. Go visual and watch your histogram as you move the slider. Gamma is somewhat crude, as adjustments go. You expect midtones to be affected, but I find that Gamma moves many more tones in the image than I'd prefer. Go easy and gentle with this one.

Clicking the Color tab shows a subset of controls as illustrated in the following figure. Much like the Color Saturation slider in the main section of the dialog box, I don't do much with the Color tab. After all, you were advised to correct white balance earlier, right? Having said that, if the saturation in highlights is going wacky, I will gently lower the Saturation Highlights slider. Rarely will I mess with the Saturation Shadows control.

Unlike the Color tab, the Micro tab's controls in the second figure on the following page are critical. Microcontrast enhances local detail. Adjust this to taste. Be aware that adding Microcontrast often darkens the image. If this happens with your images, you might return to the Luminosity

The Color tab controls

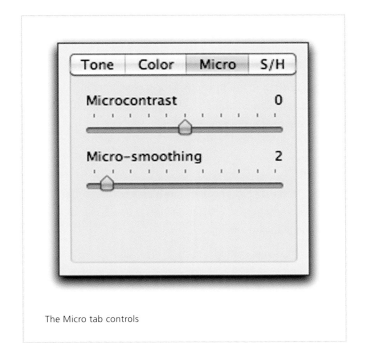

The Micro tab controls

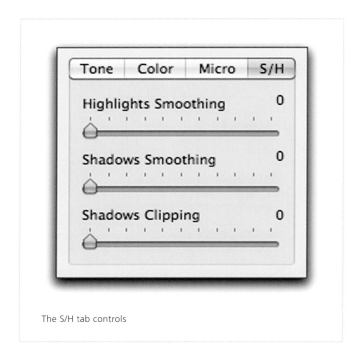

The S/H tab controls

slider or—less desirably—to the Gamma slider (in the Tone tab) to compensate for the darkening. Micro-smoothing alleviates a grittiness in smooth midtones that can accompany too much Microcontrast. If you see a pepperiness in skin tones or skies, try raising the Micro-smoothing.

If you find a use for the S/H tab in the previous figure, please let me know. Honestly, of course there will be a rare occasion in which the S/H tab comes in handy, but, to tell you the truth, if this tab were to disappear I'd probably never notice it.

So You Like the Grunge Look?

A popular look in the world of HDR has become known at the grunge effect. This look accentuates local detail, giving a gritty appearance to the image. If you'd like to try this, here are a few suggestions for your tone mapping settings.

- Take Strength to its maximum setting.

- Play with Light Smoothing, favoring 0 or 1 values.

- Try very high Microcontrast values. Remember, this can darken your image, so you might have to tweak Luminosity and/or Gamma to compensate.

The Tone Mapped Image Doesn't Look Like What I Saw in the Dialog Box!

If you find, after clicking OK, that your image doesn't resemble what you saw in the Tone Mapping dialog box, that's a pretty good indication that you didn't shed that 32-Bit Preview Options in your History panel as described earlier. If you'd like to check this manually at any time, navigate to View > 32-Bit Preview Options. Your exposure should read 0.00, and your gamma should be 1.00 in the 32-Bit Preview Options dialog box. (This menu item is only available while your image is in 32-Bit Mode.)

Using Photomatix Pro Instead of the Tone Mapping Plug-In

Now that we've covered the Tone Mapping plug-in, let's talk oh so briefly about Photomatix Pro. As previously mentioned, this software can do additional alignment and subject movement corrections that the Tone Mapping plug-in can't. The next figure shows how to export your bracketed series of images from Lightroom to Photomatix Pro. Using the stand-alone Photomatix Pro application is largely the same.

The next figure shows the Photomatix Pro dialog box. I've enclosed in red the Alignment and Subject Motion options that are part of Photomatix Pro's appeal. Choose these options when they are appropriate for your set of bracketed images.

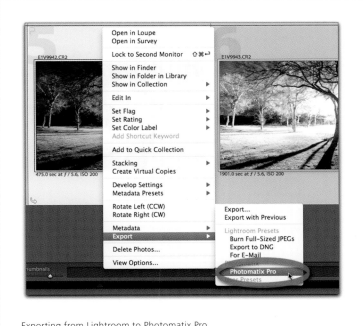

Exporting from Lightroom to Photomatix Pro

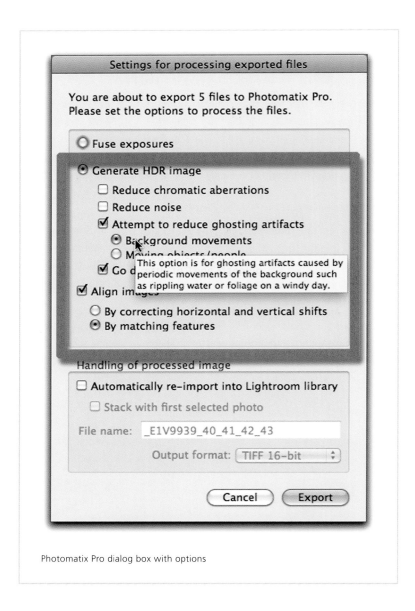

Photomatix Pro dialog box with options

Compromised Midtones in Your HDR Images

All is not perfect in HDR-land. The HDR process usually produces lush shadow detail and velvety highlight separations, just what we want instead of dumped shadows and chalky highlights. The flip side of the coin is that midtone contrast is sometimes compromised as a collateral effect. If

you find this midtone compression in your HDR images—it manifests as flat, lifeless midtones—you'll start building your image with selections, adjustment layers, and masks, just as you would for any non-HDR image.

Before you can do any serious layer construction, you should convert your 32-bit image to a 16-bit version (in Photoshop, navigate to Image > Mode > 16-Bits/Channel). If you don't convert to the lower bit depth, you'll be locked out of our most valuable of all adjustment layers: curves. In the following figure, you can see that you can't create a curve adjustment layer on a 32-bit image.

No curves in 32-bit images!

Weird Colors or Saturation

On occasion your processed and tone mapped images will display unacceptable colors. Sometimes it's simply because HDR images have more color in areas that would otherwise be empty shadows or blown highlights. But sometimes exaggerated colors are an unwelcome artifact of the process.

One simple solution I use is as follows:

1. From your bracketed series, select a midrange image that has the best tones across the board (don't worry if it's not perfect; that's why you're doing HDR, after all).

2. Process this image to be flat and have low contrast. Keep your black settings at 0 and use some recovery and fill light to best massage those tones.

3. Open this flat, single capture in Photoshop and shift–drag it onto the top of your HDR image. You want it to land on the top of the layer stack. Note that the standard version of CS3 and CS4 does not support 32 bit layers, so if you own this version instead of the extended package, you will have to convert your image to 16 bit before dragging the image.

4. Put this dragged layer in Saturation or Color mode. Try both because sometimes one will give better results than the other.

Final Notes

What we've covered so far should give you an idea of how I use HDR in night and other dark-environment photography. Again, this is a rapidly evolving medium, so doubt everything I say and test everything that matters in your shooting.

In the many HDR classes I've taught globally, I've found that learning HDR methods accomplishes two things, in addition to discovering how to capture more tones in high dynamic range conditions:

- Students become much more familiar with their cameras.
- They deepen their understanding of Photoshop.

So, heck, even if you don't shoot HDR in the dark, you're going to be more intimate with your hardware and software. And that, my friends, will make you a better photographer or artist.

Let's be honest—HDR techniques are simply methods designed to overcome the limited dynamic range of our camera sensors. With sensor development moving forward at an astonishing pace, anyone with foresight can easily predict that the HDR processes we learn tomorrow will be unnecessary in a few years. That's all well and good for our future shooting, but to paraphrase a former defense secretary, we go to digital imaging with the version of the sensor we have today, not the version we'd like to have.

Keep shooting, keep processing, keep playing. If you love the medium of photography, this dance is familiar and fun, and you'll be better because of your enthusiastic curiosity.

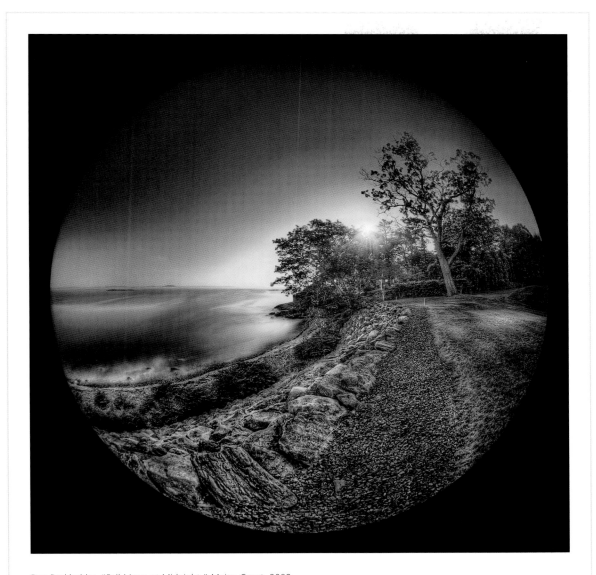

Dan Burkholder, "Full Moon at Midnight," Maine Coast, 2009

This image is a night HDR capture.

HDR WITH ENFUSE

The third and last HDR method we will address involves creating HDR images within Adobe Lightroom. LR/Enfuse is a Lightroom plug-in. It uses an engine called Enfuse that merges exposures of the same scene into a single image. The Enfuse engine is open source, and the LR/Enfuse plug-in is donationware from Timothy Armes at photographers-toolbox.com. With LR/Enfuse, you can quickly composite a series of exposures into a natural-looking 16-bit TIFF without fussing with sliders and options. The composite TIFF is made very quickly without leaving Lightroom, and it is automatically reimported into Lightroom next to the original image sequence. Because it creates a 16-bit file (as opposed to the usual 32-bit HDR file), you can immediately start developing the file in Lightroom after it is created. The results are similar to tone mapping but without the signature look often associated with tone mapped files created from HDR images. The Adjustment Brush has more to work with when dodging or burning small areas of the image. Recovery and Fill Light also have more to work with, and because they both utilize tone mapping, you can create that HDR look if you want to. But one of the best things about Enfuse is that the final image doesn't look like a tone mapped HDR file—it just looks like a great photograph with incredible highlight and shadow detail. What's even better is that the HDR file can be generated without leaving the application and fits perfectly within a fully parametric workflow.

Enfuse technology will surely evolve and be incorporated into other applications in the future because it is simple, fast, easy to use, and open source. For now, there is the Lightroom plug-in and a stand-alone graphical user interface (GUI) version, which is nice for those not using Lightroom.

LR/Enfuse Workflow

1. Select a series of two or more RAW exposures, making sure that the lightest one has full shadow detail and the darkest one preserves all important highlight detail. You can use as few as two images, but you will probably have better results with more exposures if the dynamic range is extreme.

2. Set the white balance, chromatic aberration, and noise reduction for one of the images, and sync these settings with the other images in the sequence. Do not change the other adjustments.

3. From the File menu, select Plug-in Extras > Blend exposures using LR/Enfuse.

4. In the dialog box that opens, check the box "Create blended image in the same folder as the primary image in the set."

5. Choose a file name for the Enfused image. Alternately, you can append a phrase like "HDR Master" to the end of your existing filename.

6. Select TIFF for Format, 16 Bit for Bit Depth, None or LZW for Compression, and ProPhoto or AdobeRGB for Color space, depending on which one you use in your workflow.

7. Check the boxes "Reimport image into Lightroom" and "Copy all metadata from the primary image to the final image."

Combine photos using Enfuse

Custom

| Output | Auto Align | Enfuse | Configuration |

☐ **Batch Mode (Blend all stacks containing at least one selected photo)**

Output file

☑ Create blended image in the same folder as the primary image in the set.

For filename, ⦿ use: []

◯ append [] to filename of primary image

Format: [TIFF ▾] Compression: [None ▾]

Bit Depth: [16 bits/component ▾] Colour space: [ProPhoto ▾]

After Blending

☑ Reimport image into Lightroom

☐ Open blended file in [Finder ▾]

☑ Copy all metadata from the primary image to the final image

Except: ☑ Shutter speed, ☑ Aperture, ☑ Focal length

Preview

☐ Generate new preview for every change made (Generate Preview)

(Cancel) (OK)

LR/Enfuse dialog box

There are other options for Enfuse, including an auto alignment function that can be used if the tripod moved between exposures, and you can change the blending parameters and create new presets, but the application works beautifully as preconfigured.

8. Click OK.

9. The Enfused 16-bit TIFF file will appear in your Lightroom library and catalog next to the original exposures, and it can be developed normally from that point.

LR/Enfuse two exposures

These two images that were exposed two stops apart will blend easily with Enfuse.
The clipping indicators are turned on to show shadow and highlight clipping.

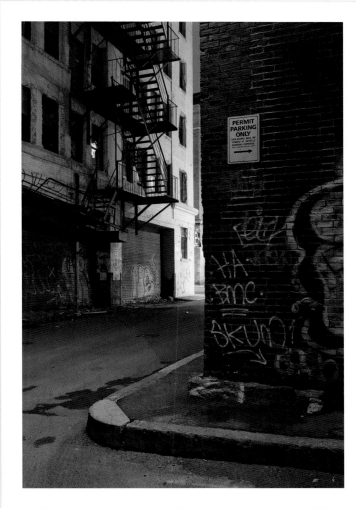

Final Enfused image. Lance Keimig, "Permit Parking Only," Boston, 2009

The final image required only minimal processing in Lightroom after Enfuse was used.

SUMMARY

We've discovered that when the scene's dynamic range exceeds the sensor's dynamic range, the difference can be compensated for with multiple captures that can be combined a number of different ways. There are other possibilities that haven't been discussed in this chapter, and new tools are being developed while the dynamic range of sensors increases with each new generation of camera. Night photography pushes the limits of DSLRs, but we have many great options to deal with these challenges.

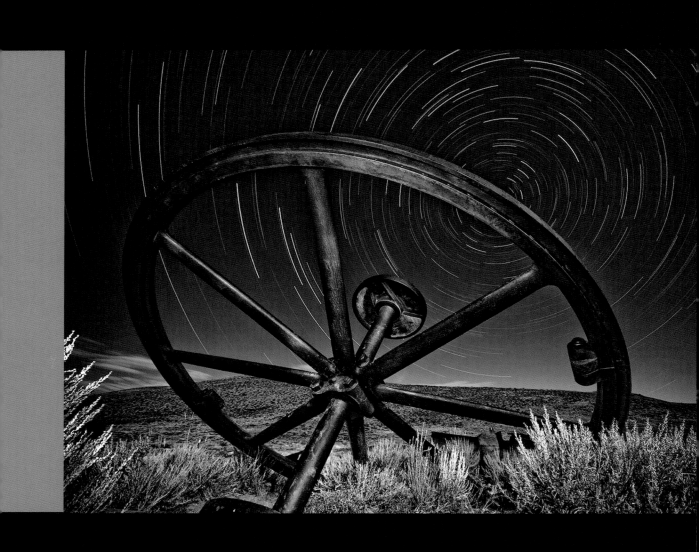

MOONLIGHT AND STAR TRAILS

DOI: 10.1016/B978-0-240-81258-8.00008-9

Photographing by moonlight can be a sublime experience. Rarely do we find ourselves alone in nature with the time and attitude to reconnect with the natural world in a very real way. It only takes a little while for our senses to open up to the night, for stress to melt away, and for creative juices to begin to flow. For many people, night photography, especially under a full moon, is as much about the experience of being in a place and creating the image as it is about the final product. The peace and solitude afforded by a night of full moon photography brings ample opportunities to ponder the great mysteries of the universe.

THE CHANGING NATURE OF MOONLIGHT

The Moon rises in the east and sets in the west every day, just like the Sun. The times depend on the phase of the Moon. It rises about 50 minutes later each day in the lunar cycle and is present in the daytime sky as often as it is at night. Throughout the lunar cycle, the new moon waxes to become a crescent moon, a half moon, a gibbous moon, and finally a full moon. It takes another 2 weeks to wane back to a new moon, completing the cycle every 28 days.

As the lunar cycle progresses, the Moon rises later each day during daytime, and it sets later and later each night. At the full moon, the Moon rises close to sunset, and it sets at about the same time that the Sun rises. As the Moon wanes, it rises during the night after sunset, rising later each night. It then sets in the daytime after the Sun rises. The new moon rises and sets with the Sun. At first quarter the Moon rises at about noon, and at last quarter it rises at about midnight.

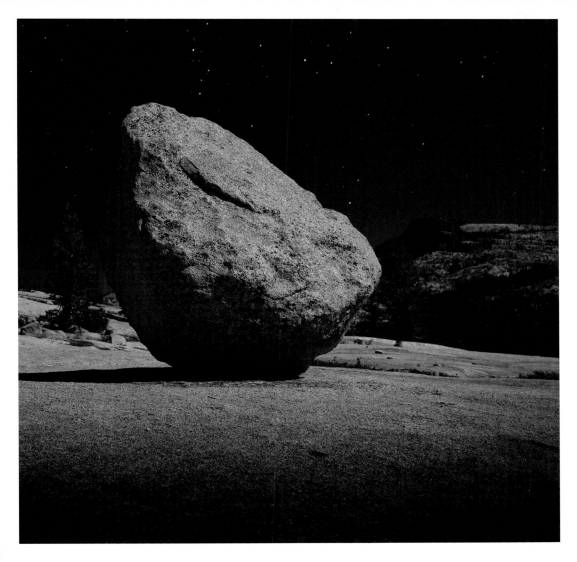

Lance Keimig, "Moonlight on Granite," Yosemite National Park, 2009

The light of the full moon and some fairly extensive processing in Lightroom illuminate the granite moonscapes of the High Sierra. Canon 5D Mark II, 35 mm f2.8 Zuiko shift lens, 30 seconds, f5.6, ISO 1600. The luminance and saturation of the blues were reduced using the HSL sliders to create a fairly natural-looking sky. The heavy processing exaggerated the existing noise in the image.

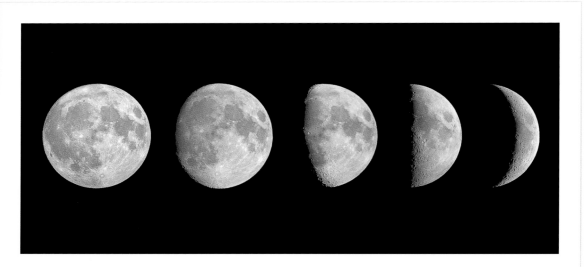

The progression of lunar phases from full to waning crescent

The position of the Moon in the sky is approximately inverse to that of the Sun. In other words, in the summer when the midday Sun is high overhead, the Moon tracks a lower arc across the nighttime sky. In winter, when the midday Sun never gets very high, the Moon is directly overhead at night. Just as with sunlight, the angle of the Moon relative to the Earth will affect the length of shadows. In photographs, shadows from moonlight will always appear softer than shadows in sunlight because of the Moon's movement in the sky during extended exposures.

The Moon moves about its own apparent diameter in the sky every 2 minutes, so a 2-minute exposure would show an elongated Moon that is twice as tall as it is wide. Long exposures that include the Moon in the frame will eventually render the Moon as a very bright and wide white line in the sky. An exposure of an hour or more begun at moonrise may show the moon traveling entirely through the image and out of the frame, depending on the angle of view and the position of the horizon.

Most moonlight photography is done within a few days of the full moon because that is when exposure times are practical. Calculating moonlight exposures is somewhat difficult because of the complexity of the numerous variables and difficulty in achieving accurate measurements of those variables. There is considerable variation in the brightness of light from the full moon from month to month, but film shooters can easily accommodate for this variation by bracketing. Digital shooters can determine the optimal exposure by performing a test exposure at high ISO, checking the histogram, and adjusting as needed.

Michael Kenna, "Full Moon Rise," Chausey Islands, France, 2007
The Moon rises through the frame in this multi-hour exposure taken in the Chausey Islands in France.

DETERMINING EXPOSURE

There are very few light meters that are sensitive enough to measure moonlight, so metering is not usually an option when light levels are so low. Those with a keen interest in mathematics and astronomy might enjoy calculating lunar luminance levels, but it is time consuming and not particularly necessary.

The amount of moonlight when the Moon is full will never vary by more than two stops (and usually considerably less) after it is well above the horizon. However, two stops represents a significant increase or decrease in brightness and needs to be accounted for in an exposure. There are several factors that cause moonlight brightness to vary. The phase of the Moon has the greatest and most obvious effect on lunar brightness, and fortunately it is relatively easy to compensate for. Simply adding a half stop of exposure to your baseline full moon exposure either 1 day before or after the full moon, and adding one stop of exposure 2 days before or after the full moon will usually be sufficient to account for phasic variations in lunar brightness.

The brightness of moonlight varies by approximately 3{½} stops of light between the first or last quarter and the full moon, based on the relative positions of the Earth, Sun, and Moon. Also, due to the elliptical orbits of the Moon around the Earth and the Earth around the Sun, lunar brightness can vary by as much as 30 percent, or another one-third of a stop.

The opposition effect, which is caused by retroreflective properties (think cats' eyes) of the Moon's surface, may account for an increase in lunar brightness of another one-third to one-half of a stop when the Sun is almost directly behind the Earth, or in opposition to the Moon. Determining whether the Moon is near its apogee or perigee and the angle of incidence of the Earth and Sun relative to the Moon is relatively easy to accomplish with software for PDAs or from the Internet, but I find it unnecessary and distracting from the enjoyment of photographing the moonlit landscape.

A more important consideration when photographing by moonlight is the Moon's angle of elevation above the horizon. In general, the higher the Moon is in the sky, the more illumination it will provide to the landscape. The Moon becomes a useful light source when it reaches about 30 degrees above the horizon. The Earth's atmospheric conditions can dramatically affect the intensity of moonlight reaching the surface of the Earth. It is fairly obvious that moonlight diffused by cloud cover will not only be dimmer than direct moonlight, but also softer and shadowless. It is less obvious that particles in the atmosphere, such as smog, dust, moisture, and even the air itself, can reduce moonlight intensity, especially when the Moon is near the horizon and the light must travel through considerably more atmosphere before it reaches the Earth. The difference in exposure when the Moon is directly overhead and when it is just above the horizon is about seven stops in clear, dry air; the difference is considerably more in moist or dusty air. This is because moonlight travels through 40 times more atmosphere when the Moon has just risen than when it is directly overhead. A simple illustration of this effect is the fact that it is possible to observe the sunset by looking directly at the Sun, but you cannot look directly at the midday Sun without damaging your retinas. Also for this reason, higher altitudes and clear winter skies may lead to slightly shorter exposure times.

PHOTOGRAPHING THE FULL MOON

When most people think of full moon photography, they understandably imagine taking pictures of the full moon. To the seasoned night photographer, however, full moon photography means photographing by the light of the Moon, which is a different thing altogether. If you want to include the Moon in your night photographs and record detail in the surface of the Moon while having a balanced overall exposure, you are generally limited to photographing on the actual day of the full moon, near moonrise and moonset, or by combining multiple exposures. This is the only time in the lunar cycle when the exposure for the Moon and surrounding landscape is approximately the same. It is very rare for the sunset and moonrise to occur at the exact same moment, and the two times can vary by as much as 30 or 40 minutes, even on the night of the full moon. The ideal photographic situation would be for the Sun to set about 10 minutes before moonrise.

Latitude and season will determine how long conditions will be favorable to photograph the moonrise. Darkness always comes quickly near the equator, regardless of the season. At equatorial latitudes, it may be possible to photograph the moonrise successfully only a few nights of the year, depending on the congruence of sunset and moonrise times. In far northern or southern latitudes, twilight lasts much longer, and this increases the opportunities to photograph the moonrise. The following table illustrates the differences in the length of twilight at different latitudes at different times of year.

Because the difference between sunset and moonrise times change from month to month and year to year, you can see how your chances of finding the Moon rising during twilight is greater the farther away from the equator you are. Once again, the reason to photograph the moonrise during twilight is because the exposure for the landscape and for the Moon are the same for just a few

TWILIGHT AT DIFFERENT LATITUDES (MINUTES FROM SUNSET)

	Twilight at summer solstice	Twilight at winter solstice	Twilight at equinox
Singapore Latitude 1° north	+/– 20 minutes	+/– 20 minutes	+/– 20 minutes
Boston Latitude 42° north	+/– 35 minutes	+/– 25 minutes	+/– 30 minutes
Helsinki Latitude 60° north	+/– 110 minutes	+/– 60 minutes	+/– 40 minutes

minutes. When the full moon is high in the sky, it will be dark, and the difference in exposure for the Moon and landscape will be extreme, necessitating a compromise favoring exposure for one or the other. You'll either end up with a well-exposed landscape and blown out, overexposed Moon, or a very dark landscape with no details and a properly exposed Moon. For this reason, capturing detail on the Moon is for low-light, or twilight, photography. True night photography tends to show the Moon as a streak, or more commonly, it does not include the Moon in the frame at all.

Because moonlight is reflected sunlight, and the surface of the Moon is approximately equal to middle gray in tonality, the exposure for a full moon that is high in the sky is roughly equal to a midday landscape exposure in full sunlight. This is also known as the Sunny 16 rule, which is expressed as $1 \div ISO$ at f16, where $1 \div ISO$ is used for the shutter speed. The exposure will vary within a stop or two depending on atmospheric conditions, the distance from the Moon to the Earth (which varies with the Moon's orbit), the angle of lunar opposition to the Sun, and most importantly, the elevation of the Moon relative to the horizon. The Moon will always require considerably more exposure just after it has risen than when it is high in the sky. Note that these are the same factors that affect the length of exposures when photographing the Moon itself, as well as by the light of the Moon. As with all night photography, the best results are achieved by shooting in RAW mode and confirming the exposure with the histogram and flashing highlight functions.

Another way to include the Moon in the landscape is to take two separate exposures and combine them later in Photoshop or other software. The usual technique for this method is to first make an exposure of just the Moon surrounded by dark sky with the camera mounted on a tripod, using the longest available lens. Using your longest lens provides the most flexibility when pasting the Moon into another image because you will not have to increase the resolution of the Moon image to have it appear fairly large in the frame. After you have an image of the Moon, and because the same side of the Moon always faces the Earth due to their synchronous orbits, there's no reason not to use the same Moon image any time you want to use this technique. Although some purists will cringe at the thought, your Moon can now be incorporated into any photograph you like. It is very easy to select the Moon from the image and paste it into another frame, but it does take some skill to apply this technique without it being fairly obvious. For example, a wide angle night view of a city skyline with a gigantic moon filling the sky would not be very believable.

It is interesting to note that the Moon appears much larger when it is near the horizon than when it is fully risen. This is an illusion due to the frame of reference provided by the Earth when the Moon is low in the sky. An easy way to confirm that the relative size of the Moon is constant in the sky is to hold a coin at arm's length in front of the Moon just after it has risen and again after it is high in the sky. You may be surprised to see that the size of the Moon relative to the coin is unchanged, although to your mind the Moon seems much larger near the horizon. Additionally, the reason that the Moon sometimes appears pink, yellow, or orange when it is low in the sky is because of the greater amount of atmospheric particles the light must pass through at low angles.

Full moon night photography is quite different from shooting in urban areas for several reasons. First, to use moonlight as a primary light source, it is necessary to find a location that is away from streetlights and other artificial lights. Ambient light levels are much lower, which

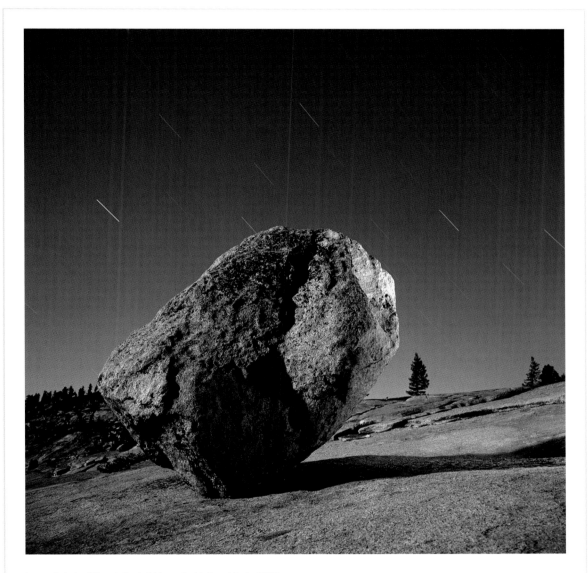

Lance Keimig, "Steve's Rock," Yosemite National Park, 2003

Named after Steve Harper, this famous granite bolder at Yosemite's Olmsted Point has been photographed by many a night photographer over the years. This version, shot under a full moon in 2003, was lit briefly with a flashlight from the right side. Hasselblad 500 C/M, 80 mm f2.8 lens, 15 minutes, f8, Fuji Neopan Acros.

necessitates considerably longer exposures. Second, that same lack of artificial light sources makes for much less contrasty lighting situations than are typically found in urban and suburban areas. Finally, longer exposures and lower light levels provide the opportunity to add light— referred to as light painting—in your photographs. Light painting will be discussed in-depth in the next chapter.

A primary consideration for photographing by moonlight should be to establish a baseline exposure for a landscape that is lit by the light of the full moon. There are several rules of thumb you can use to make this determination, such as the Looney 16 rule, which assumes that the Moon is about 250,000 times dimmer than the Sun, or 18 stops less than the Sunny 16 rule discussed earlier in this chapter. Using the Looney 16 rule gives us an exposure of 44 minutes at f16, ISO 100, or 11 minutes at f8, ISO 100. The rule of Three 4's calls for an exposure of 4 minutes at f4 with an ISO of 400. This is 2½ stops more exposure than the Looney 16 rule! The greater exposure called for by the older rule of Three 4's is better suited to older film emulsions like Tri-X or HP5 that suffer from severe reciprocity failure.

I have found that the Looney 16 rule is a reasonable starting point for contemporary digital cameras and most modern film emulsions. None of the various rules for moonlight exposures take into account all of the variables, be it cloud cover that varies during the exposure, changes in the altitude of the Moon over the course of a long exposure, the elevation above sea level and corresponding variance in atmosphere, the influence of distant sources of artificial illumination, or the reciprocity failure of film. It is also important to consider the desired effect in the final photograph. Do you want a realistic nighttime appearance with deep, dark shadows; a brightly illuminated scene with full detail everywhere; or something in between? Remember that when shooting digital RAW files, it is best to expose for a right-biased histogram, which will yield an image that looks like broad daylight. Exposing to the right will ensure clean and detailed shadows when the RAW file is developed, especially with older or consumer-level cameras. Darkening an image by developing it down in postprocessing moves more exposure information into the shadows, which makes for cleaner images. As always, film shooters are advised to bracket to ensure a good exposure.

Moonlight is sunlight reflected off of the gray surface of the Moon. The color of moonlight is about 4000 K, slightly warmer than daylight, but our eyes are more sensitive to blue in low light. Many film shooters use tungsten-balanced film because it more closely resembles the way we see at night. The ability to adjust the white balance in-camera and refine it even further in postprocessing is a great advantage for digital shooters. For the sake of consistency, it is a good idea to pick a color temperature between 3400 K and 4200 K, and use that setting for all of your moonlight photography. Most DSLRs have a Kelvin setting in the white balance options, and this can be set to the desired temperature. Older or less expensive models may not have this feature, in which case you will have to choose a preset white balance setting, usually either tungsten or daylight.

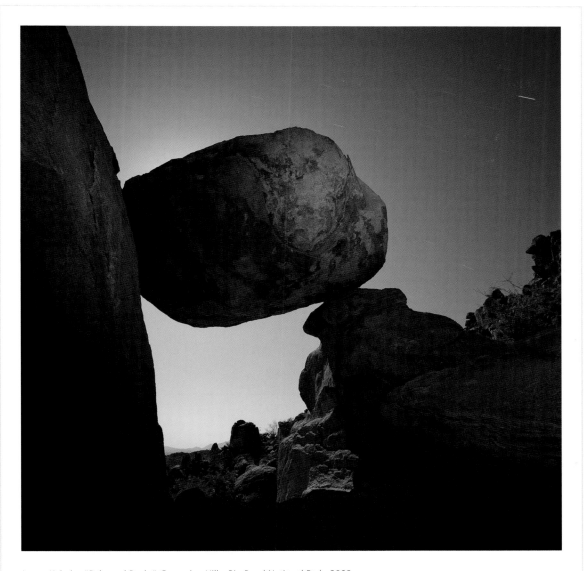

Lance Keimig, "Balanced Rock," Grapevine Hills, Big Bend National Park, 2009

The Moon is rising behind the balanced rock at Grapevine Hills in Big Bend National Park during this 8-minute exposure. Canon 5D, 14 mm f2.8 lens, ISO 100, f5.6.

As long as you are shooting RAW files, the white balance can be adjusted in postprocessing, but it is good practice to try to get the white balance close to the way you want it to look in-camera. Changing the white balance will change the appearance of the histogram, which can influence the way you determine exposure.

BASELINE EXPOSURES FOR PHOTOGRAPHING BY MOONLIGHT

Moon phase	Days before or after full	Exposure adjustment	Digital exposure time	Modern 100 ISO film emulsions	Tri-X/HP5
Full	—	—	10 minutes	10–20 minutes	30–60 minutes
Waxing/waning gibbous	1	{1/2} stop	15 minutes	15–30 minutes	45–90 minutes
Waxing/waning gibbous	2	1 stop	20 minutes	20–40 minutes	1–2 hours
Gibbous	3–4	1{1/2} stops	30 minutes	25–60 minutes	1{1/2}–3 hours
Quarter	7	3{1/2} stops	2 hours	2–4 hours	6–12 hours
Crescent	10–11	6{1/2} stops	Not practical	Not practical	Not practical
New	14	13{1/2} stops	Not practical	Not practical	Not practical

HIGH-ISO EXPOSURE TESTING

Unlike film, digital sensors do not suffer from reciprocity failure. This makes high-ISO testing for long exposures a simple and effective way to determine the correct length of long exposures without waiting 10 or 15 minutes for a test shot at optimum ISO. By increasing your digital camera's ISO to the maximum setting and opening your lens to the widest aperture, you can take a well-exposed moonlight photograph in just a few seconds. This flexibility is enormously liberating and provides the opportunity to get a feel for a location by doing a series of quick handheld shots to assess the exposure, lighting, and framing of a shot without investing too much time. Most people can handhold a 2 or 3 second exposure steady enough to evaluate whether or not the scene merits a full-length exposure. When working in moonlight or other very low-light environments, temporarily raising the ISO and doing a short exposure and then translating it into a longer exposure at optimum ISO will save you a lot of time.

Efficiency can be further increased by choosing test exposure settings that allow for second to minute translations. In other words, you'll want to use the exposure settings that enable you to have the same number of minutes at your native ISO as you have seconds at high ISO. Find your

camera's maximum and native or optimum ISO settings from one of the following tables, and keep the one equation that is relative to your camera taped to your tripod leg. That way, you'll never have to get bogged down with calculations in the field.

For example, cameras that have a native ISO setting of 100 can test at 6400, and cameras with a native ISO setting of 200 can test at 12,800, which makes for a direct translation from seconds to minutes. One second at ISO 6400 is equal to 1 minute at ISO 100 at any aperture. Accordingly, 10 seconds at ISO 6400 is equivalent to 10 minutes at ISO 100 at any aperture. If you are fortunate enough to have a camera that has an ISO range of 100–6400 or 200–12,800, high-ISO exposure testing is a piece of cake. If your camera's highest ISO setting is 1600 and the lowest is 100, you'll need to open up the aperture two stops to make up for the last two stops of sensitivity. For example, 1 second at ISO 1600 at f4 is equivalent to 1 minute at ISO 100 at f8. If your camera's native or optimum ISO is 200, then you will also need to make an aperture adjustment as well as an ISO adjustment to switch between second and minute exposures. A camera with an optimum ISO of 200 and a maximum ISO of 1600 would use the following calculation: 1 second at ISO 1600 is the same exposure as 1 minute at ISO 200 – three stops. It is important to be aware that this technique only works for ambient light exposure testing, not for light painting. The purpose is to quickly determine your ambient exposure and to check your composition.

The only risk is forgetting to reset your ISO to the camera's optimum ISO setting. Almost every night photographer has stories about the best photograph they ever took being inadvertently shot at ISO 3200! If your camera has customizable shooting modes that allow you to preprogram exposure settings, this is a convenient way to quickly and easily switch back and forth between high and optimum ISO settings.

CANON AND OTHER NATIVE ISO 100 CAMERAS						
1 second	2 seconds	4 seconds	8 seconds	15 seconds	30 seconds	1 minute
ISO 6400	ISO 3200	ISO 1600	ISO 800	ISO 400	ISO 200	ISO 100
ISO 3200	ISO 1600	ISO 800	ISO 400	ISO 200	ISO 100	ISO 100 – 1 stop
ISO 1600	ISO 800	ISO 400	ISO 200	ISO 100	ISO 100 – 1 stop	ISO 100 – 2 stops

Maximum ISO

NIKON AND OTHER NATIVE ISO 200 CAMERAS						
1 second	2 seconds	4 seconds	8 seconds	15 seconds	30 seconds	1 minute
ISO 12,800	ISO 6400	ISO 3200	ISO 1600	ISO 800	ISO 400	**ISO 200**
ISO 6400	ISO 3200	ISO 1600	ISO 800	ISO 400	ISO 200	ISO 200 − 1 stop
ISO 3200	ISO 1600	ISO 800	ISO 400	ISO 200	ISO 200 − 1 stop	ISO 200 − 2 stops
ISO 1600	ISO 800	ISO 400	ISO 200	ISO 200 − 1 stop	ISO 200 − 2 stops	ISO 200 − 3 stops

Maximum ISO

Unless your shooting location is far from any populated area, even a small town, your full moon exposures are likely to be influenced by artificial lights. Along the East Coast of the United States, for example, there's so much light pollution that it is virtually impossible to avoid all artificial light. In some cases there may be only a faint glow on the horizon from a distant town, which won't affect your exposure, but it will register in the image. Sometimes nearby streetlights may be bright enough to influence your exposure and the white balance of the scene. Adjusting for the exposure is simple for the digital shooter, but film photographers will need to rely on bracketing and past experience with similar scenarios. Nearby streetlights will affect the color of the foreground, and distant lights can influence the color of the sky, especially on cloudy nights, and especially near the horizon. Unless the artificial light sources are overpowering the moonlight, it is probably best to use your normal moonlight white balance and tweak the images during development. Shooting toward the Moon can create dramatic images, but it also increases the likelihood of lens flare, increases overall contrast, and changes the exposure. More than likely, you'll use a shorter exposure in backlit situations and may need to or want to fill in the shadows with some added light of your own. The next chapter will discuss adding light, or light painting.

STAR TRAILS VERSUS STAR POINTS

Although the movement of both the Earth and the Moon affect the Moon's appearance in night photographs, it is primarily the rotation of the Earth that causes stars to appear as trails in the sky in night photographs. All of the heavenly bodies in the universe are indeed moving

Lance Keimig, "The Table, Bodie," Bodie, California, 2009
A tired old table grazes in the field under the full moon in Bodie, a ghost town in California. The table was lit with an incandescent flashlight from the right side, and the Moon was just above the top of the frame, creating a backlit effect and lighting up the tin roof on the shed. Canon 5D Mark II, 50 mm f3.5 Canon macro lens, 12 minutes, f8, ISO 100.

through space, but the relative distance from Earth to the stars makes the movement of the stars insignificant during the length of an exposure. To illustrate this phenomenon, imagine a car traveling at 60 miles per hour passing directly in front of you versus the same car a mile away. The near car would pass through your entire field of vision in less than a second, and the distant car would remain in your field of vision for quite some time. Multiply this effect by light years, and you can see how the stars are so far away that their movement relative to their distance doesn't matter.

On the other hand, the Earth's rotation causes stars in night photographs to appear as lines in as little as 15–20 seconds, depending on the camera format, focal length, and which direction the camera is pointed. In the northern hemisphere, all of the stars in the sky appear to revolve around Polaris, also known as the North Star. This is due to the fact that Polaris is the closest star to alignment with the northern polar axis of the Earth. As a result, pictures including the northern

sky will show relatively short star trails circling the North Star. Photographs of the eastern sky will show star trails that resemble slightly curved forward slashes, and photographs of the western sky will have star trails that look like slightly curved back slashes. Photographs taken with the camera pointed due south will show long star trails that are relatively straight and parallel to the horizon.

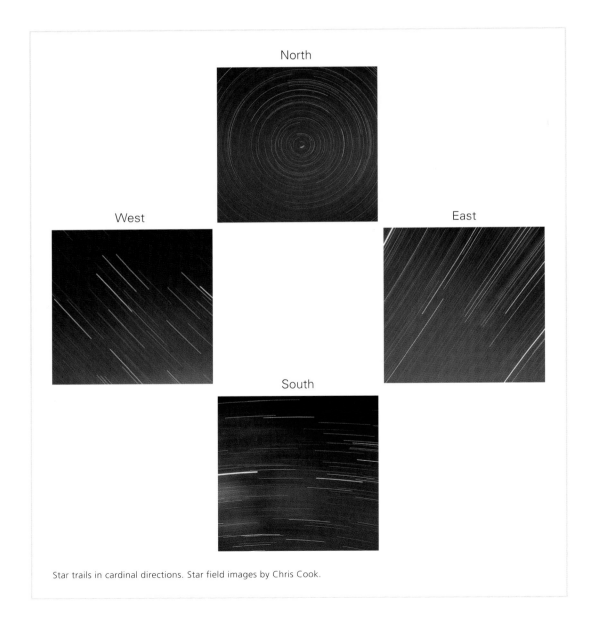

Star trails in cardinal directions. Star field images by Chris Cook.

Here are a few generalizations about star trails:

- The further away from the North Star your camera is pointed, the longer star trails will appear in your photograph. A star trail from a 5-minute exposure in the northern sky will be much shorter than one from a 5-minute exposure in the southern sky.

- The wider the aperture and higher the ISO, the more stars will be recorded in the image. Longer focal length lenses will yield brighter star trails than shorter lenses at equivalent apertures.

- The less ambient illumination at ground level, and in space, the more stars will register in the image. You will not see many star trails on full moon nights or in the city.

- Broken cloud cover will cause star trails to appear as irregular dotted lines rather than lines. Chances are that if you can't see the stars, your camera can't either.

- Star trails will have slightly different colors depending on the age or type of the star. Younger, hotter burning stars will be cooler or bluish in color. Older, dying stars will be warmer, or reddish in color.

- The lights of airplanes, light reflected from satellites, and even the International Space Station may appear in your photographs of the night sky.

There is a simple formula to determine the longest exposure that will render stars as points rather than lines. For 35 mm, the formula is 600 ÷ (focal length) = maximum exposure time. For medium format, the formula is 300 ÷ (focal length) = maximum exposure time. For example, if you are using an 18 mm lens on your DSLR, the equation would be 600 ÷ 18 = 33.33 seconds. Any exposure longer than about 30 seconds with an 18 mm lens will render stars as lines rather than points in the image. Longer focal lengths or larger format cameras make for significantly shorter exposure times before the stars appear as lines, which means you will need to use significantly higher ISO levels, which in turn means you will have more noise in your photographs. Cameras introduced at the end of 2008 or later, especially full-frame models, have much lower noise levels at high ISOs than previous DSLRs. With this and the recent advances in noise reduction software, particularly in Lightroom 3, it is now possible to shoot at high enough ISO settings to record stars as points rather than trails. There are aesthetic reasons for wanting long star trails, but it is great to have a choice that has never been feasible with film or even digital until recently.

To record stars as points of light on film, it is necessary to use ISO 1600 or faster film and expose for 15 or 30 seconds with a wide-angle lens at maximum aperture. The result will be a grainy image with a shallow depth of field and little or no detail in the foreground. Lighting the foreground will emphasize the fact that it may not be completely sharp, unless the nearest point in the image is at infinity focus. In this case it may be difficult to light a more distant foreground during the

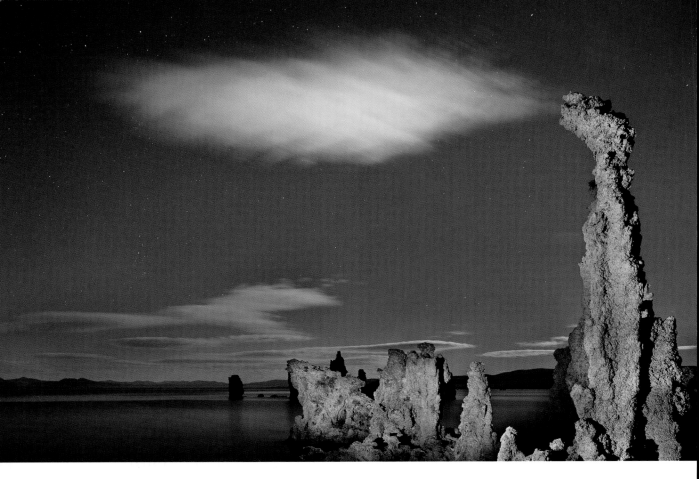

Scott Martin, "Wisp," Mono Lake, California, 2009

This striking image taken at Mono Lake in California takes advantage of the Canon 5D Mark II's ability to capture noise-free images at high ISO levels. The fast-moving cloud was captured in the ideal position relative to the tufa tower, and the stars are rendered as points of light rather than trails. Scott took several exposures as the cloud moved through the scene, but it took quick thinking and second-nature familiarity with his camera to catch this fleeting moment. This kind of spontaneity is unusual in night situations, but when the moment arises, it is great to be prepared for it. Canon 5D Mark II, 24 mm lens, 15 seconds, f5.6, ISO 1600.

short exposure. Photographing the starry sky on full moon nights or in an area with significant artificial illumination will minimize the number of stars that appear in the image. An alternative method for capturing stars as points of light is to use an equatorial mount, a tracking device that is normally used with telescopes in astrophotography. The equatorial mount moves the camera in the opposite direction as the Earth to maintain a lock on the stars. The disadvantage to this method is that anything on Earth will be blurred as the device moves in relation to the heavens. The Israeli photographer Neil Folberg employed this method and combined his astrophotographs with nighttime landscape images of the Sinai desert in his "Celestial Nights" series.

Shooting at ISO 6400 or higher with a good digital camera will facilitate more detail at ground level and also record more and fainter stars, adding visual interest to the image. Wide-angle lenses

allow the inclusion of larger swaths of sky and more stars, as well as a greater depth of field, than longer focal lengths. Using a relatively wide aperture will also show more stars and foreground detail. Low-end APS-C sensor cameras will not perform well at these higher ISO settings.

Ironically, another challenge of digital night photography is that star trails tend to be relatively short because exposures are shorter than they would be on film due to reciprocity failure. With most cameras, it is difficult to make digital exposures longer than about 15 minutes without generating a lot of noise, especially in warm conditions. Creating long star trails is one area where film really excels. On a night with little or no moon, it is possible to expose for as long as it is dark outside without fear of overexposure, provided that there is little light pollution nearby. Long star trails can enhance an image, especially if the direction of the trails works in conjunction with the rest of the composition. Very long exposures of the northern sky can be quite dramatic because the stars appear to revolve around the North Star, creating a circular pattern in the sky.

STACKING IMAGES FOR LONGER STAR TRAILS

Stacking, or combining a series of relatively short exposures, is a great way to create longer star trails with digital cameras. Shooting images for stacking is straightforward, but there are many different ways to combine the images after you have captured them. The concept of stacking is simple; by shooting a sequence of short exposures and blending them in postprocessing, it is possible to minimize noise and achieve exposure times that are not possible with a single frame. There is no special equipment required to create stacks of images for long star trails, but a release with a built-in timer is immensely helpful. There are several different ways to stack images in Photoshop, but there are also a number of stand-alone applications designed specifically for this purpose. In the following sections, we will look at the procedures for exposing, processing, and stacking images to create long star trails with digital cameras.

Camera Settings

The first step is to set up the camera. The basic settings are the same as for most night photography—native ISO, RAW quality, bulb exposure mode, manual focus. You should turn off image stabilization (IS) or vibration reduction (VR) lens functions if your lens has this feature. Make sure your battery is fully charged. An external grip that contains a second battery is useful for this type of work because the combination of long exposures and cold can drain a battery quickly. It is essential to turn off long-exposure noise reduction (LENR). This feature works by creating a second exposure, without opening the shutter, immediately after the initial exposure is completed. The result is that most cameras will not be able to take another exposure until the LENR is finished. The Canon 5D family of cameras does allow continued shooting for a few frames while holding the exposures in the camera buffer, but after about four or five exposures, the buffer fills and no further images can be captured until the processing is completed and space is cleared in the buffer memory.

Camera Setup for Stacking

- Set the exposure mode to bulb.

- Turn off LENR.

- Set the quality to RAW.

- Use your camera's native ISO.

- Use an aperture between f2.8 and f8.

- Focus manually using hyperfocal, live view, or infinity focus.

- Turn off the image stabilizer on IS or VR lenses.

- Use a release with a built-in timer programmed with 1-second intervals between exposures.

Capturing the Images

Now it is time to compose the shot. Choose a location that is far from artificial light sources and has something of visual interest in the foreground. Even the lights from a distant town on the horizon can have a negative impact on your image by obscuring dimmer stars that are low on the horizon. Make sure that the closest object in your foreground is not too close to the camera because you will be shooting at a fairly wide aperture, albeit with a wide lens. If you want to create a star circle, you'll need to locate the North Star, which is called Polaris. The North Star can be located with the aid of the Big Dipper. After finding the Big Dipper in the sky, locate the two stars on the right-hand edge of its cup. Extend an imaginary line through these two stars until it intersects with another bright star, and you've found the North Star. There is no polar star in the southern hemisphere, but the Southern Cross points toward the South Pole. The stars in the southern hemisphere will also form a circle over the South Pole, but it is more difficult to establish your camera position without the aid of a polar star. The North Star does not have to be placed in the center of the frame to create the circular star pattern in the sky. It can even be cropped just outside of the frame to make a semicircle of star trails.

Select the widest aperture that enables you to focus on your foreground, preferably f8 or larger. The larger the aperture you use, the more stars will appear in the image, because dimmer stars will not be recorded with small apertures. If you choose to include foreground elements in your shot, focus using the hyperfocal distance for one f stop larger than your actual aperture setting. In other words, if you are shooting at f8, set the hyperfocal distance for f5.6. This will ensure that the stars are truly sharp and crisply in focus in the image. Scott Martin recommends focusing on the foreground for the first frame and then refocusing at infinity for the remaining frames where only the sky will be used in the stack. The sky can be masked out of the foreground layer to hide

any gaps in the star trails that appear during the time it takes to refocus. If there is nothing of importance in your foreground, perhaps only the horizon, focus at infinity and use the aperture setting one stop down from maximum. You should check the foreground focus using live view and a flashlight, with the lens stopped down to your shooting aperture. Live view can also be used to focus at infinity on the stars and to assist in composing the shot by establishing the four corners of the image. You may wish to do high-ISO test shots to help you establish the composition and position the foreground elements and stars in relation to one another. However, it is a good idea to do a full-length exposure to test the direction of star trail movement in your shot. The stars will not move enough during a high-ISO shot to clearly establish the pattern and direction of movement.

If you plan to do any light painting in the foreground, you should test the lighting at your working ISO to determine the best way to illuminate the shot and how much light is needed. Because you'll be investing a long period of time in this procedure, you'll want to make sure everything is perfect.

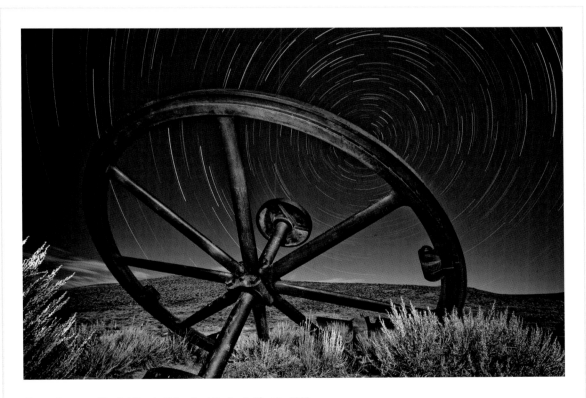

Shawn Peterson, "Bodie Wheel of Wonder," Bodie, California, 2008

This giant wheel was part of the mining operation at Bodie State Historic Park in California. Shawn Peterson and Scott Martin worked together to carefully compose this image, taking time to position the star trails so that they would mirror the shape of the wheel. The wheel itself was lit with a flashlight during the first and last of 23 4-minute exposures, which were processed in Lightroom and then stacked with Startrails, a Windows-based shareware program.

The length of your exposures is determined by a combination of factors. All of the shots should be the same exposure. It is not absolutely critical that the times are exact, but the aperture must remain constant to stack the images. You'll need enough exposure to get a reasonably good histogram—there should be no shadow clipping at the very least, but as usual, a right-biased histogram is best. If you are shooting when there is little or no moon present, it may be difficult to have the perfect histogram without raising your ISO, which should be avoided if at all possible. Open up the lens instead. The quality of your camera and the ambient temperature factor into determining your exposure times. Shorter exposures should be encouraged for entry-level cameras and warm temperatures, which both tend to create noise. Professional, full-frame sensor cameras and cold temperatures allow longer exposures with less noise. In suboptimal conditions, exposures of 1 or 2 minutes may be the longest you can do without introducing noise. Midlevel prosumer cameras on cool nights might allow for 10- to 15-minute exposures, and the best cameras can get away with 30- to 40-minute exposures on cold nights. Battery technology has improved along with camera technology, and newer batteries are remarkably long lasting. Still, you should begin this process with a freshly charged battery, especially on cold nights, which drain battery power faster. Experience will guide you as to how much time you can get out of a single battery.

There is no rule on the number of shots or total length of time, but you will probably want to have an hour and a half or more of total time for shots of the northern sky. Star trails get longer the farther they are from Polaris. Star trails will be shorter in images of the northern sky and longest in the southern sky. It is easy to see why if you take a photograph of the night sky that includes Polaris and other stars and then extend two lines from Polaris to the beginning and end of any star trail in the image. You would end up with two lines that intersect at Polaris and extend infinitely outward at a constant angle. The distance between the two lines near Polaris is very short, and it increases the further away from it you go. The measurement of that angle is a representation of the length of the exposure, measured in degrees of a circle. There are 360 degrees in a full circle, which represents a full revolution of the Earth, or a 24-hour day. Accordingly, a 180-degree angle would indicate a 12-hour exposure, a 90-degree angle would represent a 6-hour exposure, and a 15-degree angle is equivalent to a 1-hour exposure. You can determine the length of any exposure that includes Polaris by using a measurement of the angle that is formed by connecting the beginning and end of a star trail to Polaris and applying the following formula: $> \div 360 \times 24$ hours = exposure length, where $>$ = angle. For example, let's say you measure a 24-degree angle, then $24 \div 360 = 0.0666 \times 24 = 1.6$. This number indicates an exposure of 1.6 hours, which can be further multiplied by 60 to get the number of minutes: $1.6 \times 60 = 96$ minutes. Whew! That's probably more math than you are looking for, but it is interesting to be able to determine exposure length simply by looking at a photograph. Back to the procedure.

Program your timer to take a series of consecutive shots with a 1-second interval to ensure minimal gaps in the trails. Longer intervals will show obvious gaps in the star trails, making them appear as dotted lines. It is not possible to set a zero interval. If you do not have a release with a

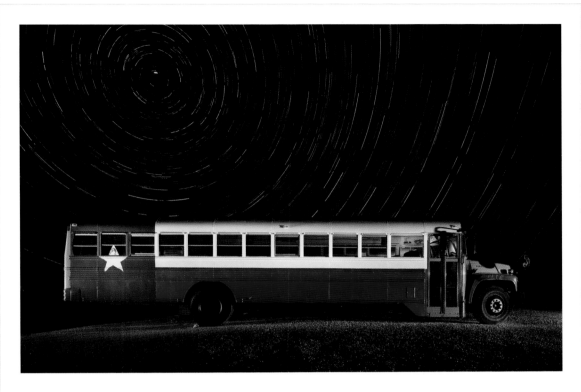

Scott Martin, "The Love Bus," Terlingua, Texas, 2009

A sequence of 32 timed exposures on a moonless night in remote west Texas with a pack of coyotes howling nearby. The camera was focused on the bus using live view and a flashlight, and then it was lit with the flashlight during the first exposure. The camera was refocused at infinity for 31 additional 4-minute exposures to record the star trails. The sky appears black because the starlight was not bright enough to illuminate the sky during each relatively short exposure. Canon 5D Mark II, 24 mm f3.5 TSE lens, f5.6.

timer, set the camera shutter speed to 30 seconds, the camera drive to continuous, and lock the release open to force the camera to take continuous exposures until you close the release, the memory card is full, or the battery dies. You will end up with many more frames and a huge file on your computer, but it can be done this way. Any lighting should be done during the first and last exposures because if you mess up and have to eliminate a frame, you don't want it to be in the middle of your sequence. If you were to remove one of the middle exposures, it would leave an unsightly gap in the star trails. By lighting the first and last frames, you have the freedom to choose whichever frame you like better and discard the other.

Processing and Combining the Images

There are many ways to stack images; you can combine them as layers in Photoshop or use a specialized application created just for this purpose. In the pages that follow, we'll go through

- Expose for a right-balanced histogram or at least no shadow clipping.

- Base the exposure length on your past experience with your camera's noise levels and the ambient temperature.

- Base the total time on the desired length of star trails.

- Without a timed release, use 30-second exposures with the camera on continuous drive and a locking release.

- Add light painting if desired on the first and last exposures only.

- Take an extra identical exposure at the end of the sequence with the lens cap on and the eyepiece covered. This can be used for a manual dark frame subtraction (discussed later) if excessive fixed pattern noise cannot be removed by other means.

the steps to process RAW files in Lightroom and combine them as layers in Photoshop, and then we'll review other software options. You can stack as many images as the memory in your computer will accommodate. It's great to have star trails that stretch all the way through an image, but it's not so great to crash your computer by trying to stack a hundred 20 MB RAW files. Large image stacks take lots of processing power and take a long time to combine. If you don't have a timed release and are stuck using 30-second exposures, you will undoubtedly have many frames to stack. At some point, it might make sense to create two or three stacks, flatten them, and then combine the flattened stacks together in another stack. Establishing the longest noise-free exposure length your camera can handle given the ambient temperature at the time of capture will speed up and simplify your postprocessing workflow.

The following list describes the steps for stacking images with Photoshop:

1. Begin by importing your images into your chosen RAW file converter application.
2. If you did light painting on more than one frame, choose which frame you will use, and set the other aside in case you decide to use it later.
3. Develop this image as you normally would *unless you use dark frame subtraction*, which is discussed in the next section of this chapter. Set the white balance and other adjustments; apply chromatic aberration adjustments and noise reduction as needed, taking care that the star trails are not obscured by overly aggressive noise reduction. If necessary, you'll be able to reduce the noise further in the final, flattened image.
4. Synchronize the image developments with the other images to be stacked.

5. Consider enhancing localized contrast (which is called *clarity* in Lightroom and Adobe Camera RAW and *definition* in Aperture, etc.) to the sky portion of the images. This will increase the visibility of the star trails. Although Lightroom's Adjustment Brush is great for applying localized contrast to just the star trails that benefit from it, you might choose to increase localized contrast to the entire image.

6. Synchronize this adjustment with the other images to be stacked.

7. Select all of the images to be stacked and open them as layers in a single Photoshop file. If you are using Lightroom, choose Edit In > Open as Layers in Photoshop from the Photo pull-down or right-click menu. If you are using Bridge CS4 or later, choose Photoshop > Open as Layers in Photoshop from the Tools pull-down menu.

8. When completed, all of the images will be stacked together as layers in one Photoshop file, but only the top layer will be visible. Open the Layers palette if it is not open already, and change the layer blending mode of each layer, except your background layer, to Lighten. The Lighten blending mode adds anything on the upper layer that's brighter than the lower layer—in this case, star trails. As you change each layer to Lighten, you will notice the star trails growing longer and longer, with little else changing.

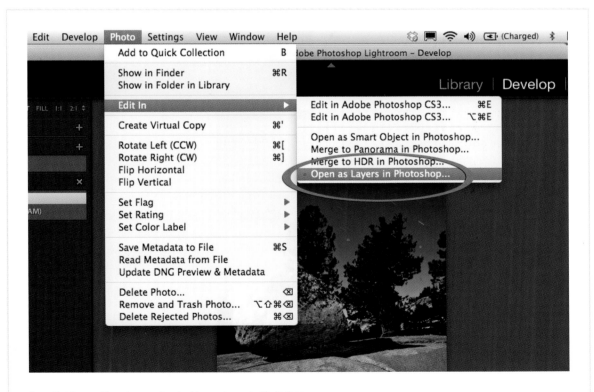

From Lightroom, Open images for stacking as layers in Photoshop.

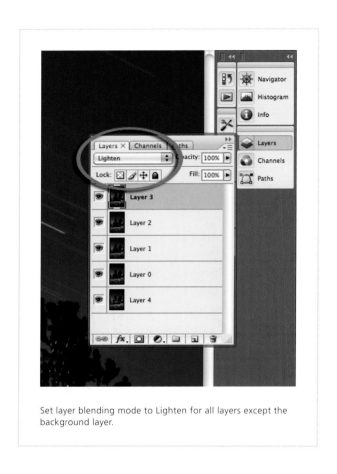

Set layer blending mode to Lighten for all layers except the background layer.

9. If there are any plane trails or other artifacts you wish to remove, now is the time. If there are elements in specific layers you don't want in your final image, create layer masks for those layers and brush out the unwanted portions with black foreground ink. After carefully reviewing the combined image for problems, flatten and save it. You may also wish to save the layered document, but it will be quite a large file. If you are using Lightroom, the modified file will be automatically saved in your catalog, and you can make any further adjustments, such as local corrections or vignetting, directly within Lightroom. It is unlikely that a stacked image will have much noise at this point, but if it does you can implement noise reduction in Lightroom, third-party plug-ins, or applications like Define, Neat Image, or Noise Ninja.

USING DARK FRAME SUBTRACTION

To compensate for the lack of in-camera noise reduction, you can take one extra frame at the end of the sequence; it should have the same exposure length, the lens cap on the lens, and the eyepiece covered. This dark frame can be used for manual dark frame subtraction in

Other Stacking Options

- Dr. Brown's Stack-A-Matic: This is a free Photoshop Extended script for Mac and Windows. The limitations of this option are that it takes longer than the Open as Layers in Photoshop option and only works with Photoshop Extended versions, starting with CS3. Scott Martin used Stack-A-Matic on his " The Love Bus" photograph.

 http://www.russellbrown.com/tips_tech.html

- Startrails.exe: This is an easy-to-use freeware program, but unfortunately it is compatible only with Windows. Shawn Peterson used it for his "Bodie Wheel of Wonder" image.

 http://www.startrails.de/html/software.html

- Keith's Image Stacker: This application was designed for astronomy images shot through a telescope, but it works for star trails as well. It has many user-defined controls and is more difficult to use than the other options. It is for the Mac only, and a $15 donation is requested.

 http://keithwiley.com/software/keithsImageStacker.shtml

- Enfuse: This open source software is available as a Lightroom plug-in or stand-alone GUI application. A donation of any amount is required for the plug-in, and a donation is requested for Enfuse itself.

 LR/Enfuse: www.photographers-toolbox.com

 EnfuseGUI: http://software.bergmark.com/enfuseGUI/

postprocessing. This image will be used only as a backup in the event that your RAW file converter does not do an adequate job removing noise in your images. When you process your images along with this extra frame, you can follow the procedure outlined with one major change. Set only the white balance and make no other adjustment to your RAW files. Make sure sharpening and noise reduction are turned off. Aside from the white balance, all adjustments must be made to the final rendered and flattened file. Place the dark frame on top of the stack, set the blending mode of this layer only to Difference, and adjust the opacity to achieve the best effect. Start at 50% opacity and increase as needed. Dark frame subtraction or calibration works by removing any fixed pattern noise created by the sensor during long exposures. Random noise, which is more of a factor at high-ISO settings, will not be removed using this technique.

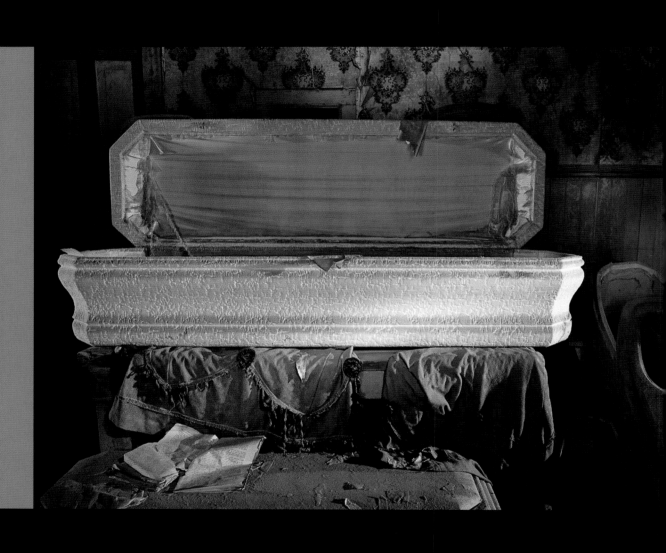

LIGHT PAINTING

WHAT IS LIGHT PAINTING?

There has been some truly innovative work created in recent years using light painting and light writing techniques. From simple fill light used to open up foreground shadows, to the use of lights with colored gels, to drawing or writing with light by pointing a flashlight back toward the camera, there are many exciting ways to work with added light. In this chapter, we'll explore light painting and light writing with flash, flashlights, and other handheld light sources.

The word *photography* translates literally from Greek as *light writing*. For night photographers, the term *light painting* is often used any time light is added to night photos from a portable source that is not connected to the camera. More specifically, light painting describes when light is added to illuminate the subject of a photograph, originating either from inside or outside of the frame, but the source is usually hidden from the camera. Light painting can be supplemental to the ambient light or the primary light source; in some cases it can be the only source of light in the photograph. When flashlights are employed for light painting, they are often kept moving during use. In contrast, *light drawing* or *light writing* are the terms that describe when a light is directed toward the camera from within the frame. In this case, the light itself becomes the subject. Light can be used to create shapes or lines in the image or even to literally write words, numbers, or symbols. Light painting and drawing techniques can be combined in the same photograph to achieve varied effects.

There are many reasons why you might want to add light to a night photograph. In the simplest and most practical form, light painting can be a form of in-camera contrast control. By adding light to the shadow areas of an image, it is possible to reduce the overall contrast by raising the luminance values of the darkest parts of a scene. Most of the time when this technique is used, the goal is to have the lighting be so subtle that the photograph appears to have been taken with only existing light. In many instances, light painting is used to emphasize or draw attention to a particular part of an image. By using supplementary lighting, the photographer has greater control over how the image is interpreted by the viewer. Some well-placed lighting can change the feeling of an image and

Lance Keimig, "Church, Terlingua, Texas," 2007

The facade of the old adobe church in Terlingua, Texas has great texture that is accentuated by the oblique lighting from both sides. The inside of the church was lit from both the left and right as well. Inside the church, the light was low to the ground to illuminate the benches and then raked along the wall on the right to add more texture. The last piece of the lighting puzzle was to add light to the window from around the corner on the other side of the church. Ambient light played almost no role in this image, so after 2 minutes when the lighting was completed, the exposure was ended. It took about five or six attempts to get everything right. Canon 5D, PC Nikkor 28 mm f3.5 lens, about 2 minutes at f8.

JanLeonardo Woellert and Joerg Miedza, "Lumen Attacks," 2009

JanLeonardo Woellert and Joerg Miedza work together with many different types of light sources to create complex scenes such as this one taken in Hude, Germany. This image involved the use of a fog machine, star projector, flash, and flashlights with colored gels. They call their technique *Light Art Performance Photography*.

shift the emphasis to different parts of a scene. The natural landscape can be one of the most challenging subjects to photograph at night because the resulting images have a tendency to look like daylight photographs if they are photographed by the light of the Moon alone. The addition of light from an unexpected direction, especially if it is a different color from the natural light, can completely transform a landscape from ordinary to sublime.

There are many ways to add light to night photographs. Some photographers, like Gregory Crewdson, take a studio approach to lighting. Crewdson's elaborate productions involve truckloads of equipment, a crew of lighting technicians, and the construction of Hollywood-style sets. Most photographers, of course, don't have access to those types of resources. Even if they did, the majority of night shooters would prefer the intimacy and freedom of working on a smaller scale. It is remarkable what can be achieved with a few simple tools added to the camera bag. Traveling lightly allows for greater spontaneity and productivity. Most light painting is accomplished either with flashlights or handheld strobes, but there is a dizzying array of lighting tools available today.

Al Hiltz, "Dog's Worst Nightmare," 2009

In this image the complex relationship between dog and fire hydrant is explored. What would happen if the roles were reversed? The image was created by pointing a red LED and penlight directly at the camera and drawing the arms, face, and hair. Images like this one require a bit of previsualization. If it made you smile, it had the desired effect.

Although both pop-up and hot shoe mounted flashes provide a ready light source when light levels are too low for handheld exposures, or when a tripod is not an option, the use of an on-camera flash is not recommended for night photography. Photographers rarely use it because the quality of light from an on-camera flash is not very pleasing. A flash fired from the camera position flattens out shapes and textures and throws hard, unattractive shadows behind the subject. In certain situations, an on-camera flash can be used effectively as a fill light, but it is limited to nearby foreground subjects. Flash is often employed as a creative lighting tool by night photographers, but it is usually handheld and fired manually away from the camera.

Just as camera technology has evolved in recent years, there have been major improvements in flashlight and battery technology. There are a wide variety of lighting tools available that all serve a specific purpose. Compact lights with fiber optic tips can be used to add light with pinpoint precision, and high-powered LED lights are capable of lighting large areas from great distances. Flashlights are available with incandescent, xenon, fluorescent, or LED bulbs, which all have different color temperatures and qualities. Glow sticks, sparklers, candles, and even car headlights or brake lights can be used for light painting, and experimentation is the best way to learn to use them effectively.

The camera can even be taken off the tripod and intentionally moved during the exposure. In this situation, any ambient lights in the scene are recorded as lines or light trails that reveal the movement of the camera. The Hungarian painter and photographer László Moholy-Nagy and American Harry Callahan may have been the first to use this form of light writing in the early 1940s, moving the camera up and down and in circles to create abstract patterns of light.

LIGHT PAINTING AND EXPOSURE

Light painting and drawing are inexact sciences, and determining the right amount of light to use will take some trial and error. The most important concept to understand when working with added light is that time is used to control the ambient or overall exposure, and the intensity of any added light is largely determined by opening up or stopping down the aperture. One of the most challenging parts of this type of photography can be finding the right balance between ambient and added light. If your exposure is too long, the background may look like daylight, and the light painting may be washed out or overpowered by the ambient exposure. If your base exposure is too short, you may end up with clipped or underexposed shadows and light painting that stands out too much from the background. Ambient exposures should be at least a half stop less than usual if you are adding a significant amount of light. A typical full moon exposure would be 15 minutes at f8, ISO 100 without light painting, or 7–10 minutes with light painting in the same scene. The reason for the shorter exposure is not because the light painting will affect the background brightness but to ensure a better contrast ratio between naturally and artificially lit parts of the image.

Lance Keimig, "Burishoole Abbey," County Mayo, Ireland, 2009

These two photographs demonstrate how changing the ratio of ambient exposure to light painting can change the entire mood of a photograph. The lighting was almost identical in both images, but the exposure on the left was 20 minutes and the exposure on the right was 7 minutes. It is up to the photographer to decide which is better. In completely dark environments, adding more time has no effect on the image other than adding more noise.

Light painting does not usually shorten the exposure, but if the light painting is the only source of illumination in a completely dark environment, the length of the exposure is determined simply by the amount of time required to do the painting. There is no need to hurry to close the shutter, but extending the exposure in this case risks adding noise, more than any useful exposure, to your image.

One instance when you probably would not reduce your overall exposure would be if you were adding light simply to open up dark shadows and were trying to hide the fact that you added light. In this situation, you'll want to make sure that the area with light painting is not brighter than the midtone areas of the image, otherwise the light painting will really stand out. Bouncing the light off a white card or collapsible reflector is helpful to keep the added light subtle. This has the effect of softening the quality of light and eliminating shadows. When shooting in color, you'll also want to be mindful of the color you add. We'll explore painting with color later in the chapter.

HIGH-ISO TESTING AND LIGHT PAINTING

To determine the right exposure length for your chosen aperture and refine the composition, use a high-ISO test as described in the previous chapter. Because changing the ISO will also affect the brightness of any added light, it is difficult to gauge how much added light is needed by a high-ISO test. For this reason, you may be able to use the high-ISO test to analyze the quality and direction of added light, but not the quantity. Technically you can make the calculations, but it is complicated

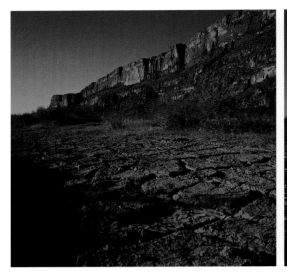 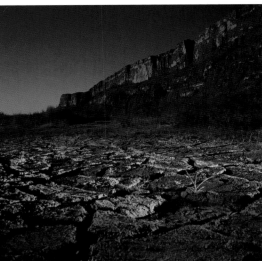

Lance Keimig, "Santa Elena Canyon on the Rio Grande in West Texas," 2007

Both of these images are 9-minute exposures by moonlight. The one on the left is only moonlight, and the one on the right has added flashlight held low to the ground to emphasize the texture of the dry mud. A conscious choice was made to use a warm incandescent flashlight to contrast with the moonlight. An LED light would have been closer to the color of moonlight and would not have been as obvious.

and has lots of opportunities for errors. Not only would you have to account for the change in ISO and possibly the aperture, you would also need to count how many seconds or minutes of painting each area in the picture will receive while you do the painting with your flashlight! Definitely do the high-ISO test to nail down your composition and ambient exposure, as well as to check for potential problems, but don't rely on it to determine your light painting exposure. All testing of light painting should be done at the working aperture and ISO to ensure accurate results.

Flash can be measured with a handheld light meter or by setting the flash power based on distance. If colored gels are used in combination with flash, the power of the flash must be adjusted to account for the light blocked by the gel. It is much more complicated to predetermine how long to use a flashlight because the light is generally kept moving during the exposure. Moving the light softens the edges and makes for interesting effects, but also makes it difficult to ensure even illumination and exposure. Sometimes the photographer will also be moving while painting with a flashlight, which makes it truly impossible to accurately

meter the light. Moving the light back and forth as if painting with a brush can cover a large area with a small, portable source. Continually changing the position of the light during its use softens shadows and makes for a more diffuse lighting effect. There is really no convenient way to predetermine how many seconds of flashlight or how many pops from a flash are required to paint a scene. Fortunately, developing a feel for using lights this way comes fairly easily, and absolute precision is rarely necessary. Digital shooters should review and analyze their images in the field to determine what improvements can be made. Film shooters are advised to repeat each shot several times, varying the lighting slightly each time to increase the probability of getting a good shot. I recall a friend saying "I'm not feeling it" during his first light painting tests. When he got to know the scene better and improved his lighting technique, he exclaimed, "I'm feeling it this time—that's it!"

DETERMINING HOW MUCH LIGHT TO ADD

There are several factors to consider when trying to determine how much and which type of light to add to an image. In addition to the working aperture, you'll need to consider the brightness of your light source, the distance from the light to the subject, the size of the object(s) to be lit, the reflectivity of your subject, the desired quality of light on the subject, and what color light will help you to achieve the look you want for the photograph.

The intensity of your light source in combination with aperture probably has the greatest impact on the image. It is fairly obvious that you'll need to paint with a penlight for a much longer time than a big, powerful flashlight, and a flash set to full power will light a larger area from a farther distance than one set to one-quarter power. Additionally, the same amount of added light will appear brighter with a wider aperture than with the lens stopped down. Flashes will maintain their intensity as batteries begin to wear out, but recharging between flashes takes longer as the batteries get weaker. Flashlights become dimmer as the batteries are drained, and incandescent lights become warmer in color.

Another consideration is the distance from the light source to the subject. When a light is moved farther from an object, the amount of light reaching the object will decrease by the square of the inverse of that distance. For example, doubling the distance from light to subject will result in only 1/4 of the light reaching the subject. If the light starts out 6 feet from an object and is then moved to 12 feet from the object, only 1/4 of the light falling on the object at 6 feet will reach it at 12 feet. Tripling the distance results in the light being only 1/9 as bright; quadrupling the distance results in the light being only 1/16 as bright; and so on. The inverse square law applies to any type of light source. Remember that if the light is reduced by half, the exposure will need to be increased by one stop. Camera-to-subject distance has no impact on lighting, it is only light-to-subject distance that matters.

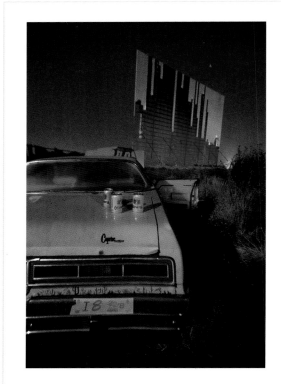

Troy Paiva, "Westside Drive In," 1990

It was such hard work lighting the movie screen with 80 pops of a red-gelled flash that a celebration was called for. Tom Paiva lit the screen while his brother Troy manned the camera and lit the car and beer cans. Neither one admits to drinking Olympia beer.

The size of the area to be illuminated also needs to be taken into account. A small object can be lit with a single pop from a flash or with a relatively stationary flashlight. If you need to light a large area, you may need to fire a flash repeatedly or use a flashlight for a longer duration, changing positions to cover a wide area. The Paiva brothers (Tom and Troy) tell a story about lighting a drive-in movie screen with a red gel-covered Vivitar flash connected to a Quantum battery. While Troy was busy lighting an abandoned car in the foreground, Tom was repeatedly firing the flash up at the screen while walking along the base of it. Because he wanted to make sure that the red flash overpowered the relatively bright ambient moonlight on the towering white and reflective screen, Tom fired the flash about 80 times until it became so hot that he couldn't hold onto it. To make matters worse, Tom

stepped in the carcass of a dead animal underneath the movie screen. Fortunately, their efforts led to a perfect exposure. To this day, neither brother claims responsibility for the beer cans on the trunk of the car.

The reflectivity and color of the object(s) you intend to light also influences how much light will be required. A light colored or metallic subject needs much less illumination than a dark, nonreflective subject. The difference can be several stops. Trees are notoriously difficult to light because they absorb most of the light that falls on them. Shiny and wet surfaces are more reflective than dull or dry ones and therefore require less exposure. The night photography pioneers of the 1890s frequently photographed street scenes on rainy nights for this very reason.

The quality of light from a strobe is similar to sunlight. Strobes are a bright, even point source and cast a hard shadow. Flash is best for lighting large, broad areas, like an empty room. The strobe can be fired multiple times from different positions to evenly light a large area. It is difficult to control if you are trying to light a small object in a crowded space. You might want to mask the light with a black card or your hand to prevent the light from spilling over where you don't want it. A flashlight is softer, more diffuse, and easier to use on a small, localized area. If you want

Two flashlights

These two flashlights have tape snoots to prevent light from shining in the lens unintentionally. The neutral white light on the left is a Streamlight PolyTac LED, and the warmer light on the right is a SureFire G2 xenon light.

to highlight one object in a busy scene, a well-aimed flashlight will do the job nicely. Changing the position of the flashlight during use will overlap any shadows, softening or eliminating them altogether. Keeping the flashlight in a fixed position will cast a harder shadow. Modifying your flashlights with a snoot made from gaffer's or duct tape can help prevent the camera from picking up the light source if you're using it inside the frame. The width of the beam of light can also be modified this way.

The positioning of the light plays a significant role in the quality of light. Frontal lighting that is perpendicular to the subject is flat and obscures detail. As mentioned earlier, on-camera flash is an example of this type of lighting, which is why it is best to avoid it. Light directed from oblique angles will emphasize the texture of any surface and bring out detail. This kind of lighting is much more dramatic than frontal lighting and almost always makes for a more successful photograph. While you're light painting, you see the light from the position of the light, not from the camera's perspective, so it is helpful to have someone assist you with the lighting; you will be able to remain at the camera and have a better sense of how it is going to look in the picture. Two photographers working together, taking turns at the lights and camera, can make for a more productive session. Collaborating and exchanging ideas is a great way to learn light painting and can truly enhance the experience. Cenci Goepel and Jens Warnecke, the German photographers whose work is presented in the next section, are a great example of successful collaboration.

Reflected, frontal, and sideing

The left photo shows the effect of reflected light from the side. It is soft but shows the texture of the wall. The center photo shows frontal lighting from the camera position. It obscures texture and depth. The right photo illustrates hard side or oblique lighting. It is contrasty and has lots of texture. The light will not look the same from the lighting position as from the camera, so it is helpful to have someone else hold the light while you stand at the camera until you can confidently anticipate how it will look.

Cenci Goepel and Jens Warnecke: All That Shines

Light painting and drawing has recently experienced a massive boom largely due to digital photography. Digital cameras are an excellent tool for experimentation, allowing the photographer instant feedback for every image. To paint with light, all you really need is something that emits light and can be moved. Classic items are LED flashlights or strobes, but the imagination certainly knows no limits. People juggle with Star Wars light sabers, develop their own pyrotechnics, and program blinking LED arrays to make complex designs using extended exposures to capture constant motion. Others throw fluorescent boomerangs, send boats carrying candles over water, or tag tiny lights on herds of sheep. Do you have some ideas of your own? Just try it!

It's All in the Details

We've experimented with a lot of complex, colorful, blinking lights, but in the end we always turn back to bright yet simple light sources. Most of our photos are painted with LED lamps, which make all the difference in the world when it comes to detail. Finding the perfect lamp isn't exactly a quick task because seeing the results in the photograph is the only way to truly tell if a light is good for the job. Besides their light color and brightness, lamps vary greatly in how they emit light. The design of LEDs, reflectors, lenses, and even safety glasses influences the internal configuration of the light and, therefore, the dynamics of the light drawing. With a brush and paint, the line thickness is influenced by the amount of pressure applied, but a stroke with the flashlight becomes more intense the more directly it faces the camera. If the light is pointed directly at the camera, the result is a bright and glimmering spot, yet as it turns away, the stroke becomes thinner and thinner until it disappears. Very few lamps are able to actually create a continuously subtle transition between bright light and darkness. We had to make some slight adjustments to most of our lamps to accomplish this; we filed back the protruding plastic casing on some, taped diffusion foil over lenses, or altered the reflectors using aluminum foil.

The Composition as a Whole Is the Deciding Factor

For us, light drawing is only one element of the finished photograph. The composition as a whole is the deciding factor, which is why we seek out motifs that are also spectacular without light painting in the daytime. We then use some type of ambient lighting so the setting is visible in the night. There are usually plenty of lights in the city, and the Moon is nature's illuminator. Although the light painting is usually complete in a relatively short amount of time, the ambient exposure takes a lot longer. When the drawing is finished, we allow the exposure to continue for a few minutes longer, sometimes up to an hour.

Two Heads Are Better Than One

We find working as a team to be a great advantage. This way, one person can remain with the camera while the other is active in front. The person on the camera has two important tasks. First, the camera person directs the light painter to the right spot because it is easy for the painter to lose orientation in the dark. The painter isn't always able to see the camera and gains no sense of where he or she is in the photo. Secondly, the camera person can take a break by holding a black piece of cardboard in front of the lens to temporarily stop the camera from recording light. This is a tremendous help when it comes to making designs with numerous parts, and it also allows the light painter to find new positions. It is also easier to find the right focus in the dark with two people. One person stands in the focal plane with an illuminated lamp while the other finds the focus.

Why Isn't the Light Painter Visible in the Photographs?

The most frequently asked question about our photos is why the person behind the painting isn't visible. We need not review the fundamental concept behind extended exposure to answer this question. First of all, we dress in all black for photographing and cover up any reflective object that might create light tracers, making black electrical tape an essential fashion accessory. To darken our hands and face we wear black gloves and a black motorcycle mask, but when wearing this outfit, you have to be absolutely aware that encounters with other people or the police can easily lead to uncomfortable misunderstandings. Quick movements and leaving the scene while exposing the background keep the light painter from showing up as a shadow in the foreground of the photo.

A Few Core Rules

There are a few core rules that we use for light painting:

- Know your equipment and what it can do for you, especially your lamps.
- Wear black, move fast when you're in the frame, and avoid shining light on yourself.
- Find good sources of ambient light and use them to add depth to your shot.
- Don't be so engrossed with your light painting that you forget to consider the overall composition.
- Collaboration helps to achieve better results.
- Keep your ISO low to avoid noise.

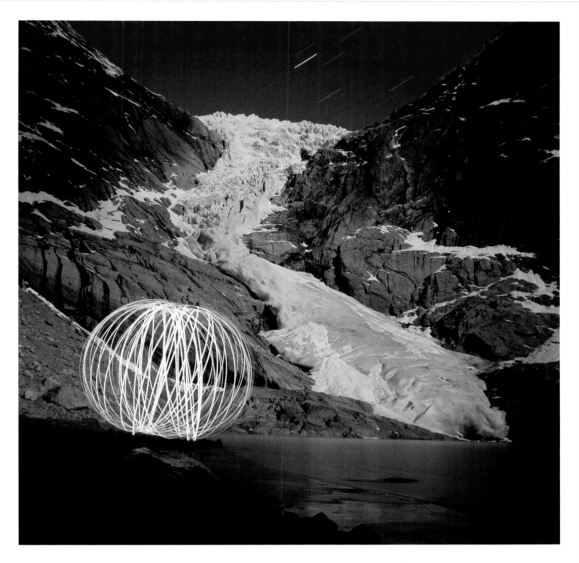

Cenci Goepel and Jens Warnecke, "Lightmark No. 63 | N 61°39'51.9" E 6°51'27.8", Briksdalsbreen, Norway," 2007

It took a 3-hour uphill hike on a frozen path to reach the foot of the glacier and 3 nights to create this photograph. From below, it was impossible to tell what the weather would be like above. The first 2 nights were so bad that we couldn't photograph a single thing, but it was a beautiful hike nonetheless! The third night was a charm—perfectly clear, as you see here. The ball was created by spinning an LED flashlight attached to a band in a circle as well as around the painter's own axis.

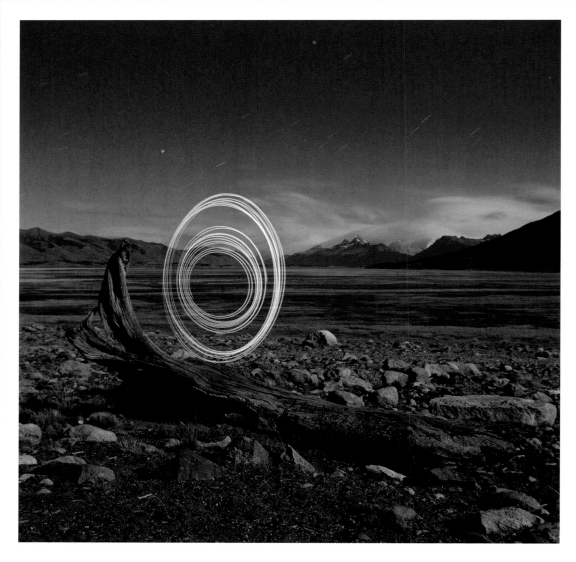

Cenci Goepel and Jens Warnecke, "Lightmark No. 54 | S 50°24'40.1" W 72°42'04.7", Provincia de Santa Cruz, Argentina," 2007

In this photo, we spun a band with an LED flashlight only on a single plane. The spiral shape is a result of the gradual shortening of the band as it spins. To achieve the space between the outer and inner rings of the spiral, we took a break by covering the lens briefly during the exposure.

COLOR

Color can have a strong psychological impact on your photos. Its use can be subtle or dramatic. In particular, complimentary or opposite colors in the spectrum can be used to highlight or isolate certain aspects of your image. Different sources have different color temperatures, and the selection of a light should not be made randomly. Incandescent flashlights have a color temperature of about 2800 K, which is close to the 3200 K tungsten white balance. Flash has a color temperature of approximately 5000 K, or daylight white balance. LED lights can range from 2900–7000 K, but the majority of LED flashlights are in the 5000–7000 K range. Consider whether you want your added light to blend in or contrast with the ambient light. In typical urban areas with predominantly warm sodium vapor lighting, cold flash or LED lights will stand out. Although the light added from a tungsten-balanced source will not match exactly, it will be more subtle than the light from a bluer source. Areas lit with metal halide lights will have a similar color balance to LED lights and flash. If you want your lighting to simply fill in a deep shadow, use a light that is similar to the ambient light. If you want to emphasize something, use a different-colored source. The color of the object to be illuminated should also be taken into consideration. It seldom makes sense to light a warm-colored object with a cool-colored light, or vice versa. For example, painting a red car with a cool LED light would probably not look very good.

You can also add color by placing lighting gels in front of your flashlight or strobe. As previously mentioned, gels block part of the visible spectrum of light, allowing only light that matches the color of the gel to pass through. Because the gel will block some of the light from your source, you'll need to compensate with either more time with the flashlight, multiple pops of the flash, or increased flash power. Different colors reduce the light output by varying amounts. For example, yellow and amber gels will let much more light pass through than deep blue, green, or purple gels. Some of the most saturated colors reduce light output by as much as four stops. You can calculate the difference using the transmission data supplied by the manufacturer, by measuring the light intensity both with and without a handheld light meter, or just by trial and error. Lighting gels come in individual 20 × 24-inch sheets or in the more practical 3 × 5-inch and 1 × 3-inch sample packs from Rosco. The sample packs are ideal because for a minimal investment you'll get more than 100 different colors. The 3 × 5 size is more versatile because it will cover a wider array of lights. The smaller size fits perfectly over most flash heads, but the pieces are too small to use with many flashlights. Before you venture out into the field, disassemble the swatch book and choose five or six colors to carry with you. You may find it helpful to laminate the smaller pieces because they are thin and can be awkward to handle, especially in windy conditions. If carried intact, the swatch book becomes cumbersome and frustrating to use. LumiQuest makes a compact gel holder that attaches to your flash head with Velcro, holds the gels in place, and stores the ones you're not using with the flash. Double-stick tape on your flash head or flashlight bezel will work as well.

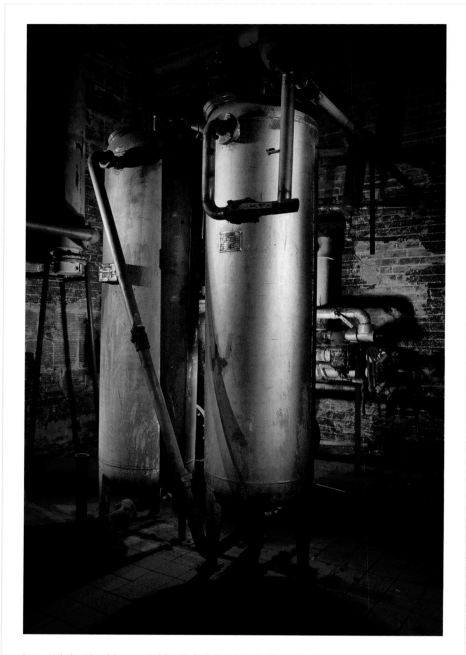

Lance Keimig, "Pearl Brewery Soldier Tanks," San Antonio, Texas, 2009

Warm incandescent flashlight was contrasted with blue-gelled flash in this shot taken inside the Pearl Brewery in San Antonio, Texas. Flashlight was added from the left and right sides, and the flash was popped six times at full power from behind the tanks. Five flashes were fired at the back wall, and one flash pointed forward, which lit the floor beneath the tanks and created the shadows in the foreground. The contrasting colors of light make the shot.

Scott Martin: In the Absence of Light

I've always been drawn to spaces in transition. Construction sites, demolition sites, and abandoned structures evoke a temporary and rarely celebrated beauty. Naked, their structural elements exposed, some seem more proud than others, ready to show their soul.

After 118 years of continuous operation, San Antonio's old Pearl Brewery recently shut down. Exploring the site, one finds buildings in different stages of demolition, isolation, and construction as the area is slowly and thoughtfully redeveloped. Of the many cellars, #8 caught my attention because the large tanks were only partially dismantled, and a row of skinny red solider tanks stood tall, bisecting the room.

Composing a shot was unusually difficult because the entire building was pitch black and only visible by flashlight. I knew that I would have to rely on added light to make an image. I started by taking several test exposures to get a feel for the composition, crudely illuminating the room each time with a flashlight while standing at the camera. The first photo is one of those first exposures, which gives you a feel for what this scene looks like to the viewer walking around with a flashlight.

When I had determined the composition, I was eager to start lighting the scene in a more captivating way. I wanted to light the solider tanks from the sides using a warm, incandescent SureFire flashlight. For juxtaposition, I decided it would be fun to move throughout the scene using a handheld flash and blue gel to illuminate the rest of the room. I would need to pick my locations to fire the flash from carefully and use the tanks to hide my position and the hot spots that a flash can create. The second figure shows my first attempt at lighting the scene.

This first attempt felt like a good start, but it made me realize that the insides of the larger tanks needed illumination. So I used the next exposure to test this, lighting each of the six large tanks differently. I also used this exposure to fine-tune the lighting on the soldier tanks, which still didn't feel right. Because I was primarily testing the light added to the inside of the large tanks, I decided to let the flash rest during this exposure and not light the walls.

I liked the lighting in tank #4 (from left to right) the best. I climbed into the tank and used my white shirt as a reflector for 10 seconds of diffused light painting. I committed this to memory and made another attempt at lighting the entire scene, this time with the inside of the large tanks illuminated.

This attempt shows promise, but the floor and ceiling are calling out for attention. I decided to perform another test exposure, this time to experiment with floor lighting.

Several shots were made with crude lighting to establish the composition.

The lighting concept starts to take shape with the first attempt at lighting. It becomes obvious that the inside of the large tanks need to be lit.

The intent of this shot was to try different lighting methods for the large tanks, and refine the lighting on the red tanks in the back of the shot.

It's starting to come together, but the floor and ceiling need work.

The lighting on the floor looks good in this test shot, but the ceiling needs much more light.

The floor exposure is good, but I noted the harsh lines and planned different flash positions for the next attempt. The distant ceiling looked like it would require much more light. At this point I grew even more excited because I could feel the shot coming together. I immediately started another exposure that combined the lighting on the solider tanks, large tanks, walls, floor, and ceiling.

As with all of the previous attempts, I shot using bulb mode and manually stopped the exposure when I was done adding light. It took only 7 minutes and all the remaining flash and flashlight battery power to complete the light painting. Because there wasn't any existing light, there wasn't any point in extending the exposure after the light painting was completed. I stopped the exposure and let the 7 minutes of long-exposure noise reduction begin. Although I wouldn't be able to review the shot until the long-exposure noise reduction completed, I could *feel* that I had the shot. I had been working on this shot for 3 hours in a dank, humid room where the Texas summer temperatures were in the 90s, even at night. I hadn't seen the shot yet, but as I walked back to the car I knew a had a little jewel of a RAW file waiting to be brought to life.

The final version after three hours of trial and error. Scott Martin, "Pearl Brewery Cellar #8," San Antonio, Texas, 2009

It might be worth mentioning that although one can use Photoshop to combine multiple exposures, I like to capture everything with a single exposure when possible. Although several of these attempts could have been tediously combined in Photoshop, getting it right in a single exposure is a worthwhile goal. Parametric editing in Lightroom from a single RAW file adds an elegance to the process that is very satisfying. Like almost all of my work these days, the final exposure was processed in Lightroom with only minor density adjustments and without the use of Photoshop at all.

There really is no right or wrong way to approach light painting, but it does take time to learn how to anticipate how a shot will turn out and to develop the confidence to pull it off. You'll want to develop your own ideas and style, but looking at the work of other photographers and shooting with others is a great way to learn. There is a huge global community of light painters on Flickr that I recommend exploring and participating in if you have more than a passing interest in the topic.

References

CHAPTER 1

1. Vincent van Gogh, letter to Theo # 533, September 8, 1888.

2. Richard Leach Maddox, An Experiment with Gelatino Bromide, *British Journal of Photography*, Volume 18 (1871), pp. 422–423.

3. *Harper's New Monthly Magazine*, Volume 78 (December 1888), p. 288 and *The Columbian Cyclopedia*, Volume 23, 1897.

4. M. Susan Barger and William B. White, *The Daguerreotype*, Smithsonian, (August 17, 1991), p. 85.

5. ibid, p.89.

6. Naomi Rosenblum, *A World History of Photography*, Abbeville Press, 4th Edition (January 29, 2008), p. 248.

7. *Quarterly Journal of Science*, (January 1864), pp. 352–353.

8 Chris Howes, *To Photograph Darkness: The History of Underground and Flash Photography*, Southern Illinois University Press, 1st Edition (February 1, 1990).

9. Paul Martin, *Victorian Snapshots*, London: Country Life Limited, (1939), pp. 24–29.

10. James B. Carrington, Unusual Uses of Photography, *Scribner's Magazine*, Volume 22 (1897), pp. 626–628.

11. Dorothy Norman, *Alfred Stieglitz, An American Seer*, New York: Aperture, (1960), pp. 43–45.

12. *Anthony's Photographic Bulletin*, (April 1871), pp. 589–590.

13. Joel Smith, *Edward Steichen, the Early Years*, Princeton University Press, (1999), pp. 34–36.

14. ibid, pp. 34–36.

15. A. H. Blake, *The Amateur Photographer and Photographic News*, (December 1, 1908), pp. 519–521 and A. H. Blake, *American Photographer*, Volume 6 (February 1910), pp. 65–70.

16. ibid, Carrington, pp. 626–628.

17. Edward Van Fleet, letter to the editor, *The Photo Beacon*, Volume 10 (1898), p. 30.

18. From email correspondence with Peter Yenne, July 2009.

19. The original 1933 version of *Paris de Nuit* was printed in photogravure, as was the 1987 Pantheon reprint. It's worth seeking out a used copy of the 1987 version as opposed to the 2001 Bullfinch version because the quality of the reproductions is far superior.

20. Known as *The Secret Paris of the Thirties* in English, this book is still widely available and inexpensive. There are no major quality differences among the different editions, but the first edition is collectible and fairly expensive compared to later paperback printings.

21 Paul Delany, *Bill Brandt, A Life*, Jonathan Cape, (2004), p. 77.

22. ibid, p. 79.

23. Unfortunately, *A Night in London* has never been reprinted, and original copies are extremely rare and expensive.

24. An extensive but unsuccessful search was done to trace the copyright holder for this work to gain permission to print one of Burdekin's images in this book. The author highly recommends seeking out *London Night* from a library or used bookseller.

25. ibid, Delany, pp. 166–168.

26. Bill Brandt, Blackout in London, *Lilliput*, (December 1939) and Bill Brandt, London Under Blackout, *Life*, (January 1, 1940).

27. ibid, Delany, pp. 166.

28. Margaret Bourke-White, *Portrait of Myself*, Simon and Schuster, (1963), p. 178.

DOI: 10.1016/B978-0-240-81258-8.00030-2

29. Richard Doud, Interview with Jack & Irene Delano, *Archives of American Art*, Smithsonian Institution, (June 12, 1965).

30. From email correspondence with Jeff Brouws, July 2009, author of *Starlight on The Rails*, New York: Harry N. Abrams, (2000).

31. From email correspondence with Arthur Ollman, August 2009.

32. The author of this book was a student of Steve Harper's at the Academy of Art College in San Francisco from 1989–1990.

33. From a conversation with Steve Harper, July 2009.

34. Paul Martin, *Victorian Snapshots*, London: Country Life, (1939), p. 25.

35. Michael Kenna, *Nightwork*, Tucson: Nazraeli Press, (2000), pp. 10–11.

36. ibid, p.12.

37. I have attempted to include as broad a sample of night photographers' work as possible in this chapter, knowing that many would necessarily be left out. I have tried whenever possible to include the work of photographers outside of Europe and North America, but the limited scope of my research has not as yet uncovered historic night photographers from Asia, Africa, or Australia, though surely they exist. I have also generally included photographers whose night work was a significant part of their portfolio, rather that photographers who made one or two great night photographs. Please see the resources section at the end of this book for a list of books and Web sites on both historic and contemporary night photographers.

CHAPTER 3

1. Dynamic range and other qualities of digital cameras are compared and analyzed on the Web site www.dxomark .com. This Web site is a very useful resource if you are considering a new digital camera.

Resources

Online Community

Darkness Darkness is an online and brick-and-mortar exhibit of contemporary night photography curated by Lance Keimig.
http://www.darknessdarkness.com/

The Nocturnes is *the* resource for all things night photography. It has the largest list of night photo Web links, as well as online galleries, competitions, workshops, and classes in California. Be sure to visit the "O.Winston Links" page for an ever-growing list of links to night photography websites around the world.
http://www.thenocturnes.com/

Bay Area night photography legend Steve Harper inspired a generation of night photographers, and taught the first college-level course on the subject.
http://www.steveharperphotography.com/

Other Night Photography Books

There are numerous other books on night and low-light photography on the market.

Jill Waterman's book has lots of useful information, and many inspiring images. There are contributions by many notable night photographers, including the author of this book.

Jill Waterman, *Night and Low-Light Photography: Professional Techniques from Experts for Artistic and Commercial Success*, ISBN-10: 0817432418

Andrew Sanderson's Night Photography offers the most complete information on black and white film-based night photography, including darkroom techniques. Sanderson really gets it.

Andrew Sanderson, *Night Photography*, ISBN-10: 0817450076

Michael Freeman's book focuses on postprocessing techniques for dealing with problems that arise in night photography. Lots of technical information.

Michael Freeman, *The Complete Guide to Night & Lowlight Photography*, ISBN-10: 1600592066

Night Photography Workshops

Lance Keimig offers several night photography workshops and classes each year. Locations include Boston, Texas, California, Ireland, and Scotland.
http://www.thenightskye.com

San Antonio–based Scott Martin teaches with me on some of my workshops, and he offers one-on-one and classroom instruction on workflow and Lightroom.
http://www.on-sight.com/workshops/

Troy Paiva and Joe Reifer teach their own style of night photography and light painting, mainly in remote desert locations.
http://www.lostamerica.com/workshop.html

Tim Baskerville and I started teaching workshops together in San Francisco in 1998. Now based in Vallejo, California, Tim continues to offer classes and workshops in different venues around the Bay Area and in Death Valley.
http://www.thenocturnes.com/workshops.html

Brent Pearson of Sydney, Australia occasionally offers workshops on night photography and light painting.
http://brentbat.wordpress.com/

Flashlights

There are many different types and qualities of flashlights available today. The technology has advanced almost as much as camera technology in recent years. Many flashlights are offered through police and military supply companies. Streamlight and SureFire have a great selection and are well made. There are numerous poor-quality knock-offs that don't compare to these two brands.
http://streamlight.com/
http://www.surefire.com/

Stacking Software for Star Trails

Dr. Brown's Stack-A-Matic is a free Photoshop Extended script for Mac and Windows. The limitations of this script are that it takes longer than the Open as Layers in Photoshop option from Lightroom, and it only works with Photoshop Extended versions, starting with CS3. Scott Martin used Stack-A-Matic on his "The Love Bus" photograph.
http://www.russellbrown.com/tips_tech.html

Startrails.exe is an easy-to-use freeware program, but unfortunately it is compatible only with Windows. Shawn Peterson used it for his "Bodie Wheel of Wonder" image.
http://www.startrails.de/html/software.html

Keith's Image Stacker was designed for astronomy images shot through a telescope, but it works for star trails as well. It has

many user-defined controls and is more difficult to use than the other software. It is for the Mac only, and a $15 donation is requested.
http://keithwiley.com/software/keithsImageStacker.shtml

HDR Image Blending Software
EnfuseGUI is a stand-alone image blending application for Windows and Mac.
http://software.bergmark.com/enfuseGUI/

LR/Enfuse is a Lightroom plug-in that uses Enfuse to keep your HDR workflow within Lightroom.
http://photographers-toolbox.com/products/lrenfuse.php

Photomatix is the best-known HDR software.
http://www.hdrsoft.com/

iPhone Apps for Night Photographers
Darkness ($0.99) and Photoluna ($4.99) are iPhone apps for studying Sun and Moon times and positions. Photoluna has a live compass and will point to the part of the sky where the Sun and Moon will rise and set.

Flashlight (free) is surprisingly useful for illuminating your way, seeing in your camera bag, and the like.

iMoonU ($0.99) displays the phase of the Moon for the current or any other date, and it has a monthly lunar calendar and full moon countdown.

Starmap Pro ($18.99) is one of the best apps for stargazers and astronomy buffs. It contains more information than most of us will ever need.

Field Tools (free) is a basic app that calculates depth of field and hyperfocal points.

Tack Sharp ($0.99) is another depth of field and hyperfocal calculator. With this and Field Tools you have to know your camera's lens magnification factor because there isn't a list of cameras to choose from.

DoF Calculator ($1.99) and DOF Master ($1.99) are very easy to use with camera lists.

Astronomical Information
This U.S. Navy Web site provides complete information on sunrise and sunset, and moonrise and moonset times.
www.usno.navy.mil/USNO/astronomical-applications

Subject Index

Page numbers followed by "*f*" indicates a figure and "*t*" indicates a table.